I EXAGGERATE

This book is dedicated to all of my subjects who either wittingly or unwittingly agreed to be a part of this collection of caricatures and witty anecdotes. This book would not be possible without many of you. You are all either wittingly or unwittingly good sports and I thank you in advance for not removing me from your speed dial.

I EXAGGERATE

MY BRUSHES WITH FAME

Portraits & Stories

KEVIN NEALON

Abrams, New York

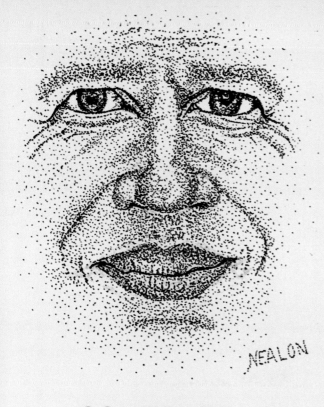

NEALON

CONAN

Kevin 92

CONTENTS

INTRODUCTION

When I was a cast member on *Saturday Night Live* from 1986 until 1995, during the Tuesday-afternoon table reads I would sometimes drift off and sketch fellow cast members in the margins of our scripts. Whoever was sitting across from me, be it Chris Farley, Dana Carvey, Jan Hooks, or maybe even that week's guest host, they became my unwitting subjects.

I first became interested in drawing at the age of eight when I discovered a sketch of a serviceman on a napkin left behind at a café. I would spend many hours trying to re-create that drawing, an animated profile of a man with a cap, an exaggerated large nose, and a protruding chin.

Several years later, hanging over a dresser in my childhood bedroom were colorful pastel caricatures of my parents, each separately framed. These were no ordinary run-of-the-mill drawings but the work of a talented Parisian caricature artist. For years, as I lay in bed, I would stare at those brilliant caricatures, studying the exaggerations, colors, and contours, analyzing every stroke. As a child I was also impressed with the works of caricaturist Al Hirschfeld and Mort Drucker of *MAD* magazine.

Even as a child I was told I had a talent for drawing, but I never pursued it with much focus or passion until recently. The only pseudo art lesson I had as a child was re-creating maps in school. Our assignment often was to draw maps of various countries, their borders, and rivers. Under no circumstances could we trace the existing map. This was a great lesson in hand–eye coordination. I realize now that my drawings were unintentional caricatures of maps. Italy was a boot, but it looked more like a platform shoe from the 1970s.

In my late twenties I developed an intense interest in the nineteenth-century French Impressionist painters—specifically Claude Monet, who I learned, to my surprise, was also a caricature artist early in his career. On occasion, I began to visit the museums in Paris and elsewhere to study their paintings, techniques, use of colors, and blending.

In more recent years, as I flew to and from stand-up gigs around the world, I would secretly sketch fellow passengers on a drink napkin or barfbag. I never showed them my finished work and they never knew. After my stand-up shows, I might meet the audience in the lobby of the club or theater and have my picture taken with them—I would then go home and use these pictures of those audience members to practice my caricatures.

In the summer of 2019 I learned how to paint on a digital tablet, which is how I've painted the portraits you'll see in this book. Though I sometimes drew friends and strangers, I also found myself drawing celebrities—some of my famous friends, sure, but also some of my idols from my early years, and those from before my time. With each person, I discovered there was some deep or meaningful personal connection. A story beyond the painting itself.

The only downside of becoming a caricature artist is that, now, whenever I look at people, I automatically see their character traits exaggerated in my head. Every day I feel as though I'm walking through a carnival filled with fun-house mirrors.

During the pandemic, since live stand-up was halted, I began sketching more and more. Drawing caricatures became a substitute for stand-up, a nonverbal form of comedy and a great creative outlet. I was immensely encouraged by how much my Instagram followers, and fellow artists, supported and appreciated my work. It's through their consistent encouragement, support, and generosity of knowledge that I've continue to learn and grow as an artist. And I'm not stopping—I look forward to painting more and more as my life goes on.

In this book you will see my paintings of celebrities or other notable people that have influenced my life. Each is painted with some degree of exaggeration, some more than others. I may have also chosen some because I have fun, meaningful, unexaggerated stories to tell about them. Others, maybe, because I thought their physical traits would lend to a humorous caricature. Interestingly and for whatever reason, I have rarely heard back from any of these subjects after posting on social media. I'm OK with that, though. Everything is done in good fun and I appreciate that most people are good sports—they may even be flattered I chose to paint them. In fact, I have also included a self-caricature I painted. I'm not above making fun of myself.

Because I am still learning this world and not incredibly expedient in the process, I typically spend hours upon hours, sometimes weeks completing each caricature. I would venture to say that some spouses have not looked at each other's faces as much as I have studied and examined those in the following pages. I hope you enjoy my exaggerated renditions of these icons, or at least recognize their likeness. They are each truly a labor of love.

AA #02 Seat 3 CDE
LAX - JFK

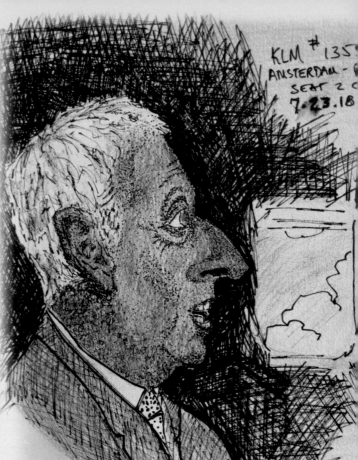

KLM # 135?
AMSTERDAM -
SEAT 2 C
7.23.18

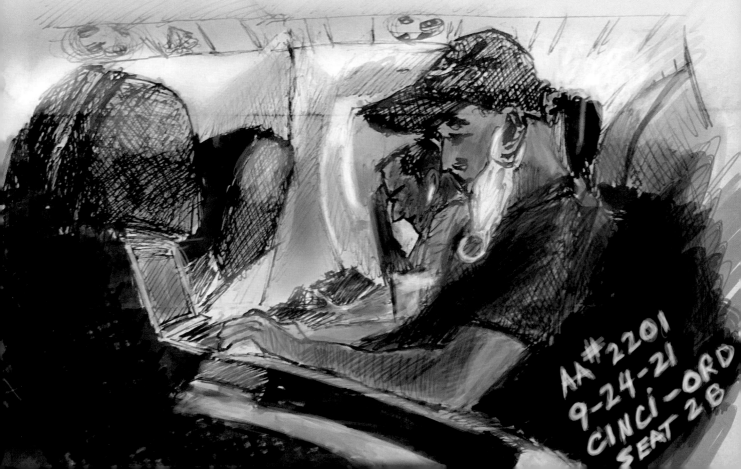

AA #2201
9-24-21
CINCI - ORD
SEAT 2 B

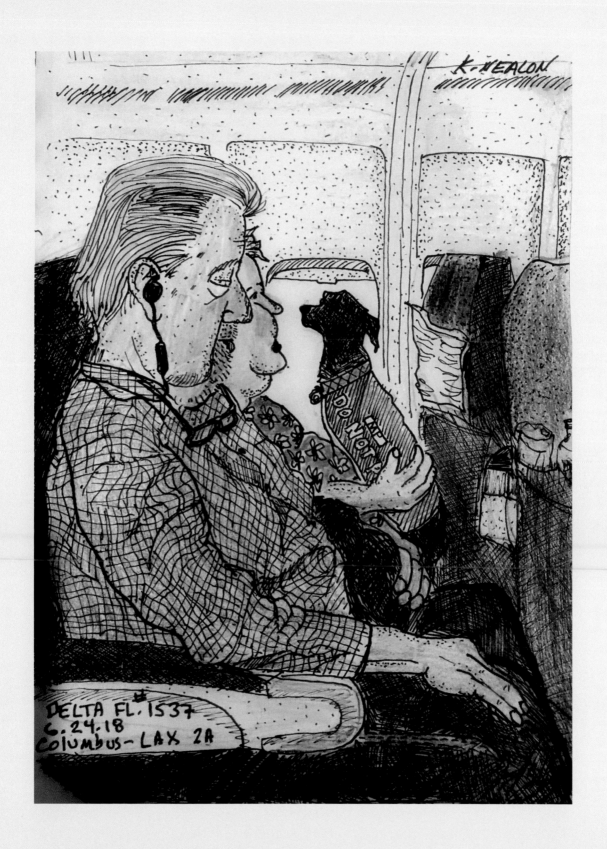

ROBIN WILLIAMS

1951-2014

This painting portrays the Robin I first met in 1979. I was still pretty much a newbie to stand-up comedy but loved it, so much so that I studied comedians and never missed my favorite comedians perform on TV. In my midtwenties, most of my evenings were spent at clubs in Los Angeles either performing at open mics or watching seasoned comics at the Improv or Comedy Store. There were as many good comics as there were bad ones; most comedians followed the traditional setup-and–punchline format. I thought I had seen just about every comic and style out there until the night I went to the Laff Stop in Newport Beach. The headliner was a guy I had never heard of: Robin Williams.

They introduced Robin and he moved to the stage, never quite getting there. He never used the microphone and instead projected his voice to carry into the audience. He was dressed in a tight, open-neck collarless shirt, very loose-fitting thrift store pants, and a floppy Shakespearean hat. That was his look. Everything about him was unique and memorable, down to his thick mat of body hair that mostly resembled fur. Even his fingers were bushy. By the end of his act, he was drenched in sweat.

Robin wasn't your traditional stand-up. He worked his way into the audience, occasionally embarrassing a woman by opening her purse and pulling various items from it. He would hold up each item and always made some hilarious observation. Then he would move on and break into a nonsensical Shakespeare soliloquy. He was in fact a modern-day Jonathan Winters. No one was quicker or funnier; I was absolutely floored by his wit, improvisational skills, characters, and voices. He was pure genius.

As much as I laughed, I also found myself depressed because I knew I could never be that funny. He was Amadeus Mozart, and I would be Antonio Salieri at best. But I eventually realized that Robin couldn't be everywhere at once so I would probably, at least, get some work. A few years later, after establishing myself as

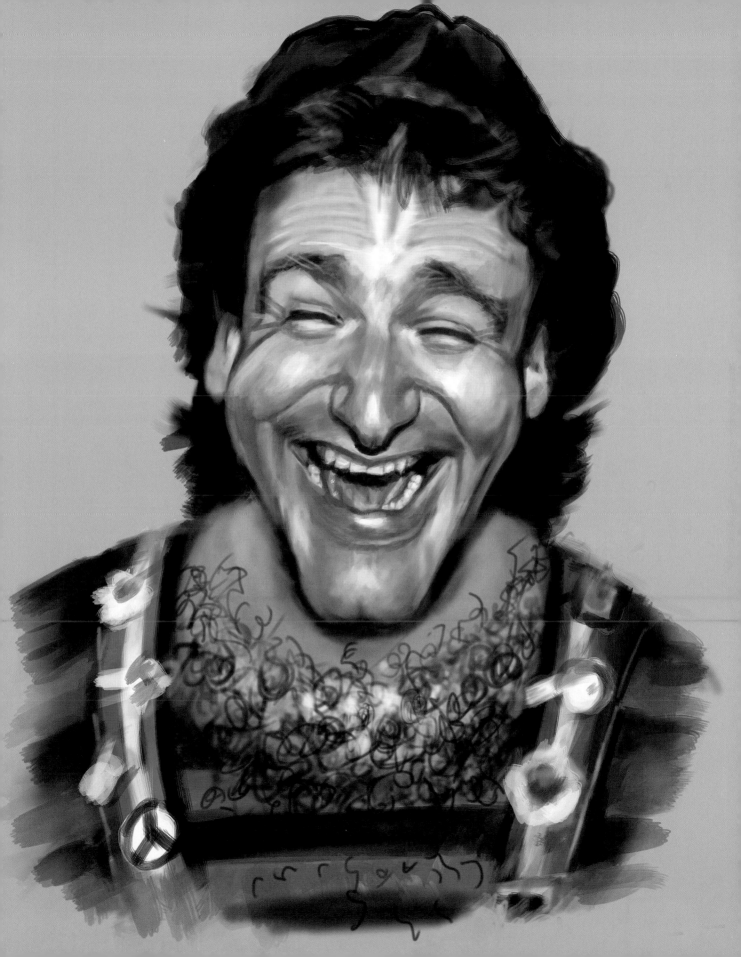

a comedian, I popped into the Improv in New York, where I had to follow Robin's act. You can only imagine the crickets I heard.

Not much later, when I was bartending at the Hollywood Improv under Budd Friedman's stewardship, Robin would often come in after long hours of taping his popular sitcom, *Mork & Mindy.* He would show up for a set still dressed as Mork, wearing thrift clothes like in this painting, but now with the famous colorful suspenders covered in various pins. His thirst for performing was insatiable. I'd done sitcoms before doing stand-up and it was usually pure torture. Not for Robin. He would not only show up at the Improv to perform but would then hustle over for a set at the Comedy Store, followed by some after-hours get-together. I can't imagine the stress of always having to be on.

He was always met with thunderous applause and he always proceeded to destroy the room.

After watching and studying his performances over time, I began to discover the method to his madness. Yes, much of it was improvised but there was also a pattern he followed. He had certain go-to jokes and bits (like the purse routine) and the silly Shakespearean solilo-quys. From what I remember, he had a cache of characters and voices including a Texas red-neck, a smart-assed child, a Russian dude, and many others. What also separated Robin from the pack was that he knew how to move. He didn't just stand onstage behind the mic—he danced and flitted through the audience like a butterfly. I later discovered that he learned taking courses in dance movement at New York's Juilliard School, which is also where he studied Shakespeare. Even before Juilliard he honed his craft by performing in the streets of San Francisco—and if there's one type of per-former I respect, it's street performers. They have no mic; they must gather their own audi-ence; and they need to keep lured in by being incredibly energetic, entertaining, and funny.

I would say that Robin and I were friends but never really hung out aside from the comedy clubs. We never even addressed each other by our real names. I called him "Bahboh," and he called me "Boss." He called lots of people "Boss." I can't even remember the sound of his real voice—he always seemed to be speaking like one of his characters. Most of the time offstage he seemed to have a slight Scottish brogue and a booming laugh. You would always know Robin was in the back of the audience with that laugh. He was also a delightfully cheery person—I can honestly say I've never seen him angry except for one night after a performance at Cobb's Pub in San Francisco. He told me his car wouldn't start so I followed him to it to see if I could help. I certainly couldn't help him with any mechanical condition, but I could be of emotional support. He opened the hood, pushed down on a few cables, and then climbed into the driver's seat. He put the key in and gave it another try—nothing. He got out, slammed the door, and cursed that car up and down. Though this felt out of character, he was human after all.

It was always a thrill for me whenever Robin hosted *Saturday Night Live*. Who would have thought we'd both be working together on that show one day? He was absolutely brilliant every time (I had my moments, too).

I often feel bad thinking of the pain and torment he went through in his final years. For someone who brought so much laughter to this world, his fate certainly wasn't deserved. I hope he eventually realized that he was enough—more than enough—and finally found solace somewhere. God bless you, Robin Williams.

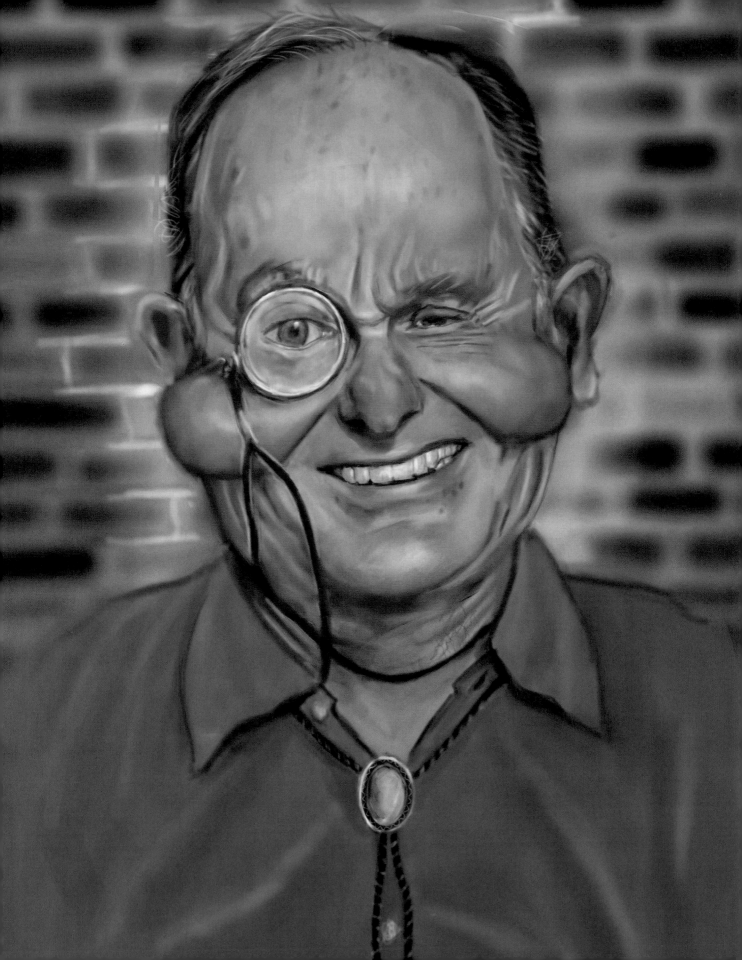

BUDD FRIEDMAN

When I rolled into Los Angeles in 1978 to try my hand at stand-up comedy, my first stop was the iconic Improvisation Comedy Club in Hollywood. I knew its illustrious reputation, originating in New York City, with another location popping up in Hollywood in 1975. In fact, a young Jay Leno had helped paint some of the interior. I also knew of its founder and house emcee, Budd Friedman.

Budd was instrumental in shaping the careers of several comedians who have since gone on to become megastars: Freddie Prinze, Robert Klein, Rodney Dangerfield, Richard Lewis, Andy Kaufman, Jimmie Walker, Jay Leno—each of them bright, inventive comedians who went on to revolutionize the comedy world. Friedman also served as Bette Midler's manager when she was just getting her career started and arranged for her initial appearance on *The Tonight Show*.

Yes, Budd was famous for starting the Improvisation Comedy Club in the Hell's Kitchen area of Manhattan, but he was also a war hero. Budd served in the US Army during the Korean War, performing his duties at Pork Chop Hill in 1953, where his unit engaged in active combat. Friedman took shrapnel from an enemy grenade on the first day of the conflict, for which he received two distinctions, the Purple Heart and the Combat Infantryman Badge. He was no slouch; you didn't want to get into a physical altercation with Budd—he was tough and never backed down. Funny how these guys always seem to be the ones most attracted to comedy.

My friend John and I entered the Improv on an October afternoon when not a soul was there—the club, of course, came alive at night. Budd saw us enter and asked if he could help us. I respectfully told him we had heard a lot about his venue and just wanted to take a peek—I was still too intimidated to reveal I was a comic since I didn't have an act yet. Still, Budd could not have been nicer, and it was obvious that he was proud of his club and its legacy. He graciously showed us around,

taking us down a hall past large pictures of well-known comedians, ending finally in the showroom. I was now standing in what I considered a very sacred place, with its stage and the famous brick wall behind it. Budd chatted about the room size, showtimes, and some history of the original NYC club. On the way out, he stopped by the entrance and showed us framed newspaper clippings on the wall, which included positive reviews and stories with photos of Jay Leno and David Letterman. Yes, Budd was very proud of his domain. We thanked him and as we left, he told us to come back anytime. And that is exactly what I did. Time and time again for many years.

Not immediately, though. It took me time to build up courage to go to a Sunday-night open mic, where aspiring comics could get five minutes onstage in front of an electrified audience. I had written some material, but I was still new to comedy, not yet comfortable in front of crowds. The first Sunday, I was so petrified I parked across the street from the club and never got out of my car. I just sat and watched people go in and out. The next Sunday I bravely went inside the club but only stayed in the bar area. Every Sunday I moved a little closer to the showroom and to my name being put in a hat and then drawn by the emcee. Finally, one

Sunday my name was called during the peak of the night. I was so nervous when I heard my name that I remained seated in my chair and joined the rest of the audience looking for a "Kevin Nealon."

The next Sunday changed my life. My name was drawn from the hat at 12:45 A.M., but the room was empty except for two tables. At one table was the friend who had given me a ride into Hollywood that night, and the people at the other table were drunk and inattentive. Perfect, I thought. I went onstage and got a few good laughs with my silly material, but that hardly mattered. What mattered was, I had been on the very same stage as all those famous comedians. I was now in that exclusive club. And I was hooked.

I soon rented an apartment a few miles away from the Improv and hung out there almost every night to watch and learn. When friends or family came to visit and wanted to tour Hollywood, I was of no help. All I knew was the Improv. After two years of attending practically every night, Budd hired me as an additional bartender for the slow nights. Coincidentally, Les Moonves also worked the service bar in the showroom before he became the head of CBS. As a bartender you always

remember what the regulars drank, and no one was more of a regular than Budd (his drink of choice was sherry or port). Eventually, as my act got a little better, and when a comic didn't show up, Budd would put me on. I would do my very mediocre act, leaving a less-than-satisfied audience, and return to the bar to find impatient customers angry they had to wait for their drinks. I loved every minute of it.

Budd enjoyed emceeing at his club. After a shorter comedian left the stage, as he adjusted the mic stand, he always delivered his favorite line: "Let's get this up to an adult height." He ran a tough ship, too. He was forever reprimanding the comics or lingering customers who milled around the showroom door. "Out of the aisle," he would demand. The waitstaff balancing large trays of drinks were grateful for Budd's policing. Around 1982, Budd also appeared as host and was the executive producer of *An Evening at the Improv*, in which I also appeared. I believe it was around that period that he took on the affectation of wearing a monocle. He needed reading glasses, but they were too cumbersome to fit in his pocket and he always lost them. He opted instead for a prescription monocle. It solved the problem of Budd losing his glasses because it was

attached to his shirt by a long chain. He liked this look, too, which we all compared to Col. Klink from the TV sitcom *Hogan's Heroes*. It was practical and functional, but the monocle became his signature look, too. I personally thought he would abandon it after several months, but he stuck with it, and I believe he continues to wear it to this day. Though not many others followed in his style. I wonder if he tried other affectations before the monocle— like a stovepipe hat or a corncob pipe.

Since my time as a bartender, the Improv has grown massively: It now has twenty-two venues nationwide since the original's opening more than half a century ago. To this day I will occasionally perform at an Improv franchise or at the one in Hollywood. On my way in I always make sure to stop at the bar to say hi to my friend Eddie Berke, the bartender who took over for me thirty years ago.

Budd has since sold his franchise—and with it, a piece of comedy history—and has retired. I will forever be grateful to him for giving me a place to develop my act, watch and learn from some of the greats, and have a place I called home away from home. Thank you, Budd.

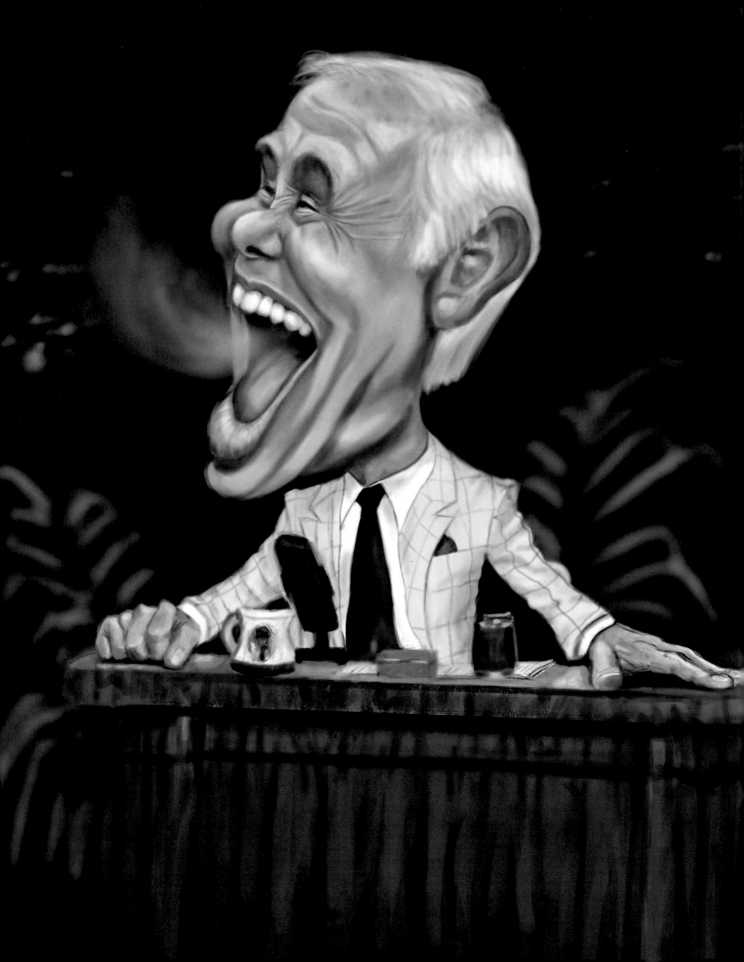

JOHNNY CARSON

1925-2005

Growing up, I used to watch *The Tonight Show Starring Johnny Carson* religiously. I loved his monologue, his little sketches, and his hilarious interviews. I was heavily influenced by him as a comedian and by many of the comedians he showcased. He was the king of late night (because he was the only late-night talk show host at the time). His interview style was so natural and effortless; he was an excellent listener with a very sharp wit that helped him easily make his guests look great.

A stand-up's dream was to be on his show—it was the ultimate validation. Having Johnny's approval meant you had a career ahead of you.

When I first moved to Los Angeles in 1979, I would drive out to NBC Studios in Burbank several times a week to watch the show tape. I considered these visits homework, and I began to learn the studio's drill. Tickets were given away to fans early in the afternoon, and they would then be instructed to wait in line outside the studio. The wait was usually at least ninety minutes. I would arrive about twenty minutes before showtime, walk up and down the line of fans, and politely ask if any had an extra ticket. I would usually luck out and get one because, invariably, a ticket holder's guest wouldn't arrive. Once the audience was ushered in to take their seats, the excellent *Tonight Show* band, led by jazz trumpeter Doc Severinsen, would perform a few songs. Doc would then introduce Ed McMahon (Johnny's sidekick), who would come out to greet the audience and explain how the show worked. This was part of the audience warm-up process. Ed, in turn, would then introduce Johnny, who would walk out to a very starstruck and excited audience. He would say a quick hello, tell a few jokes, thank the audience for coming, and then encourage us to have a good time. He'd give a little wave and exit. The stage had now been set and anticipation was high. Every episode began with Ed McMahon announcing the name of the show and the starring guests for that night.

This was followed by the trademark line introducing the host: "Heeeeere's Johnny!" Those very familiar rainbow-colored velvet curtains would part, and Johnny would come out to thunderous applause. The energy in the studio was palpable. He would often act surprised at the audience's excitement as he sauntered out to his mark on that shiny black floor.

Being there was like being at a Vegas show. I got to enjoy Johnny delivering his monologue followed by all these famous and talented guests' performances and interviews. I began visualizing Johnny introducing me. The curtains would part, and I would walk out to my mark on that shiny black floor. Once the audience applause died down, I would begin my five-minute routine. But I was putting the cart before the horse.

I was just starting out in stand-up and needed to develop an act. I needed to get experience onstage and discover my style. All of this needed to happen before Johnny Carson's impending retirement, which was probably only a couple of years away. I performed at as many clubs and open mics as I could and constantly worked on my material. I ate, drank, and slept comedy. After about five years of constant stage time, developing material, and defining my brand of comedy I decided to audition for Jim McCawley, the *Tonight Show* segment producer. He watched from the Improv audience as I performed my five-minute routine. I was terrified. Sweat dripped from parts of my body that never sweated before: behind my knees, from my Achilles tendon, even from my elbows. Sadly, Jim said I wasn't ready for *The Tonight Show*—yet. That news devastated me, but I wasn't about to quit. I kept at it and after another year I auditioned for Jim again, this time for a different show. He was now looking for stand-ups for a new variety show hosted by Michael Nesmith of the Monkees fame. I was less nervous for this audition and felt pretty good about my performance. The next day I received a call that I wasn't right for the Nesmith show but . . .

he thought that my routine would be perfect for *The Tonight Show*. Would I like to do it that following Monday? Oh my God! Yes! Yes! Yes! A thousand yeses! I was beside myself and giddy beyond belief.

Then the reality set in. I only had that weekend to rehearse my set. I wanted to run it into the ground over and over until it was second nature. Over that weekend, if you had a conversation with me I actually would not have been present. I may have been nodding my head at you as if I was listening, but really, I was going over my five-minute act in my head on a constant loop. This would either make me or break me. I barely even thought of what to wear (I just copied actor Ted Danson's outfit from his recent appearance: khakis, a light blue shirt, a red tie, and a blazer).

On Monday, as I was driving to NBC Studios, it began to settle in that I wouldn't be in the audience this time. Maybe another aspiring comedian would be studying *me*.

At the studio's gate, I told the guard my name and that I was there to perform on *The Tonight Show*. It was then that I noticed the steering wheel of my Datsun B-210 was covered in sweat. Even my steering wheel was nervous! The guard handed me a pass to put on my dashboard, opened the gate, and I rolled through. I spotted Johnny's expensive, metallic blue Porsche parked in his reserved spot convenient to the entrance. My heart pounded. *Get ahold of yourself*, I kept thinking.

I was taken to my dressing room, which had my name with a star next to it on the door. Trying to stay composed, I removed my Danson ensemble from the garment bag and began to dress. Before I knew it, I was with Hans, the show's longtime makeup artist, who made small talk while applying a thin coat of bronze foundation to my face. I could slightly hear the *Tonight Show* band playing in the studio. I knew the audience was already loaded in and I knew their excitement level was

high—but nobody was more excited than me. Suddenly, Johnny Carson himself briefly stuck his head in the makeup room, smiled, and said, "Knock 'em dead." For that moment I stopped playing the loop in my head. Johnny Carson had just friggin' told me to knock 'em dead!

Everything unfolded as it usually did except that I was watching it in a fog. Commercials came and went and then there was a knock on my door. Jim McCawley stood outside my room with a big smile. "All set?" he asked. He led me to the backstage area directly behind those familiar rainbow curtains. I was in the batter's box now as the show was in a commercial break. The horns from the band were blasting and I could picture every musician's face by heart. Jim tried to lighten things up a bit by doing a little dance, but in truth, it only confused and distracted me. This would be the last time I could review my routine, and he was prancing around me like a leprechaun doing an Irish jig. When the band ended their song and the commercial break was over, Jim patted me on the back and said, "You're gonna

be great." *Breathe*, I kept reminding myself. Johnny welcomed everyone back and then introduced me, adding that it was also my debut as a stand-up on his show. "Won't you please welcome, Kevin Nealon!"

The stagehands on each side of me pulled open the curtains and I headed out onto that shiny black floor in what felt like slow motion. I casually glanced over to Johnny and Ed at the desk and gave a little smile and wave as I continued toward my mark. That's when it happened. My mind suddenly went blank. My routine was gone, even as the audience applauded me on. *Oh no*, I thought. *This can't be happening.* I smiled as if everything was fine. *What is my opening line?* I begged my brain. The last clap resonated. And it came to me.

I was now delivering my five-minute routine aloud and not in my head. My lips were moving, and words were coming out. The audience began laughing in all the right spots. I didn't show my nerves, but my mouth was extremely dry. When I smiled, my top lip stuck to my

gums and wouldn't go back down. I didn't want to lick my teeth or gums because that would be a dead giveaway that I was nervous. I quickly adjusted by bringing my lower lip up extra high. No one noticed and I assumed things looked normal. I had an out-of-body experience delivering my act—I was *actually* on *The Tonight Show*, fulfilling my dream. Soon I settled into a comfortable pace and my heart slowed. I was getting stronger laughs than I ever thought and even applause breaks! I could hear both Johnny and Ed laughing from the desk. This could not have been going better and I was absolutely thrilled. I finished strong and thanked the audience. After a few seconds I casually turned to Johnny, smiled, and gave a quick wave of thanks. He was still laughing and gave me the OK signal. I turned back to the audience, absorbed some more applause, then turned and triumphantly walked back through the curtains. The show went to a commercial break. Jim was waiting for me there with a huge smile and a high five. "You did great!" he said. "How do you feel?"

"Just unbelievable!" I replied. I was shaking now but in a good way. I'd done it. It was done and I'd killed it!

I, at least, thought it was done but then Jim put his hand on my shoulder and said, "When we get back from commercial break, Johnny is going to bring you back out to sit and talk with him."

"What?" I stammered. "I'm getting panel, too?" This was the sure sign that Johnny liked you. It was a known fact that very few comics got panel after their debut. At this point I really didn't think it could get any better. "What can Johnny talk to you about?" he asked. In that moment I felt like pushing Jim aside while saying, *Get out of my way! Johnny wants to talk to me.* Jim followed up, "Let's not worry about it. You've got plenty of good material to work in still." Well, they came back from commercial, and Johnny told the audience he was going to bring me back out and that's exactly what he did. Beaming, I walked

out to another round of generous applause, shook Johnny's and Ed's hands, and sat on the couch next to Johnny's desk. He asked me a few questions for which I luckily had witty and funny answers. He asked if he was pronouncing my last name correctly. I replied, "Yes, but my first name is pronounced *Kevan* and not *Kevin*," to which Johnny threw his head back with a laugh. I can still picture the residual smoke escaping his lungs from the cigarette he toked during commercial breaks. He asked if I liked touring and working on the road. I said, "I don't mind it. Sometimes it gets a little lonely." "Does it?" he responded. "Yeah," I said. "Ya know," I continued with one of my strongest jokes I hadn't used yet, "AT&T says calling long-distance is the next best thing to being there, but I say the next best thing to being there is being with someone who looks similar." POW! The audience exploded with laughter, and he threw his head back again. After a few minutes of fun back-and-forths

he thanked me for being a guest and wished me good luck with my career. I had Johnny's approval at last. I was now complete.

Never have I had such a natural high of euphoria and pride. Nothing since that has compared to or exceeded that feeling—including my time on *Saturday Night Live* and *Weeds*. Appearing on that show, that conquest, was what I had set out to accomplish and it was checked off. I was only thirty-one years old and I had already realized my biggest dream.

I was floating that whole afternoon between the end of that taping before it aired at eleven thirty that night. I called my parents and told them how well I had done, and they couldn't have been happier for me. I just prayed that there would be no natural disaster that would preempt airing of *The Tonight Show* . . . ya know, I didn't want people dying and/or unable to see my debut.

I decided to watch at my good friend Mike Brown's house. Mike had helped me construct some of my act and is still one of my best friends today. I watched anxiously from the couch between him and his wife with a pillow held just below my eyes so I could cover them if necessary. I knew that during the airing, at the Hollywood Improv, the TV over the bar was turned to NBC. It was a tradition for all the comics, Budd Friedman, employees, and customers to watch a comic make their debut on *The Tonight Show* on that TV. I got my start at the Improv, so this made my debut of particular interest. The bar was as quiet as could be and all watched with anticipation. When my set was over, the bar burst into applause. I wasn't there but I could feel the love and pride from across town. Some soon left the bar area but then quickly came back when they heard Johnny invite me back out for panel. I was now a verified comedian! What a night that was!

Following the airing of my set, my phone rang off the hook with congratulations. My answering machine began to fill with well-wishes and congratulatory messages from friends, family, agents, and other comedians. I remember hearing from, among others, Garry Shandling, Bob Saget, Paul Reiser, and Brad Garrett. I still have that answering machine tape to this day. My only regret from that performance was my wardrobe. The Ted Danson ensemble turned out to be a bad choice. I looked like an NBC usher.

There is no question, that appearance was the highlight of my career and still is. Thank you, Jim and Johnny, and may you both rest in peace.

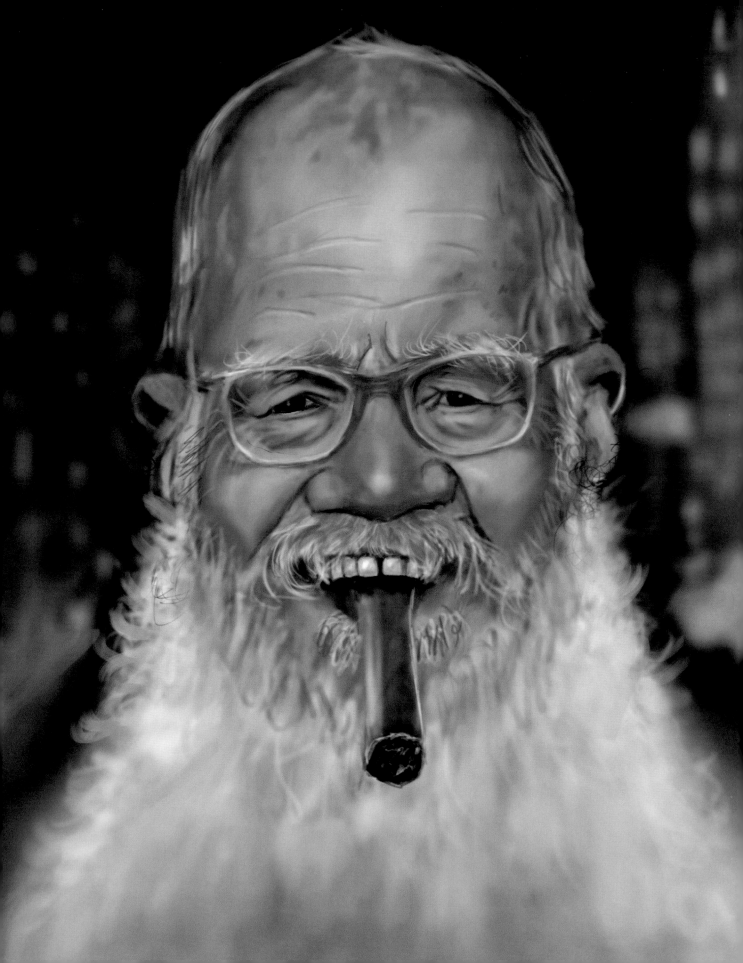

DAVID LETTERMAN

When I first started stand-up in the late seventies I would, on occasion, catch David Letterman performing at the Comedy Store in Los Angeles or at the Hollywood Improv. I could never remember his name, but I knew him to be that very funny, dry, Midwestern comic with a big gap between his two front teeth—and as a former weatherman. As it turned out, these appearances would be some of his very last comedy club performances as his career began to soar. The only time we ever interacted was several years later as a frequent guest on his now-defunct, groundbreaking talk show *Late Night with David Letterman.*

During my first appearance, I was immediately struck by his bushy eyebrows. The truth is, I actually *could* have been struck by them if I was an inch closer. Each brow was like a wild, wiry blond lawn neglected for decades. I honestly would not have been surprised to have seen a small bird fly out from one of them. In California, they would definitely be considered fire hazards and he would be required, by the city, to trim them back within three feet of his eyes. Obviously, manscaping his brows was not at the top of his agenda. But amazingly, he did not have a unibrow—his kept their identities separate.

I always enjoyed being a guest on Dave's show and I also admired his fashion choice of a suit and tie paired with white Adidas running shoes. It was common knowledge that Dave wouldn't talk to his guests during the commercial breaks or even before the show. I assume he wanted to save any interaction for camera time, although it seemed like every time I sat down with him, during the first commercial break, he would lean into me and yell over the Paul Shaffer Band about how crappy the audience was. Something I liked about this show was they let you pick out the song Paul Shaffer and his band would play as you walked out. One time I picked the Doobie Brothers' "What a Fool Believes" because my girlfriend had just dumped me for another guy. I assumed she'd watch my appearance and hear the song and get the message. Ha!

Another funny, little-known detail was that they kept the studio very cold, thinking the audience would be more reactive and attentive in subzero temperatures. The audience shivered through my stand-up, their breath visibly rising from their chattering mouths. The freezing studio was in the old Ed Sullivan Theater on Broadway and it came with a prestigious past. Among many other acts, this was the very stage where The Beatles played during their first visit to America. Don't think that image ever escaped my mind while I was there.

My first performance there went very well and I received plenty of good reviews from my sycophant acquaintances. My second appearance, about six months later, was somewhat nerve-wracking and a disappointment. My plan was to follow up my very solid debut with a very strong and more memorable performance of my "portrait artist" bit. In this routine I had an easel onstage with a large sketch pad. I would announce to the audience that I was studying to become a portrait artist and was very excited with my progress. I would then ask for a female volunteer from the audience to come up and work as my model. None of this was prearranged. I would instruct her to sit on the chair next to the easel with my back to the audience so they could see her and what I was sketching on my pad. The entire routine only took about five minutes. As street artists do as they are sketching, I would ask her lots of questions so I could personalize the picture. Only I asked her ridiculous, silly questions that would garner big laughs from the audience. Unbeknownst to her, every time I shifted her face to a new position with my charcoal-covered hands, I would leave remnants on her face. The audience would howl while my volunteer never had a clue. By the end of my sketch her face was covered in black charcoal. She thought the audience was laughing because of my bad artwork and wouldn't discover the real reason until I gave her a mirror to look in. They were always shocked, and the audience absolutely loved the volunteer's horrified reaction. This was one of my most memorable closing routines that always killed at the clubs. I was confident doing this on *Letterman* and assumed, as always, it would result in thunderous laughs and applause.

The morning of, I received a call from show's talent booker, Robert "Morty" Morten. Morty, with ruffled feathers, informed me that he was *not* on board with my set. Morty, like most staffers, just wanted to make Letterman happy and wasn't interested in taking creative risks that might put them on unemployment lines. Morty, obviously, was unfamiliar with the popularity of my routine and didn't realize it could make him a hero as well. "We want you to do a traditional stand-up set and not the portrait thing," said Morty. This sent me into a panic. I wasn't prepared to do a totally different set. Besides, I only had scraps of barely decent material still available. "No worries," I told him and hung up. To say I was frazzled was an understatement, but I couldn't cancel my appearance for that evening. It was listed in *TV Guide*—once you were listed in the *TV Guide*, you had to show up. Not only had I not run my set, I didn't even know what my set would be! Before a talk show performance, like most comics, I like to rehearse that set for several nights at various comedy clubs around town. Well, that was not going to happen this time. (I did, however, consider rehearsing in a cold meat locker.) Instead, I would have to settle for the Jamaican housekeeper at my hotel who spoke very little English. I stood on my bed as if it were a stage and recited my quickly assembled set to her. She smiled politely as she vacuumed around me. I'm sure the Beatles didn't have to do this.

It ended up being a mediocre set. I was hoping during the commercial break Letterman would say it was a crappy audience but this time he didn't. Still, I was apparently good enough to be asked back many times thereafter. By the way, if you're looking to buy a home, Morty is now a real estate broker in Los Angeles.

These days, Letterman's most striking feature is his very long gray-and-white beard. The man is not trying to look younger than his age, which I respect. Has he ever mentioned why he decided to grow this very long gray beard? Is he in the "Talk Show Host Relocation Program"? If he thinks it works as a disguise, he is mistaken. The bushy eyebrows still give him away.

ANDY KAUFMAN
1949-1984

Andy Kaufman remains, without a doubt, one of my biggest comedic influences. Whenever I saw Andy perform at the Hollywood Improv, I was blown away by his stage persona and incredibly absurd routines. Andy took more risks than any comic I knew, earning him the label "anti-comedian" for how often he broke conventional rules. In truth, he was more of a performance artist than a stand-up but described himself as a "song and dance man." His routines delved into the psychology of humor that confused and provoked. Sometimes he did this by being relentlessly annoying, pushing the limits of his audience, or using repetition that tickled and baffled. But every routine offered some sort of surprise or payoff —after one of his performances he actually took the audience out for milk and cookies.

One of my favorite characters was the endearing, gentle "Foreign Man," an innocent immigrant from a mythical country. He would later adapt this character into Latka Gravas on the hit TV show *Taxi*. Tony Clifton, another character he created in the late 1970s, was the opposite of Latka. Tony was an absurdly foulmouthed and domineering lounge singer from Las Vegas, the kind of performer you loved to hate. Andy made himself unrecognizable by donning facial prosthetics and a fat suit. Tony would put unsuspecting audiences through uncomfortable yet elaborate improvised lounge singer performances where he ended up insulting many audience members. It got to the point where Andy, as Tony Clifton, was so reviled, he had to perform behind a chain fence so that he would not be hit with objects from the booing audience. On occasion he would have his brother, Michael, or his producing partner, Bob Zmuda, perform disguised as Tony so he could take the stage elsewhere, proving he and Tony Clifton were not one and the same. He never admitted that he was in fact Tony Clifton even though we all knew it.

During the height of his fame, while on *Taxi*, Andy took a job working one night a week as a busboy at Jerry's Deli in Studio City. He

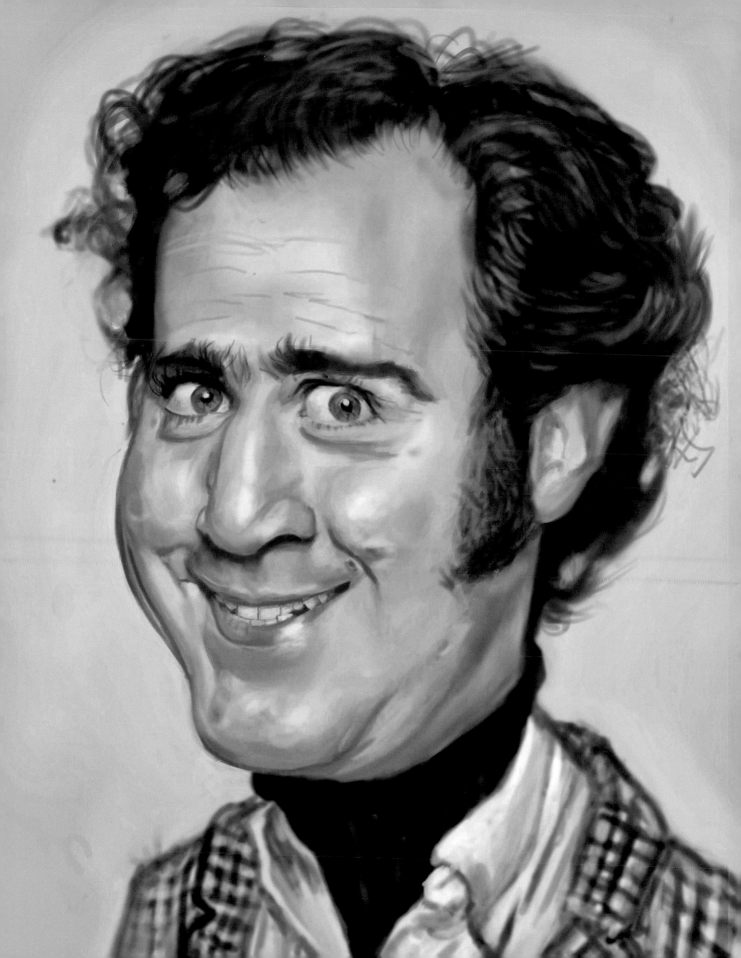

would stay in character as a humble busboy, studying customers, watching their response as he snatched plates away before they were finished. Another routine that befuddled and enraged many was his male chauvinistic wrestling character called the Intergender World Wrestling Champion. He offered any woman $1,000 if she could pin him in a match. He fought more than sixty bouts and never lost one. Another popular and ridiculous routine of his I loved involved sitting at a table onstage eating a piece of watermelon as his clothes were being washed next to him in a washing machine. The audience didn't know what to make of it, but he got laughs.

When I bartended at the Hollywood Improv, I would often leave the bar to watch Andy perform in the main room, sometimes watching him through a little hole in the upstairs office wall because the showroom was so packed. One night, he read from *The Great Gatsby*. But he didn't just read a paragraph or a chapter, he read and read and read and read. At first, the audience was amused and excited about where he might go with this routine. As he continued to read, though, I saw them become bored and eventually annoyed, some going as far as to walk out. The remaining audience members finally began to laugh. He did always manage to get laughs.

I remember nervously approaching him once outside the Improv. I knew he was passionate about Transcendental Meditation, so I asked him his thoughts on it. He generously philosophized with me for about half an hour. I'm not sure what he was saying, really—I couldn't believe I was actually speaking with Andy Kaufman! I just watched his lips moving and studied the constellation of moles on his face. In a sense I was meditating on his face.

Not long after that, Andy, a nonsmoker and health-food nut, developed lung cancer. Aside from chemo and radiation, I had heard he also tried all types of nonconventional treatments in different countries. During his chemo treatments, he stopped in at the Improv. He'd lost all his hair and arrived dressed as a punk

rocker. Somewhat lighter, he had a Mohawk wig glued to his bald head and wore a studded leather jacket, leather pants, motorcycle boots, and lots of large silver chains. That was the last time I saw him. Soon after that, at thirty-five, he died. Because he was always pranking and creating elaborate ruses, many fans didn't believe it. They thought this was just another one of his stunts, a hoax, that he'd faked his own death. They waited for him to make his triumphant return.

Andy remains respected to this day for his plethora of characters and his uniquely counterintuitive approach to comedy. Simply put, there will never be another Andy Kaufman.

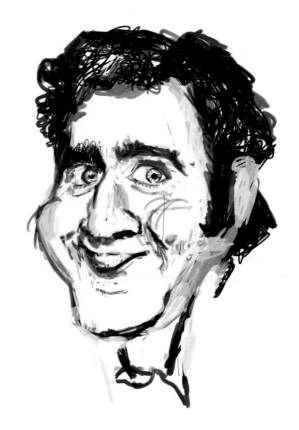

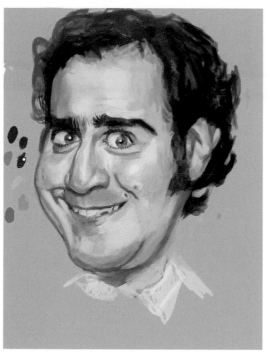
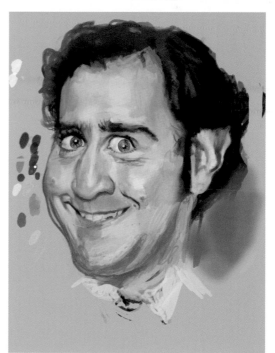

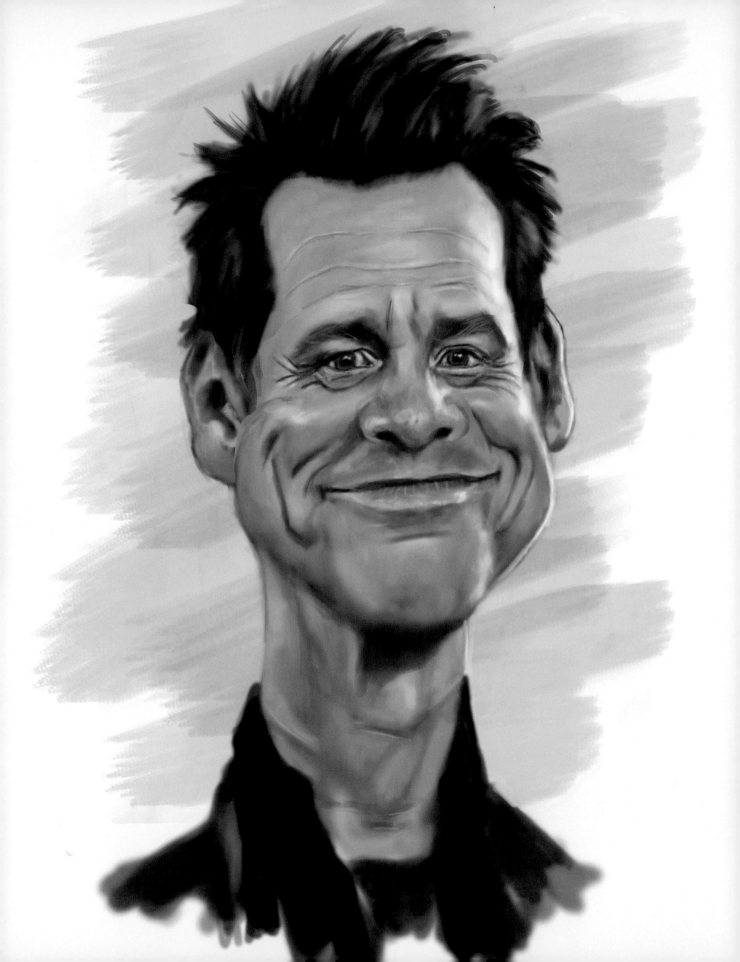

JIM CARREY

I first met Jim Carrey in the early eighties when we were both fledgling comics. Although we have performed at the same comedy club shows over the years, I've never worked with him theatrically.

Jim was my favorite impressionist because he could convey so much with the simplest facial contortion. Critics claimed he had a rubber face unlike any other comic. Jim would stand onstage facing the audience, turn away, and when he'd turn back his face would be twisted and elongated to resemble Jack Nicholson; he'd turn away again and reveal his face all scrunched up like the Grinch. You could tell exactly who he was impersonating without him saying a word—it was all in the look and attitude.

Not long ago, I ran into a salt-and-peppered, and now very relaxed, Jim at a party. It was there I learned we had something else in common: He was focusing on his artwork, really enjoying painting and sculpting. His pieces had been getting some nice acclaim and for a

good reason. He said what attracted him to art was that while actors and singers might fade and be forgotten, artists and art are forever immortalized. Jim made a great point. I've done a lot of thinking about that theory. I figure, unless your handprints and footprints are embedded in the cement at Grauman's Chinese Theater, or even just a star on the Hollywood Walk of Fame, you could be easily forgotten. I guess there's always that chance of developers paving over it all. But that doesn't necessarily mean you'll be forgotten. There's always that possibility that thousands and thousands of years from now, after you are long forgotten, archeologists may dig up Hollywood and discover your handprints at Grauman's. They would probably not remember you as an actor but label and classify your fossilized prints as some human sub-species and stick them in the Smithsonian Museum. You really can't rule anything out.

The truth is: Putting your artwork out there is a risk. If it is not good, people will quickly try to forget you even *before* you die, or constantly

remind you of how untalented you are. That's the beauty of doing a stand-up set. Once it's done, whether you killed or bombed, it's gone. People will remember that you were good, or they will simply forget you. There is no lingering evidence like a piece of crap hanging on a wall somewhere.

I'm sure that Jim was correct. Famous actors, for the most part, are forgotten after fifty years or so. When their fans die, they take that star's legacy with them. Take, for example, that I was hiking with an Olympic skier a few years ago and I learned she wasn't aware of the very famous actor Warren Beatty. Warren Beatty hadn't even died yet.

I suppose we all want to be remembered in one way or the other. Some people go as far as committing heinous crimes to be remembered—and I'm not referring to the remake of *The Heartbreak Kid*, although I still believe that nothing will ever come close to the original version starring Charles Grodin (sadly no one will remember him in about fifty years). The fact is: People just want to be counted. They want to leave their mark. Hence, graffiti. Graffiti must last at least a hundred years, right?

As funny as Jim is, I sometimes feel he has a quiet sadness in his heart (hence this caricature) . . . and maybe that's where his sense of humor was born. Maybe he just wants to be remembered as more than "Rubber-Faced Funnyman." Perhaps one day Jim will paint a self-portrait that art lovers will flock to see in some museum and say, "Boy, that Jack Nicholson was one funny guy.

BUZZ ALDRIN

It would be a hard sell to convince a teenager that a ninety-two-year-old former astronaut named Col. Edwin "Buzz" Aldrin did the moonwalk long before Michael Jackson. Most teenagers today probably don't even know who Michael Jackson is. But, yes, Buzz moonwalked—on the actual moon—in the 1969 Apollo 11 mission. Though Neil Armstrong took the first step, Buzz holds the distinction of being the second. I wonder if Neil going first will always haunt him. Does he mind being Neil Armstrong's plus-one? He still probably did a lot of other firsts on the moon, like taking pictures of the first man to walk on the moon or being the first to fart on the moon (but of course nobody heard it).

It was a very risky mission indeed. I have read that then-President Nixon had a draft of a speech prepared if the mission was a failure. He would have extolled their heroism, what great Americans they were, and how much they would be missed by their loving families. Thankfully, that speech was not needed and is now available for a future, undetermined Jeff Bezos launch.

The mission was a huge success and our heroes returned to earth, now suddenly more popular than any rock star, celebrity, or politician. Certainly, they were unprepared for that type of fame, and its accompanying adulation, praise, and temptations. Eventually, both went on to struggle with alcoholism and failed marriages. Neil, unfortunately, is no longer with us, but Buzz has since remarried and is now sober.

I first met Buzz about twenty years ago on a beach in sunny Puerto Vallarta, Mexico. I was on a cheesy celebrity junket sponsored by some tequila company. Buzz was with his third wife, who constantly called him "Buzzy." I was literally over the moon—pun intended—to meet him and had so many questions about the Apollo 11 mission. Our conversation went something like this:

"Hi, Mr. Aldrin. I'm a big fan of your moonwalk," I began. "I was curious, during your time on the moon, were you scared about maybe not getting back to earth?"

Buzz became immediately defensive. "What are you, a wise guy?" he asked. I thought it was a fair question. I've since learned that "scared" is a not a word in Buzz's vocabulary.

"No, sir," I clarified. "I'm not trying to be a wise guy. I only ask because it would have been my concern. I mean, any number of things could have gone wrong on the mission."

"No, I wasn't concerned. What could have gone wrong?"

"Well, for one, what if the lunar module didn't start up when you got back in? You would have been stuck on the moon with no possible rescue."

"Wait a minute," he said, now intrigued. "Hold on. Why wouldn't it have started?"

"I don't know. I mean, sometimes my car doesn't start." I had to remind myself that Buzz is also a real-life rocket scientist. To him, everything is calculated and worked out on paper. He lives without fear in his heart.

"Well," he said, "there was one little possible hiccup. When we climbed back into the module and strapped in for liftoff, we did notice one of the small fuses on the panel was sticking out a little."

"Oh my God! Did you freak out? Did you think, oh man, we are screwed?"

He smiled, and calmly replied, "No. We simply called Mission Control Center in Houston and they said just to push it back in. So we did and went home."

"Wow, that was a pretty close call, eh?"

"OK, now you're being a wise guy."

"Busted."

We left that beach on good terms, and the next time we spoke was while I was hosting a TBS show called *The Conspiracy Zone*. That week's topic? Whether or not the 1969 moon landing was a hoax. I called Buzz and asked if he would be a guest on our panel. He politely thanked me and declined the invite. "I would never even justify the notion that it was a hoax," he explained.

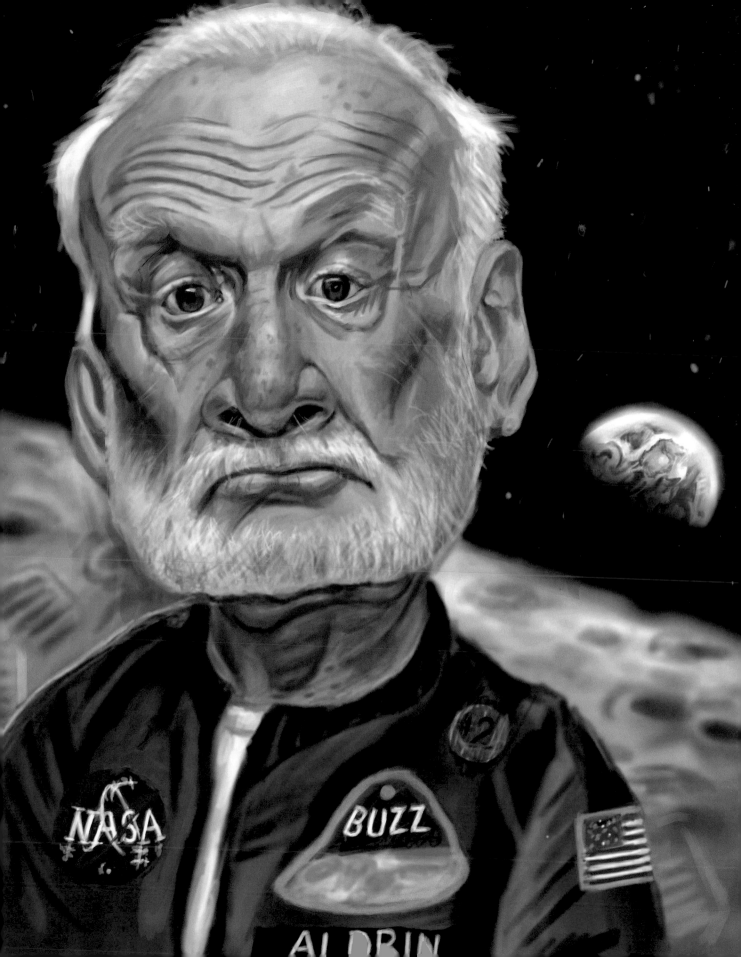

I never got to ask him my wise-guy questions, so I will share them with you now. First, once Neil exited the lunar module and began his "small step for man but big leap for mankind" speech, did you consider slamming the door on him and jettisoning away? Second, do you get any royalties on the sale of the toy character Buzz Lightyear? Third, do you think Jeff Bezos is the greatest astronaut who ever lived? What about Sir Richard Branson? And finally, if you lived in England, do you think you would have been given the title "Sir Buzzy"?

Buzz, if you're reading this, please feel free to text me with your answers. Over and out.

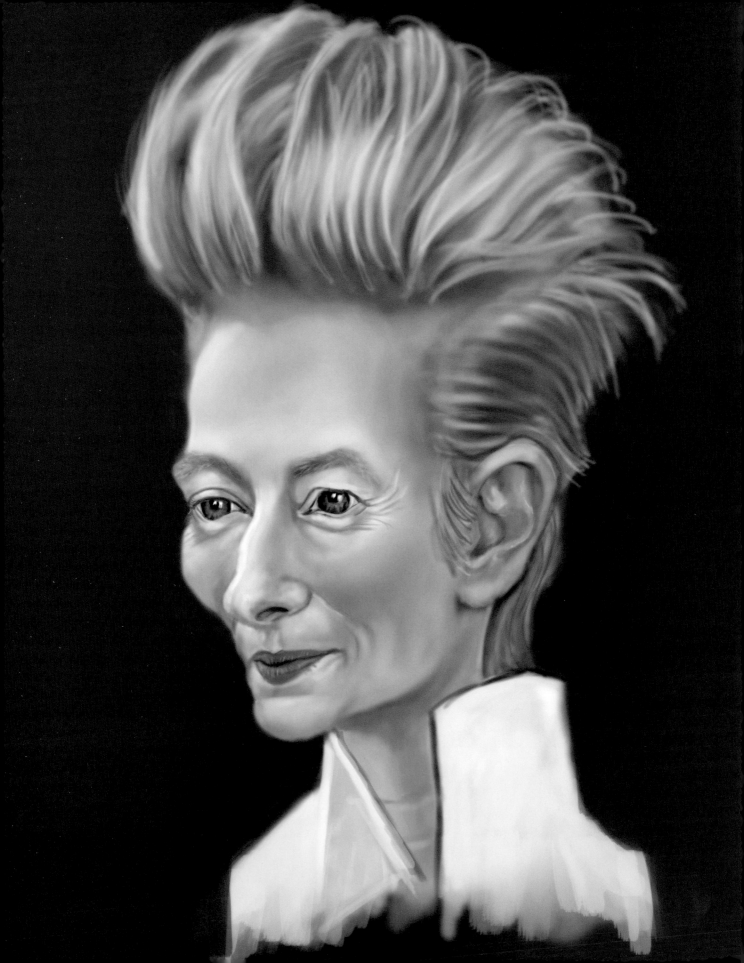

TILDA SWINTON

I find Oscar Award–winning actress Tilda Swinton to be utterly fascinating. We've never met, although I once stood behind her in line at the coat check during a Golden Globe Awards ceremony. There's a mysteriousness to her. I don't know if she is American, if English is her first language, or even if she lives in America. If you told me Tilda was a onetime Olympic volleyball champ from Russia, I would tend to believe you. To me as a painter, she is incredibly alluring in an odd and beautifully androgynous way. What I do know about Tilda Swinton is that she owns a stunning belted pink cashmere coat and is a very *good* tipper. Oh, she's also a phenomenal actress.

I googled Tilda to explore more of her background and so I could say, "I googled Tilda." The Swinton family is an ancient Anglo-Scots line that can trace its lineage to the Middle Ages. Swinton considers herself first and foremost a Scot. I wouldn't be surprised a bit if William Wallace, the hero in *Braveheart*, was an ancestor.

In 1995, with producer Joanna Scanlan, Swinton developed a performance-slash-installation live art piece in the Serpentine Gallery in London, where she was on display to the public for a week, asleep, or apparently so, in a glass case. The performance was titled *The Maybe*. My feeling is, if you're sleeping, you are not performing, and it is misleading to call it performance art. I think it should have been titled *Tilda Under Glass*. Either way, this live piece of art continued on to the Museum of Modern Art in New York City. Add accomplished performance artist—and accomplished sleeper—to her already impressive résumé! Personally, I could never accomplish a performance like that. I have sleep apnea and would need to rely on my CPAP machine, which is basically a device with a hose attached to a mask that fits over my nose and mouth. It forces air into my lungs while I'm sleeping so I don't snore. The first night I wore it my wife looked over, saw it, and exclaimed, "Jesus, this is like sleeping with someone in the ICU." I suddenly got very jealous and snapped back, "How do you know

what it's like to sleep with someone in the ICU? Are you seeing someone in the ICU? How much longer do they have? Are they gonna pull through? Should I be worried?"

In another artistic venture, Swinton once collaborated with the fashion designers Viktor&Rolf. She was the focus of their *One Woman Show 2003*, in which they made all the models look like copies of Swinton, and she read a poem (of her own) that included the line "There is only one you. Only one. So you better register your name on social media before someone else takes it."

But is there only one you? My friend and fellow comedian A. Whitney Brown used to joke, "It's not easy to stand out in a crowd of a billion people . . . a billion people, that means if you're a one-in-a-million kind of guy, there's still a thousand just like you."

DANA CARVEY

People often ask me how I got on *Saturday Night Live*. Although they phrase it more incredulously, like "How did *YOU* get on *Saturday Night Live*?" Quite simply, my fellow comedian and friend Dana Carvey recommended me to the show's creator and producer Lorne Michaels. Dana, an accomplished impressionist and mimic, landed a role as cast member the summer of 1986 and left Los Angeles for New York City. I was so proud of him and loved to brag that not only did I know Dana Carvey but we were also friends. About two weeks after he left, he called me. Excited, he quietly revealed that he was in the back bedroom at Lorne Michaels's house in Amagansett. He wanted me to guess who was in Lorne's kitchen.

Without giving me a chance to guess he blurted out, "Dan Aykroyd and Bill Murray!" I gasped and said, "You're kidding me!"

"No!" Dana replied. "Anyway," he went on, "Lorne is looking for one more sketch player to round out the cast for the year and I

recommended you." Stunned, I responded, "Dan Aykroyd and Bill Murray are actually in the kitchen?" It didn't even register with me that Dana brought my name up to Lorne. I knew I would never get on that show. I didn't do impressions, characters, accents, or have any experience with sketch work. I was just a stand-up comedian (a really, really good stand-up, I might add).

Nevertheless, I sent in my audition tape, which was mostly clips of me doing stand-up on various talk shows. Two weeks later Dana called again. Just as excited as his last call, he said, "I'm in the back bedroom of Lorne's house again. Guess who's in the kitchen?" Again, without giving me a stab at guessing he blurted out, "Steve Martin!"

"Steve Martin?" I asked. "Steve Martin is in the kitchen?" I was still dismissing any notion of me and SNL in the same sentence. "Yes," Dana said and continued, "and Lorne liked your audition tape. He wants to fly you in for an audition." I couldn't believe this—in fact, I

LORNE MICHAELS

Lorne Michaels is an Emmy Award–winning producer and writer, best known as the creator and executive producer of *Saturday Night Live*. He is also originally from Canada, and while I'm not, a lot of people think I am. I guess because they may know I'm from Connecticut (which starts off sounding like "Canada") and I'm a comedian (when said quickly may sound like "Canadian") and I was also on *Saturday Night Live*, which employs quite a few funny Canadians . . . oh, and I'm also polite. There's a joke I heard once that struck me quite funny: "How do you get one hundred Canadians out of the pool at the same time? You ask them nicely."

Over the decades at *SNL*, the cast members have supplied countless on-screen impressions, characters, and catchphrases—but our greatest work was done off-screen, impersonating Lorne. The garden-variety impression of him went something like this: "Kevin, you have to understand, Dana is simply going through that whole 'I don't want to just be known as the "Church Lady"' thing. Danny

went through that with John. I can't talk now, though, because I'm on the phone with Steve." Lorne would never use last names. You just assumed that Steve was his good friend Steve Martin, and that Paul was either Paul Simon or Paul McCartney. One time when I was at lunch with Steve, Lorne, and a few others, Lorne casually mentioned Cher in a conversation. Steve immediately piped up, "Cher who?"

Aside from Lorne's impressive knack for discovering talented comedians (including myself, of course), sketch players, and writers for his show, he is also a wonderful and generous gift-giver. Several weeks before a cast member's birthday, I assume he would gather with his assistants (which I've heard some cast members refer to as "Lornettes") to brainstorm gifts. I'm sure my fellow cast member Phil Hartman (a Canadian) was easy to shop for because he always had such varied interests and was always passionate about a new hobby. One week I'd stroll into his office, and he'd be into playing the blues guitar with a small amp. A month later, his new passion

might be sailing, and so his dressing room would be littered with sailing books, navigational charts, and model sailboats. Other passions included flying and scuba diving.

On one of my birthdays, Lorne gifted me with an awesome pair of Rossignol skis, poles, and bindings because he knew I liked to ski. I only recently threw those skis out . . . thirty years later. He knew I loved to travel the world, so on another birthday he gifted me with a beautiful leather-bound atlas, which I still have, tucked into a low shelf because it weighs almost as much as the world. During one of my years in New York, I mentioned to him that I was rereading all the great classics like *Tom Sawyer, Huckleberry Finn, The Catcher*

in the Rye, Moby Dick, and *The Great Gatsby*. I honestly couldn't remember if I ever read them in high school or simply skimmed the CliffsNotes of each. Lo and behold, on my next birthday he presented me with beautiful and rare first editions of Mark Twain's *Tom Sawyer, Huckleberry Finn*, and *A Connecticut Yankee in King Arthur's Court*. Accompanying each gift, always, was a personalized typewritten and hand-signed note on his engraved stationery with a clever, humorous, and sincere birthday wish. To this day I think it was some of the best writing he's ever done!

The gift of all gifts I received from him was at the after-party for my final *SNL* appearance. At the time, I had set the record for

being the longest-running cast member—nine seasons—which has been broken many times since. The party was held at the outdoor restaurant just outside 30 Rock nearby the famous skating rink. Lorne approached me sometime during that evening and thanked me for everything I brought to the show and for being part of the family. I could tell that he was genuinely grateful for my services and friendship. That really meant a lot to me since all of us enjoyed getting Lorne's approval or praise. He then handed me a gift: a stunning Cartier watch (which I immediately had appraised at $18,000). On the back was engraved "SNL 1986–1995 Love, Lorne." With a hug, I thanked him for giving me this incredible opportunity that I absolutely treasured.

Despite us both being funny guys, a moment of unexpected emotion passed between us.

Three decades after that sentimental farewell, sadly, my house was broken into and that cherished watch was stolen. It had doubled in both price and sentimental value over the years. Just a shout-out here, if anyone ever comes across that white-faced Cartier watch with a leather band with that engraving on the back . . . please alert me. No questions asked. I hate to even consider this, but you don't think Lorne took it back, do you?

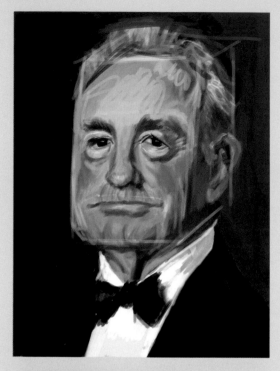
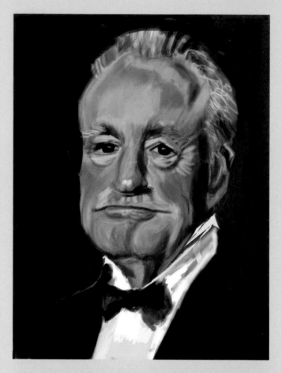
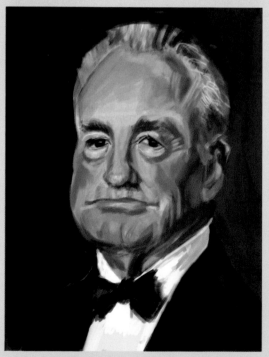
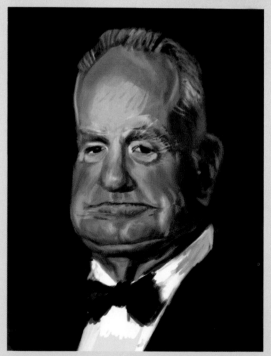

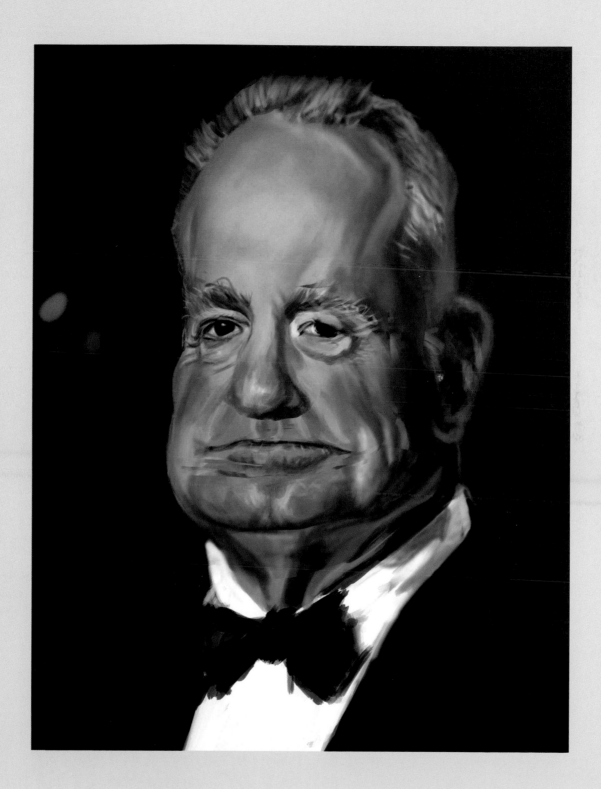

STEVE MARTIN

It was I who first discovered comedian Steve Martin. This is absolutely true. In the mid-1970s I stumbled across his performances on *The Tonight Show Starring Johnny Carson* and *Saturday Night Live* before any of my friends or acquaintances had ever even heard of him.

I loved his silly, anti-comedy style of humor. I had never seen anything like it. In fact, his comedy had a huge influence on me. When every comedian starts out, they emulate someone. When I started, aspiring young comedians at open mics were mostly influenced by Richard Pryor, Robert Klein, Woody Allen, or Steve Martin. I haven't been to an open mic lately, but I'm sure the young comics are now emulating *me*.

I was relieved none of my friends were aware of Steve because I wanted him all to myself. But that was not to be for long. His comedy albums, including his first one, *Let's Get Small*, went platinum. Soon Steve Martin became a household name and was selling out huge arenas and venues across the country. I'll always

remember seeing him in concert around 1979 at the Universal Amphitheatre with the Blues Brothers opening. The audience was super-charged—you'd think the Rolling Stones had just walked onstage, except most of the audience wore those fake noses and black glasses or those gag arrows through their heads. Steve wore his trademark white suit and did all his familiar routines, including his happy feet prance, and ended with his banjo bits. He totally killed it. Steve no longer belonged only to me.

It came as a shock when he soon thereafter retired from performing stand-up. Instead, he turned his attention to writing and starring in his own films, the very first of which was *The Jerk*. To say he came out of the gate strong would be an understatement. To this day, *The Jerk* is still one of my favorite comedy films. He would quickly follow up this film with several more home runs and I loved each one.

You could only imagine my thrill when he offered me a small role in one of his films,

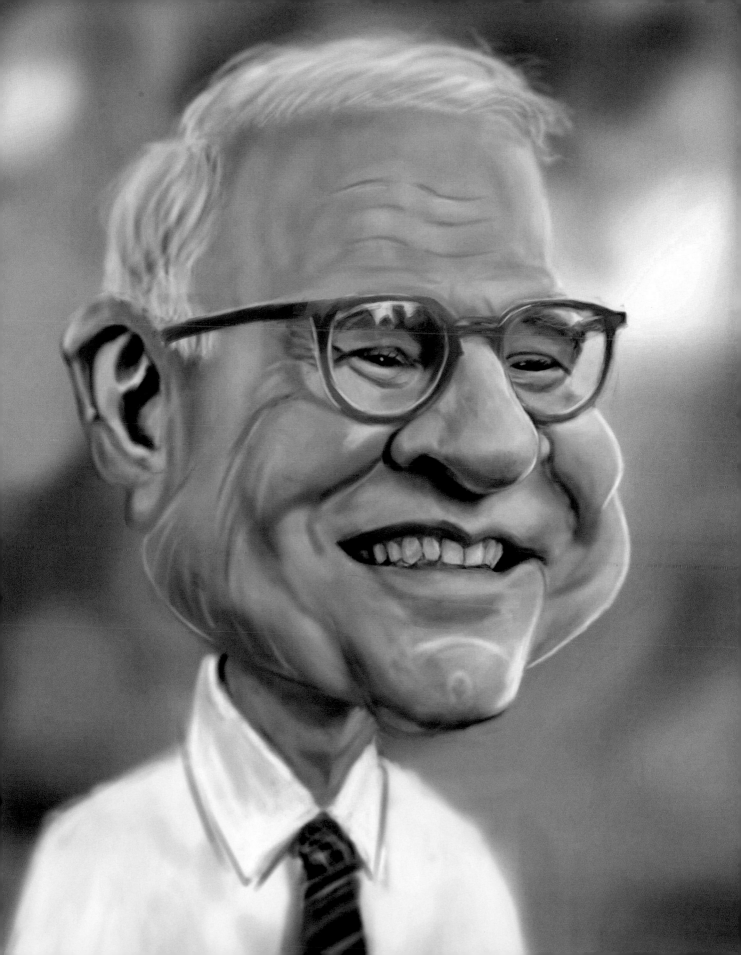

the Cyrano de Bergerac parody, *Roxanne*, which costarred Daryl Hannah. I was beside myself! I didn't even think Steve Martin knew I existed. I suspected that my having been hired earlier that summer for the upcoming season of *Saturday Night Live*, and Lorne Michaels being a good friend of Steve's, may have helped. My very first movie role would be as Drunk #2, and yes, I'm still disappointed I didn't get the role of Drunk #1, which was ultimately offered to a fellow comedian and friend, Ritch Shydner. (I only got the role of Drunk #2 because Buzz Aldrin turned it down.) *Roxanne* was filmed in the beautifully quaint ski town of Nelson, British Columbia. If you haven't seen the film, Ritch and I are the town bullies, appearing early in the film. We carry ski poles as we stumble down the street looking for trouble. In our scene we confront Steve Martin, playing the Cyrano character as the town's fire chief, returning from a tennis match with his tennis racket. We taunt him and soon get into a big duel on the street. Two drunks brandishing our ski poles as swords and Steve fending us off expertly

with his tennis racket, ultimately humiliating and defeating us.

In this film, there were quite a few stand-up comedians that were hired to play firemen. In fact, we all decided that in the upcoming week we would perform a night of comedy as a fundraiser for the local Nelson fire department. Steve got word of what we had planned and excitedly asked if he could emcee. He insisted we not advertise him emceeing, though, feeling both rusty and insecure. We agreed to keep it secret, but somehow it leaked and spread like wildfire. On the night of the fundraiser, a long line of enthusiastic fans snaked around the old dance hall. They had driven up from the States and all corners of Canada to see Steve perform stand-up. If he was rusty, you'd never know—he was amazing and the fundraiser was a huge hit. It was an incredibly magic night.

In the upcoming years, as a cast member on *Saturday Night Live* I would get to know Steve even better. He often hosted the show

or would just swing by on show night to visit and hang with Lorne. One week, when Robert Mitchum was hosting, I had written a parody sketch of a black-and-white Raymond Chandler film and called it "Death Be Not Deadly." I cast Mr. Mitchum as Raymond Chandler the private gumshoe, myself as a thug, and Jan Hooks as the moll. Immediately after we finished shooting it Steve ran over and congratulated me, which made my day—that was the highest compliment.

During those years Lorne, his friends, and fellow cast members would frequent the small, chic Caribbean island of St. Barts, with its topless beaches, celebrities, paparazzi, tiny expensive gourmet restaurants, and really cool Mokes (Jeeps) to tool around the island. I soon realized this was how the other half lived and would escape there during *SNL*'s winter hiatus. Along with several other couples, we would rent a hilltop villa for a week or two. Steve would often accompany Lorne to St. Barts, and it was there that we really got to know each other. We opted to bodysurf

daily at Petite Saline Beach, a beautiful beach with fine, white sand, topless French sun worshippers, and tucked away in a little cove. I couldn't believe that Steve Martin, whom I originally discovered, was riding the waves right next to me. It hardly mattered that we were being third wheeled by Martin Short, who also went topless. In between waves we talked banjos, comedy, and our favorite sunblock. On the flight home from this magical getaway, Steve and I didn't chat, but that was probably because he didn't want to come all the way back to the economy section. At JFK, I was still wearing my straw beach hat, cargo shorts, and flip-flops, with residuals of my favorite sunblock still evident behind my ears. Steve was impeccably dressed in an expensive beige linen suit with a neatly pressed white Tom Ford shirt. While I waited for a taxi, he waited for his limo. He eventually sauntered over, removed his Ray-Bans, leaned into me, and in his inimitable delivery confided, "Ya know . . . just because we hung out for a few days doesn't mean we're gonna be friends." I burst out laughing, thinking to myself, *Oh,*

that Steve Martin. He is so funny! I did not see him or hear from him again for several years.

Why would I? It was nothing personal. It was a time management thing. I was in big demand. I understood, of course, that he was also a very busy man and, besides, who needs more friends when you're Steve Martin? I get it. I didn't need him either!

Friends or not, I invited Steve to my fiftieth birthday bash at a very cool, rustic restaurant in Hollywood called Off Vine. It had an outdoor deck that would be perfect for a jam session later in the evening. Steve came, with his banjo in tow (I had brought mine as well). My more musically inclined friends brought other, less-annoying instruments. Jamming with Steve and everyone on the deck was the icing on my cake. By the way, that restaurant burned down shortly after my party.

Over the years, Steve and I would continue to play our banjos together at various dinner parties or musical get-togethers. He continuously improved and learned more songs on his rare prewar Gibson Granada five-string banjo, and I continued to remain at the same level, knowing only a few of the bluegrass classics. Steve is now quite the accomplished banjo player, having toured for many years with the Steep Canyon Rangers in addition to recording two albums with them. He and I actually recorded a banjo version of the opening theme to the Showtime series *Weeds*, which I starred in as Doug Wilson. Incidentally, Marty Short also weaseled his way into *Weeds* for one season as a recurring character. Between us, I was disappointed with his performance. I felt he pushed it a little too much.

Steve also loves magic and I always love being fooled by him. One time he made my banjo disappear and to this day, I still don't know how he did it. Make Marty Short disappear, I would often shout. One of my favorite pastimes with Steve was exchanging comedy bits over lunch. He would always arrive first (I liked to keep him waiting) and would be seated in a corner booth or table with his iPad

set up in front of him. He consistently had great bits or germs of ideas that he was excited to try out on me and was always excited to hear my ideas. Or at least he pretended to be.

I haven't seen much of Steve in the past few years because of the pandemic, but mostly because Marty Short continues to hog his time while they tour their two-man show and shoot their Hulu series. Let's not forget, Mr. Marty Short, it was *I* who originally discovered Steve Martin.

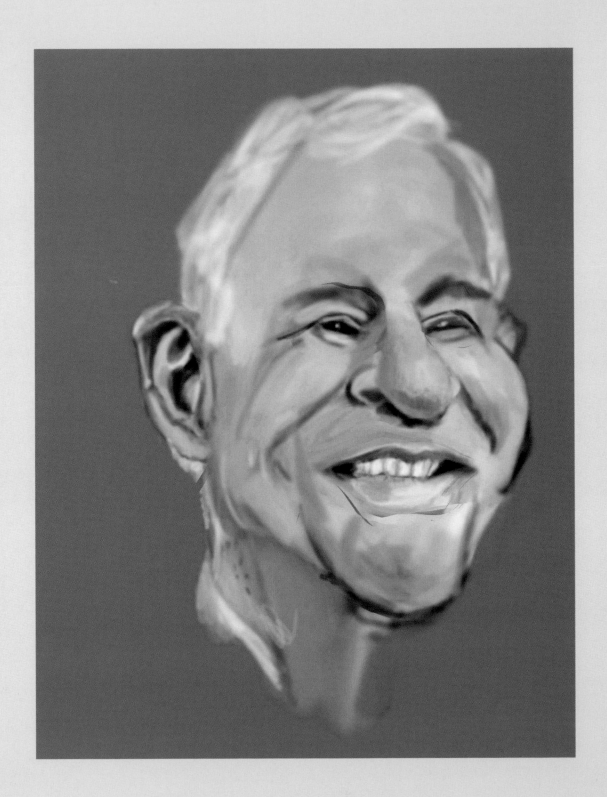

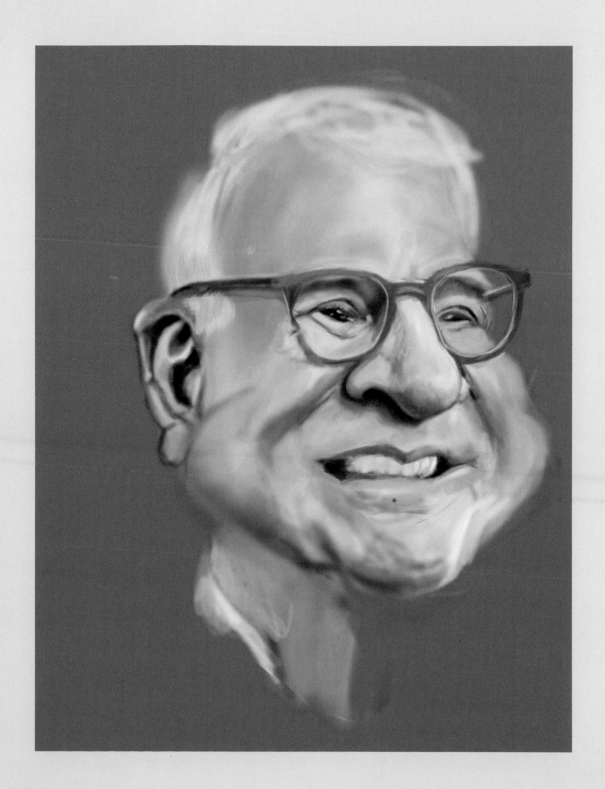

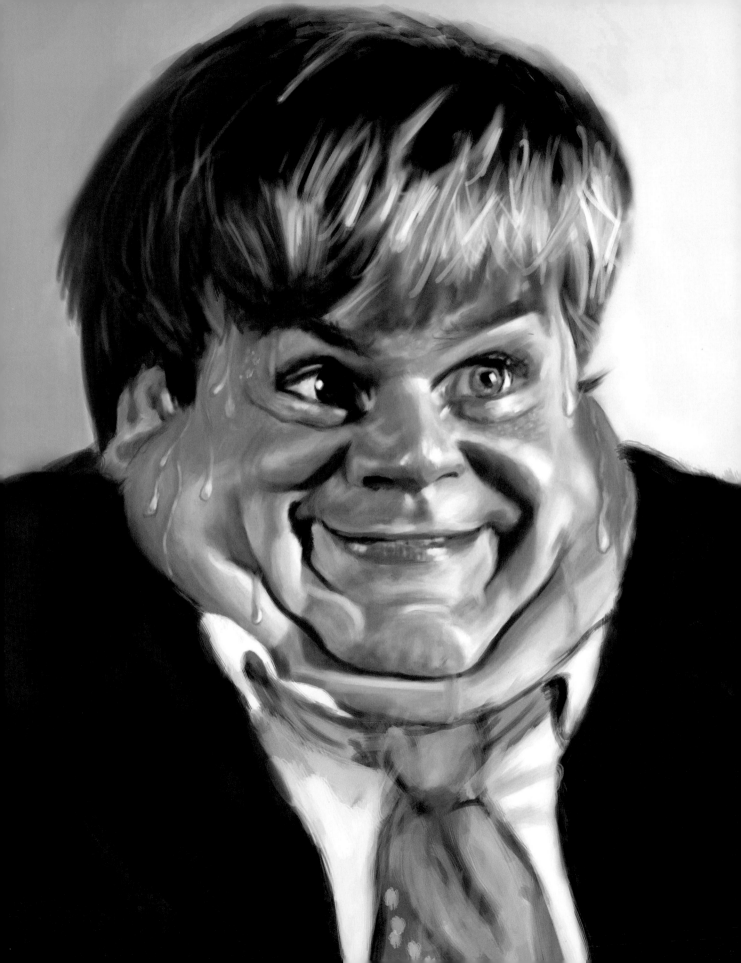

CHRIS FARLEY

1964-1997

Lorne Michaels scouted Chris Farley when he was a member of the famed Second City Improv Troupe in Chicago. Chris and I worked on *Saturday Night Live* for five years, where I saw his talents as a truly gifted comedian. He was the only person who came close to getting me to break character during my nine years on *SNL*.

The sketch in question was the now-famous Chippendales sketch, when I played one of the judges. Chris played a very eager, overweight, wannabe dancer auditioning opposite a very fit Patrick Swayze for the "coveted" spot as a Chippendales dancer. Like any good Chippendales dancer, Chris wore leather pants and a pristine white collared shirt that he soon yanked off to reveal his enormous belly and stretch marks. I was impressed at how game and uninhibited Chris was to get a laugh. But years later I learned, in fact, it was the opposite—he was not only inhibited but also tortured with anxiety and doubt about exposing his body. This surprised me because I always thought that, excuse the pun, he loved

throwing his weight around. The truth is he was very self-conscious and felt uncomfortable appearing shirtless and almost opted out. That sketch, in my opinion, became one of the most memorable and funny in the history of *Saturday Night Live*. Chris always gave 100 percent onstage, totally committed to whatever character he was playing. I can't remember ever seeing him without sweat streaming down his face.

Chris was incredibly coordinated and light on his feet. On a few occasions we played basketball at Riverside Park in New York City. He was quick, tenacious, and competitive. He brought this agility to his stage work, too, performing once as one of the figure skating pairs in an *SNL* short film that took place at the skating rink in 30 Rockefeller Plaza.

On another memorable occasion, Chris was my guest on "Weekend Update," playing his popular character, The Motivational Speaker. During one particular "Update," midrant he was meant to be hoisted up on

cables and swung out over the audience, much to their surprise. At least that was the plan. Unfortunately, as the cables began to raise him, he unintentionally swung backward and got stuck on the "Weekend Update" logo. While he struggled to free himself, the audience howled with laughter at his predicament. I quickly freed him and off he went—over the audience to thunderous applauds and laughter. It may have been uncomfortable for Chris, but audiences love when a sketch malfunctions. They love to see how the actors react to the situation.

But Chris was not easy on himself when he screwed up. He nearly embodied his character in the "Chris Farley Talk Show" sketch, where he would ask an obvious question, get called out on it, and then slap the side of his head while repeating, "Stupid, stupid, stupid." I felt as though he desperately wanted to be liked and constantly sought approval, especially from the likes of Lorne Michaels, David Spade, Adam Sandler—or any attractive woman.

From my perspective, it wasn't until a couple of years into his stint on *SNL* that Chris started losing his grip. I don't know whether it was the drugs or his inability to handle fame, but this train was about to wreck. It was well known to us that he idolized John Belushi, an original cast member of *Saturday Night Live*, and wanted to be just like Belushi in every way. I suggested that if he wanted to have a long career and life, he should take it

down a notch with his recreational drug use. He responded by saying John Belushi was hilarious *and* he did lots of drugs. "Yes, he was and he did, Chris," I said, "but think how much funnier and alive he would have been had he not abused drugs." *Really?* was Chris's response.

The last time I saw Chris in person was several years later at our mutual talent agency. I happened to be at the company that day for a meeting with my manager. I passed a conference room and noticed Chris sitting alone at the large table. He was wearing a black leather jacket and had pink hair. He appeared to be very fidgety and was sweating. I continued past him without stopping or saying hello, and I regret that. I wish I at least had said, "Hey, Chris," or even sat next to him and somehow conveyed to him that he was enough and didn't have to keep trying to be more than that. He was already beloved. At this point, though, I believed that he was beyond help and not even motivational expert Matt Foley would have been able to help him. Sadly, that was the last time I saw Chris. He died from drug abuse at thirty-three years old. The same age John Belushi died.

I always think fondly of Chris and how fortunate I was to have shared time with him. To this day, when someone mentions "a van down by the river," my heart goes out to him.

CHRIS ROCK

Back in the late 1970s, one of the other popular comedy clubs I frequented was Catch a Rising Star, owned by the very congenial and charming Rick Newman. It was, in fact, the first comedy club I ever stepped foot in. This very small club was located on New York City's East Side and, like many New York comedy clubs, made best use of its limited space. It was also no secret that it was frequented by the mob, but, in all fairness, there were a lot of popular joints in the city that were frequented by the mob. Even wise guys like to laugh, right?

I sat in the tightly packed audience and watched comedian after comedian perform fifteen minutes of edgy and funny material. They were all pretty good while matching that tough New York attitude of the chain-smoking audience. Some of those comedians went on to become household names: Larry David, Richard Belzer, Joe Piscopo, David Brenner. This club's intensity terrified me, so I decided it might be best if I moved to Los Angeles, where I heard things were much more laid-back in every way.

Eight years later, in 1986, I returned to New York as a newly hired cast member on *Saturday Night Live*. By then, I was an established comedian and had already made my debut on many talk shows. Several nights a week, after *Saturday Night Live* rehearsals, I would frequent the New York comedy clubs to work on my material. Only now, these clubs weren't so intimidating, and I returned to Catch a Rising Star as a verified comedian. There were still some comics that I remembered from my first visit, but there were also many new aspiring comedians that roamed the hall or hung out in the bar waiting for their stage time. One of those comics was the very young, ambitious, and still-unknown Chris Rock.

In my mind there were very few people that were more determined to become a successful stand-up comedian than Rock. Rock grew up in the Bedford-Stuyvesant neighborhood of Brooklyn and commuted into Manhattan almost every night to work on his act. Comedy coursed through every fiber of his being.

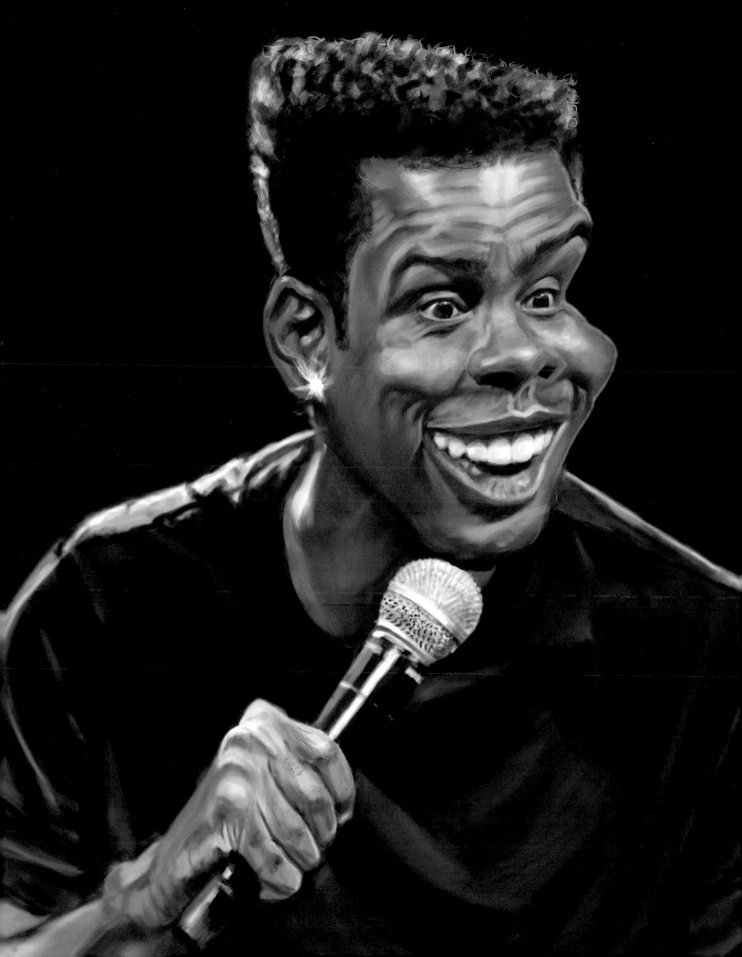

More often than not, I would enter the Catch and notice him sitting alone at the end of the bar with a bottle of water, reviewing his notes and sizing up the audience and other comedians alike. Like most comedians, he studied the others, taking note of what worked and what didn't, and he performed as much as possible. He would arrive at 7:45 P.M. and stay until closing at two A.M. He spent six hours a night mostly determining what he *didn't* want to talk about.

We didn't know each other very well at the time, but that would eventually change. Several years later, Chris Rock landed a job on *SNL*, where we worked together from 1990 until 1993. Rock's office on the 17th floor was adjacent to the workspace Adam Sandler, David Spade, and Chris Farley shared. This space was like a frat house—empty day-old pizza boxes strewn across the floor with *Playboy* magazines, empty cans of Tab soda and discarded clothes everywhere. When you stepped over all the debris and into Rock's office, it was impeccably neat. I remember he had Malcolm X and Martin Luther King Jr. posters tacked to the wall and several books on Black culture and racial justice stacked neatly on his desk. These issues were extremely important to him. I remember one rainy day when Rock had trouble flagging down a cab to get to work. "No one wants to pick up a Black man—not even a Black cabdriver," Rock lamented.

In hindsight, I think his talent and humor were not represented in its best light on *SNL*—his three years there could have been more

remarkable, but the writers didn't know how to showcase his talents. However, *SNL* may have provided the foundation he needed to reach the success that he ultimately achieved.

It wasn't until after *SNL* that Rock exploded—movies, TV series, Grammy and Emmy awards, and huge Netflix deals for his stand-up concerts. Among others, Rock has said that he was influenced by the performing style of his grandfather, Allen Rock, a preacher. I think that's very evident when you watch Rock onstage today, pacing back and forth, delivering his material with the passion of a Baptist preacher. His setups and punchlines are his sermons, the audience his parishioners. Like most successful comics, Rock's material, delivery, and stage presence evolved and improved over the years—that's why comedians perform nightly. Whenever an aspiring comic asks me for advice my answer is: Get onstage as often as possible, write as often as possible, and be as original as possible. While Rock's early sets—all very funny—were mostly sexual and race-related observations, comments, and opinions, he's recently garnered acclaim for his astute sociopolitical commentary and honesty about his interpersonal flaws. His growth, hard work, and determination paid off—there are very few comics on the scene today that have a stronger point of view than Rock.

Though his talents weren't on full display as a cast member, Chris Rock has hosted *SNL* twice since he left, in 1996 and 2014, and has made a dozen cameos. Take that, *SNL*!

DAISY EDGAR-JONES
AND TIMOTHÉE CHALAMET

I think Daisy Edgar-Jones, whom you may know from her brilliant role as Marianne from the TV series *Normal People*, is going to be a huge star. Her upcoming film, *Where the Crawdads Sing*, is in postproduction as I write this, and I truly believe that film will put her over the top. Daisy is from Britain, and I'm always impressed when an English actor can deliver a flawless American accent—or any accent really. I can't even do a mediocre English accent. When I was on *SNL*, if there was ever a sketch that required an English dialect, I would become petrified with insecurity. During the table reads, occasionally a sketch would require an English accent and everyone in the sketch would deliver an impeccable accent. Not only impeccable but they would know exactly where in England the dialect originated. Phil Hartman would do an Oxford or Cambridge dialect; Jan Hooks would speak Cockney from Essex; and Dana would do a bloke from Leeds. When it came to me, I could only revert to my monotone, John Lennon Beatle impersonation. The sketch would usually come to a screeching halt with an outburst of laughter . . . at my expense, of course.

Normal People, which starred Daisy, is a story about love, relationships, and heartbreak. I particularly enjoyed it because I am no stranger to relationships and heartbreak. In fact, I remember the awkwardness of my first kiss. I was around sixteen and on a first date with a very cute brunette named Maureen. I was incredibly shy at that time, and we were on a Halloween hayride with other couples. About forty-five minutes into the ride, I noticed that we were the only couple not making out. I knew I had to make my move soon or it would be very weird. It already was. I finally leaned over to kiss her, but because my eyes were closed (out of fear) I didn't realize I was planting a big wet kiss directly on her eye. In that moment I was confused by the texture of what I thought were her lips. I could feel her eyelashes fluttering against my tongue, and her eyebrow felt like a moustache. *Very strange*, I thought. It was only when I opened my eyes that I realized my mistake.

To this day I cannot be on a hayride without thinking about that date and the eye-patch Maureen now wears. So sorry, Maureen. Not very *Normal* of me.

As breakups go, I was incredibly fragile. In one short relationship I had with an actress in Hollywood—let's call her Shirley—I got dumped. Even though we had only dated for six months I was devastated. I didn't want to get out of bed, eat, shave, nothing. I eventually did get out of bed because my agent convinced me to audition for what could be a very lucrative McDonald's commercial. The script called for my character to be overwrought with sadness for being unable to get a Big Mac. I was called into the casting room and stood before three McDonald's clients and the executive from the advertising agency. It was like performing in front of the *American Idol* judges behind their table. When it came to the emotional lines of the script, I immediately thought of my breakup with Shirley and began sobbing . . . while delivering the lines. It all synced up perfectly and they were absolutely riveted by my performance. I could see each one of them feeling extreme sympathy for my character. They thanked me as they wiped tears from their eyes. I shuffled out and went back home to bed.

Three weeks later, I got a callback for that very commercial. That excited me. The problem was, though, I wasn't as devastated over the breakup as I had been, now unsure I could duplicate my performance. I brought with me a picture of Shirley and the answering machine tape that recorded her dumping me. I sat in my car staring at her picture while listening to her message. I tried to get back into that emotional state, but it just wasn't happening. I went in for my callback and I just couldn't bring the tears. I didn't get the commercial. Once again, Shirley screwed me over.

Daisy cried on cue in *Normal People* with no problems, I'm sure. With that American accent, I think she would play a great Monica on a reboot of *Friends*. I recently asked Courteney Cox who she'd choose to play Matt

LeBlanc's character, Joey, if there was ever a reboot. She thought about it for a few seconds then beamed, "I think Timothée Chalamet would be a *great* Joey." I think she's right. Timothée would be an excellent choice. If you're not familiar with Timothée Chalamet, he made a big splash in *Call Me by Your Name*. He has starred in several movies including *Little Women* and most recently *Dune*, and he's got shelves full of awards for his work.

Timothée is very young. I find it hard to believe he was born the same year I left *Saturday Night Live*. It also boggles my mind at how good someone can get at something in such a short amount of time. I credit it all to YouTube. Any time of the day you can go down the rabbit hole of YouTube. I mean, so many six- and seven-year-olds are now shredding guitars or violins or whatever because they learned from YouTube tutorials. What would have taken a lifetime for me to learn, a toddler can accomplish in just a few years. You can probably even find acting lessons on YouTube. Is that how Timothée got started? I know for a fact that if I'd had YouTube growing up, I would have gotten one of the roles on the original *Friends* or at least the role of Greg Brady on *The Brady Bunch*.

JAMES TAYLOR

My very first concert was seeing James Taylor at the Palace Theater in Waterbury, Connecticut, on August 22, 1972. I was eighteen (a college freshman) and he was twenty-four. I went with my buddy Bill Brackett, another huge fan. This painting is of James exactly how I remember him on that night. He was alone onstage, sitting on a simple wooden chair, singing and playing his acoustic guitar while taking swigs of wine (this was pre-rehab) in between songs. His setlist included some of my favorites like "Country Road," "Sweet Baby James," "You Can Close Your Eyes," and "Fire and Rain." I loved his humorous patter onstage as well. He had such a humble and gentle presence while at the same time a mischievous and playful nature. In this painting I tried to capture his "cat who ate the canary" essence—although, in truth, it was probably more of a "cat who at the pot brownie" essence.

Like most other fans in the audience, Bill and I dressed like James. We kept our hair very long and liked wearing simple bracelets, sometimes with rawhide necklaces. We weren't quite old enough to be considered hippies, but we could pretend. It really tickles me how much people are influenced by their idols. If you went to a Stones concert, everyone was dressed like Keith or Mick. Bob Dylan concert, same thing—dark, curly pompadours with black clothing. I've never been to a Guns N' Roses concert, but I'm pretty sure you'd see a lot of Slash-like black top hats.

Style aside, I always found James's voice and songs incredibly soothing. His intricate fingerpicking dazzled me to no end and, believe me, it was not easy to duplicate. I left the concert obsessed and promised to learn each of his songs note for note, fantasizing about becoming a singer/songwriter myself one day. I spent countless hours daily hunched over my Guild acoustic guitar next to my record player. Over and over and over, I would gently set the needle down into the vinyl groove, estimating and praying it was close to the riff I was trying to figure out. I would then pick it up and start over again. My hope was to

learn that particular song before I ruined the record with scratches, rendering it unplayable. Where was YouTube when I needed it most?

Since that evening in Waterbury, I've seen James Taylor in concert more than anyone else. I also probably own more vintage JT T-shirts than his entire family. I made it a point to never miss him in concert while I lived in New England and more recently on the West Coast. One time I actually had the chance to meet him as he exited his tour bus at the beautiful Tanglewood Theater in Lenox, Massachusetts. But I suddenly became intimidated and kept my distance. Little did I know that one day James and I would become friends.

About fifteen years later, we finally met face-to-face when he was the musical guest on *SNL*. By then, I was used to meeting my idols as they came through the show, but even so, James still intimidated me. After one of his rehearsals in Studio 8H, I started to chat with him at the craft service table—asking him nerdy questions about the chord formations he used on his various hits. As I nervously finished scarfing down two donuts, he said we should get together sometime and hang. I casually said, "Sure, that would be fun." He went on to say, "I know I say that often to people, but I really mean it." I was beyond stoked. He gave me his number and that following Monday I would meet him at his apartment and we would walk down Broadway to one of his favorite Cuban restaurants. I didn't have the heart to tell him that spicy food made me sweat profusely and left me sleepless. But if James liked Cuban food, then we were going to get Cuban food.

When I arrived at James's, he stood in the doorway holding a small dog, and we headed to our Cuban dinner. I don't remember much of what we talked about, but I do remember wondering what it would be like when we walked back to his apartment afterward. Would he invite me in? Would we just shake hands, or would he lean in for a hug—maybe a kiss? In a way, it did feel like I was on a date. And in the way that most dates are uneventful, I don't remember how this one ended. Although I haven't seen him—or his small dog—in a few years, I still consider him a friend.

I enjoy asking people who their first concert was. A look comes over their face like remembering when they lost their virginity. One time I asked an older British driver this question and he had to think about it for a minute or two and then calmly said, "It was the Beatles at the Cavern in Liverpool." Funny that he had to spend any time recalling that. He also added that he lost his virginity that night to a lass named Beatrice. (I wonder if they did it in the road?) The only thing I lost at my James Taylor concert was my puka shell necklace . . . but that was long ago and far away.

ARNOLD SCHWARZENEGGER

I originally met Arnold Schwarzenegger when he came to host *Saturday Night Live*. Back then, Dana Carvey and I were known for our popular characters "Hans and Franz": two pathetic-looking bodybuilders who constantly claimed that Arnold was their distant cousin. We wore outdated gray sweat suits stuffed with padding to simulate anatomically incorrect muscles, topped off with flat-topped wigs, black combat boots, and a blackened space between our front teeth to resemble a gap. The icing on the cake was our Austrian accents.

These characters had become so popular that it got back to Arnold—he couldn't wait to be in a sketch with them. Upon hearing this news, Dana and I glanced at each other, perplexed. "Doesn't he know we're making fun of him?" I asked. We couldn't understand why he would want to have any part in this. We finally came to the only reasonable explanation: He was coming to rip our arms off.

The day Arnold arrived, Lorne alerted us that Arnold had summoned us to his dressing room. We were like two schoolkids sent to the principal's office. Walking the halls backstage to greet our *Terminator*-style detention, we began blaming each other. "*You* came up with it!" "No, I didn't, *you* did. It was *you* who wanted to do the Austrian accent. I said not to." "No, *you* wanted to do the 'Girlyman' thing!" "No, I didn't!" We rounded the corner to find Maria Shriver (Arnold's then-wife) waiting outside his dressing room. She smiled and said hello, but I detected an undertone of distrust. We said hello back and then anxiously approached the closed door of Arnold's dressing room. His name, on a placard, had been taped to the door, but his name was so long the card actually continued over onto the wall.

Dana and I took a deep breath. As we peered in, clouds of cigar smoke wafted by. Gazing through, we could make out Arnold sitting on a little chair across the room. (Really, it was a regular-size chair, but Arnold made everything look small.) In one hand he held the script that we had written for him and

in the other was a big, fat cigar. He looked up through the thick smoke and said to us in his familiar Austrian accent, "Hello, fellas. Now how am I supposed to do the accent?" We laughed a heavy sight of relief, realizing immediately realized he had a good sense of humor.

As we all know, Arnold went on to become governor of Cal-i-forn-ia. During his campaign he would playfully use established Hans and Franz catchphrases to make his point and win votes. "Hear me now and believe me later, don't be a pathetic loser, vote for me!" I guess you can say, if it weren't for Hans and Franz, Arnold never would have won his seat.

Though I got to know Arnold over the years, to this day I don't think he knows my actual name. Anytime I run into him, he grins and says in his authentically heavy accent, "Hello, Cousin Franz."

CHRISTOPHER WALKEN

Today, Christopher Walken is a cultural icon. There was a period in the eighties and nineties when a performer's impression of him would bring down the house. Like most, I first became aware of Mr. Walken from his role as Nick in the 1978 film *The Deer Hunter*. I was riveted to my seat as he spun that gun chamber in the Russian roulette scene. Another memorable, smaller role was playing the psycho brother to Annie in Woody Allen's *Annie Hall*. But he had so many great roles—and I won't even mention his dancing in Steve Martin's *Pennies from Heaven*, although I did just mention it.

I only met Walken when he hosted *Saturday Night Live*. He came back to host several times over the years, killing it in the Continental sketches and as the cowbell instigator, with the now-infamous catchphrase: "More cowbell!"

Typically, on *SNL*, on Mondays the cast and writers would cram into Lorne Michaels's office to meet the host and pitch their sketch ideas for the upcoming show. On the particular Monday before Christopher Walken was hosting, each of us pitched an idea and he seemed less and less enthused. When it was my turn, I mentioned that the Russian circus was performing next door at Radio City Music Hall and they used performing bears. "Maybe we could do something with bear suits?" I mused. Walken lit up like a Christmas tree. Jumping to his feet, he proclaimed in his best Christopher Walken voice, "I love bear suits!" He couldn't have been happier. (In the end, the sketch was never written.)

During rehearsals, I noticed that Walken seemed to enjoy the health benefits of garlic. I didn't know if he was taking it internally or rubbing it on his skin, or if his garlic use was indeed for health benefits at all. I did know that the garlic odor was overwhelming. I could detect his arrival at least a minute before he appeared.

Two days before we were going live, Lorne approached me and confided that the sketch I wrote for Walken and myself was too long

and had two conflicting premises. I had to lose one, he said, and suggested that we lose Walken's premise. I ran into Walken later that day and sheepishly relayed the news. Walken didn't quite agree with Lorne's assessment but seemed to accept it. Somewhat distracted, he said, "I'm not sure about that but let's continue this conversation tomorrow." Tomorrow came and so did the wafting of garlic. It was the oddest thing—he literally picked up our conversation from the day before without saying hello or even recapping. ". . . No, I mean, I'm just not sure it matters that there are two premises," he went on. It was as if you went to your twenty-year high school reunion and you approached the teacher and immediately said, "No, I mean, I just thought you were grading on a curve." To make a long story short, our sketch was mounted as the last sketch of the show and, two minutes before, Lorne said I needed to shorten it even more due to time constraints. We rushed through the sketch, and I don't remember hearing one laugh. Maybe we should have added more cowbell?

LAUREN BACALL
AND HUMPHREY BOGART

1924-2014 1899-1957

If you were a friend of or worked with the Academy Award–winning Lauren Bacall, you were apt to call her by her nickname, "Betty." I came to know Betty when we worked together in the 1995 movie *All I Want for Christmas*. Although she had a small role, I honestly don't think she enjoyed much of her time on the set. This was primarily due to the unruliness of the child characters, played by Thora Birch and Ethan Embry. As kids will do, they ran amuck in between shots, chasing each other and screeching. I could see Betty losing her patience by the minute. Ultimately the kids' raucous shenanigans caused Betty to have a small meltdown. The final straw was when Thora and Ethan darted past her unexpectedly, scaring the bejesus out of her. Betty gasped and grabbed the handrail of the stairs, visibly shaken. Once she caught her breath she firmly demanded at the top of her lungs, "These brats need to behave or be reprimanded! This is no way to run a set!" And Betty, of all people, would know how a set should be run—she was one of the most popular actresses from classic Hollywood.

It was exciting to hang out with a famous starlet from a bygone era. She was considered a bridge to old Hollywood. I'm sure she would not be thrilled with being described as a "bridge to old Hollywood," but she was. Though she was sixty-five years old when we filmed together, she was once the most sought-after young actress in Hollywood. She lived that glamorous lifestyle, hobnobbing with the likes of Gary Cooper, John Wayne, Joan Crawford, Bette Davis, and many others. She even starred in several movies with Humphrey Bogart, whom she would eventually marry. Although he was many years her senior, they remained married for twelve years and had two children. She had plenty of stories from her marriage to Bogie that I was more than eager to hear—and she was more than happy to share.

In her raspy, cigarette-damaged voice, she recounted how she and Bogie once got into a heated argument about him not unloading a tray of dirty dishes, as promised, from their home's dumbwaiter. A dumbwaiter is

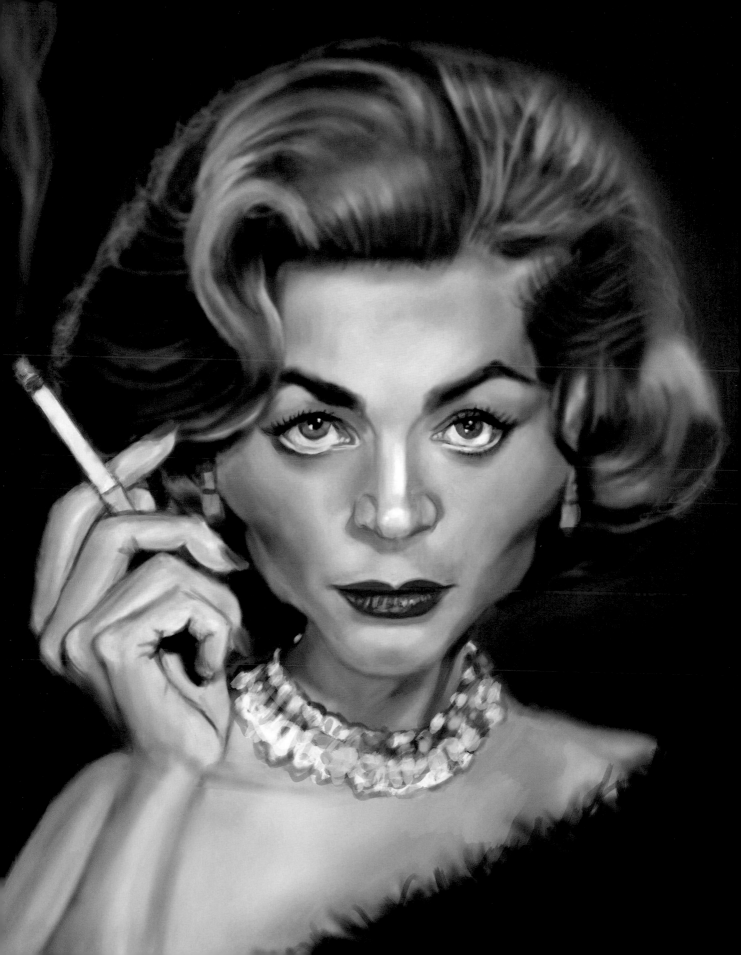

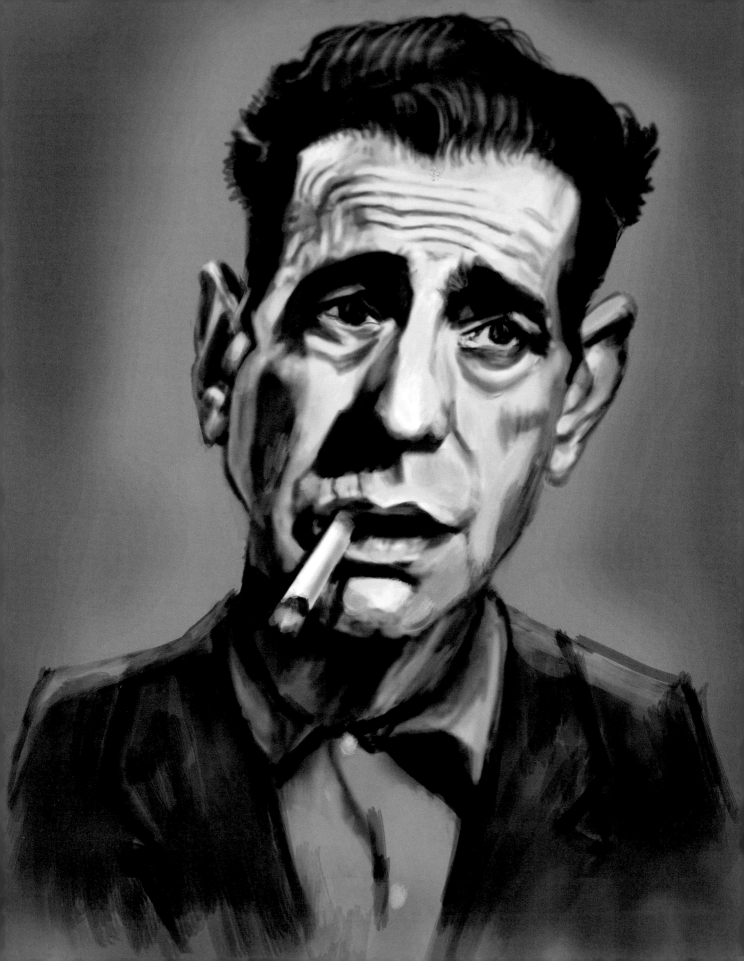

what they called those very small elevators, quite common in expensive homes back then, designed only to transport food up or down various levels by a rope pulley. Betty said, "Our argument lasted over an hour, with Bogie eventually storming out of our Hollywood home. I slammed the door behind him." He didn't come home that night, she added. After a few days she began to worry about and miss him. Very early the next morning her phone rang: It was Bogie calling to apologize. He then asked if she wouldn't mind coming to pick him up in Long Beach, a community about thirty miles south of Hollywood. She acquiesced.

Betty was a good storyteller, and as she spoke, I saw her reliving every second of that scenario in her head. While listening to her I could visualize her speeding along Pacific Coast Highway in the early morning hours with me in the passenger seat, wind blowing in our hair and Siri feeding us directions. She said, "As I got closer to Long Beach, in the distance, I spotted a solitary figure, walking alongside the Pacific Coast Highway toward me. The sun was rising behind him. As I got closer, I saw that it was Humphrey. He was unshaven, tired, and looked forlorn." She took a deep drag from her cigarette, and with the smoke still held deep in the recesses of her lungs, she continued nostalgically, "He was carrying a single long-stem rose." She then looked off, smiled softly, and slowly released a long, billowing plume of smoke through her nostrils and nicotine-stained veneers.

There was another story she shared I will never forget. Bogie, in his final year, was stricken with cancer and as a result had lost a considerable amount of weight and strength. She revealed that, "even though he was in this condition, he insisted on welcoming houseguests on occasion for dinner." Betty continued, "Our bedroom was on the second floor, but he didn't have the energy to climb up and down the stairs." She took another drag from her cigarette and explained that the toll the cancer took on him made him frail and small enough to fit into the dumbwaiter providing

he had not left any dirty dishes in it. So, when a dinner party was in the books, she would help fold him up, contort his now slight body, and help stuff him into that very small box. "I would lower him down to the first floor in that dumbwaiter, then open the small door to reveal Humphrey to our guests. 'Dinner has arrived!' I would joke." I suppose you could say this was an extreme case of fear-of-missing-out for Bogie.

I sometimes wonder if their house is still around and if the current residents know their dumbwaiter used to transport one of Hollywood's most famous and celebrated actors along with his dirty dishes. Here's looking at you, kid. And here's looking at you, too, Betty.

HOWARD STERN

I love listening to Howard Stern on SiriusXM Radio—although, for years, I stayed away from the idea of ever being a guest on his show. As a listener I witnessed Howard putting his guests on the spot, asking them embarrassing questions, provoking gossip, and instigating bad-mouthing. Why would anyone support this type of show? But I suppose it's the very reason I listened to him. It made for good radio. If a guest didn't answer his questions honestly or avoided them, they usually weren't asked back. Another reason I avoided going on his show was that he used to (unfairly) critique me and my fellow cast members from *Saturday Night Live*. It was surely OK for the *SNL* cast to make fun of others, but God forbid anyone turn the tables on us.

I started to notice that in recent years he'd mellowed out a bit, and his interview style changed. Maybe he finally matured, or maybe his monstrous financial deal with Sirius meant he no longer felt insecure. I guess a therapist could answer that. But now, I honestly think he is of the best interviewers on the radio. I love his technique of posing rapid-fire questions to his guest until they settle in, following up with unexpected and creative questions.

About eight years ago I woke up one morning and made a pledge to finally face my fears—I was going to let Stern interview me. I was terrified. When I arrived at SiriusXM Studios on 6th Avenue in New York City I was met by a security guard and Howard's chauffeur, Ronnie (who was also his on-air foil). Ronnie, with walkie-talkie in hand, escorted me up to the studio. As I waited in the greenroom and rummaged through my swag bag, Gary Dell'Abate, the show's longtime producer, came in to say hello. *What is he after?* I wondered. I suspected perhaps he was prying me for information Howard could use against me. Gary lingered and I kept my answers short. I made sure that I was very careful not to divulge any possibly embarrassing information.

Finally, I was led into the studio where Robin Quivers, the show's long-running news

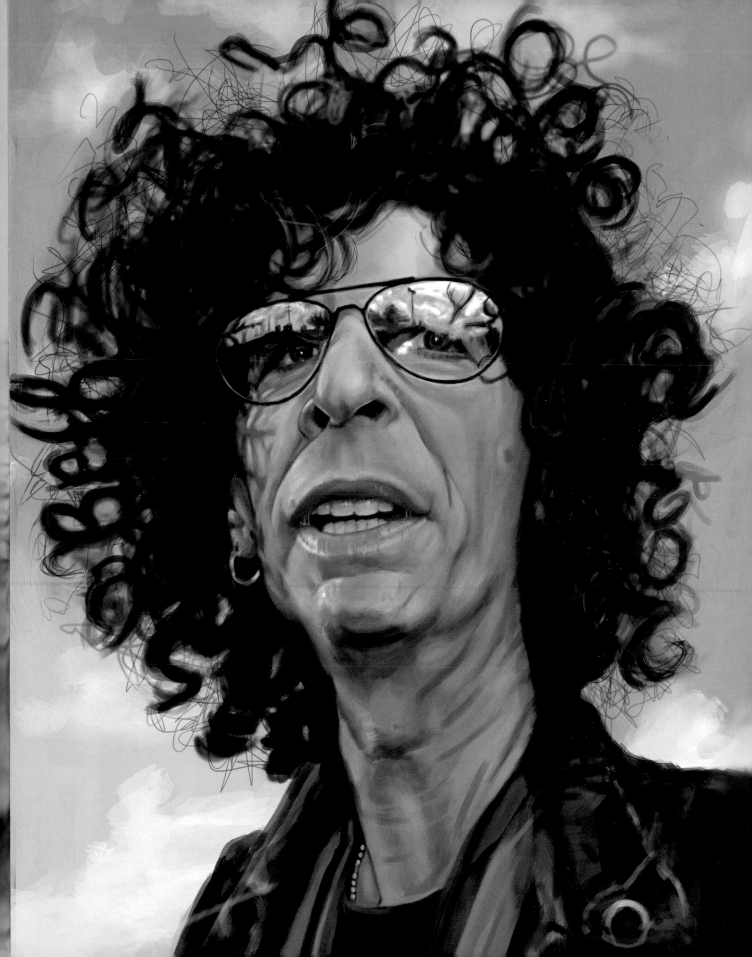

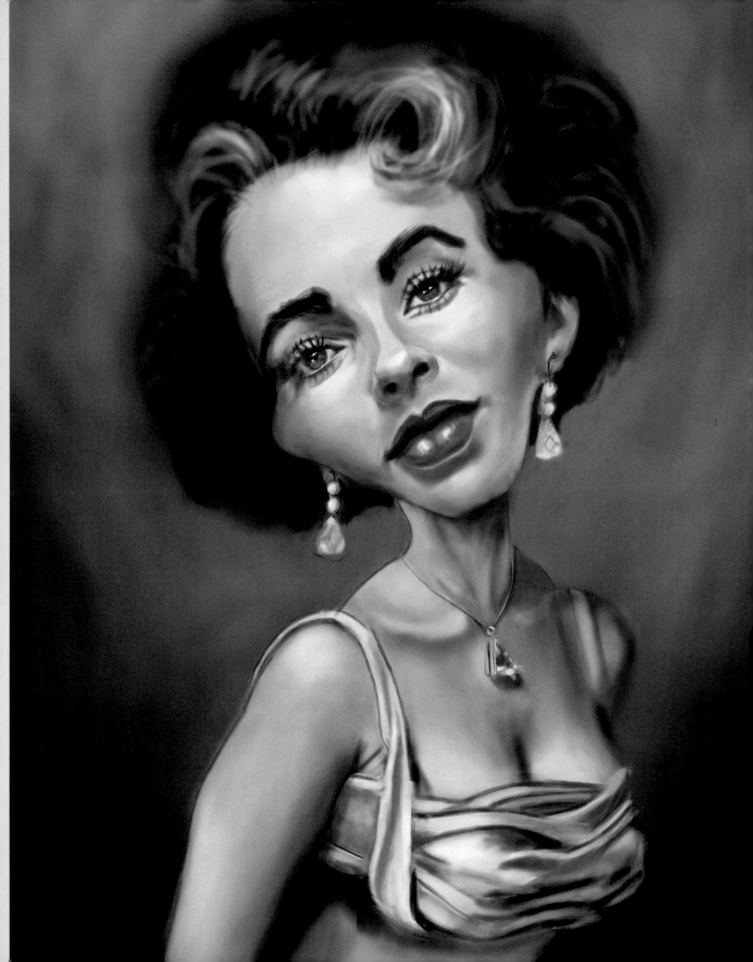

ELIZABETH TAYLOR

1932-2011

My memory of Elizabeth Taylor, then in her late seventies, was when she was standing by the couch in Carrie Fisher's living room. It was another one of my friend Carrie's star-studded parties with her menagerie of famous people in attendance. Dame Elizabeth, with her jet-black hair and frosted bangs, was holding a small bowl of peanuts and gazing blankly upon the room and the guests. I only recognized her when I got up from the couch and was immediately starstruck. This was friggin' Elizabeth Taylor! The same Oscar-winning Elizabeth Taylor who was once married to Richard Burton, had starred in *National Velvet, Who's Afraid of Virginia Woolf?, Cleopatra, Butterfield 8 . . .* the list goes on.

Brushing kernels of popcorn from my lap, I introduced myself and asked how she was doing. She sighed deeply and said, "My back has been bothering me lately." Anytime you ask someone over seventy how they are doing, you better pull up a chair for a discussion about various medical woes. "I do understand back pain, Elizabeth," I replied, now on her level, her equal. "I get it often and I find applying ice helps relieve the pain." I had played lots of sports in school, constantly icing my injuries. In fact, for the last two decades I had pretty much lived in a block of ice. I knew a young Elizabeth had used lots of ice in her cocktails to relieve the pain, but I wondered if she ever applied ice topically. It was then that she turned to me and shared something I'll never forget: "I prefer using a bag of frozen peas on my sore back. It works so much better than a bag of ice because all the frozen peas in the bag conform to the contour of my back." Who would have known that one day I would meet Elizabeth Taylor at a party and she would pleasure me with this thermal therapy advice?

The next day I went shopping and found the perfect family-size pack of Jolly Green Giant frozen peas. Elizabeth was right! They worked like a charm. I used this same bag of peas for over three years whenever nursing an injury. My peas became like Tom Hanks's volleyball Wilson in *Cast Away*, by a different name: my

"Elizabeth." Whether it was a twisted ankle, a pulled groin, an aching lower back, or a black eye, I would apply my trusty Elizabeth. We had been through so much together. I used the same bag of peas so regularly that most of the bag's labeling had worn away from handling, or from the Bengay ointment on my skin.

What I am about to share with you, now, is a memory of unbearable pain. My mother-in-law was visiting us one summer and graciously decided to make dinner. As I sat down at the table, I saw that she had prepared a side dish of green peas. I kid you not, they tasted like stale crotch. Concerned, I asked where she had gotten these peas. She answered casually, "Oh, from the freezer. I used that bag of peas from the drawer." I gasped and practically fell off my chair. "No! Not Elizabeth! You cooked my Elizabeth!" She looked at me as if I had

gone crazy. As the peas sat in front of me, the overwhelming minty vapors from years of Bengay exposure irritated my eyes and they began to water. Saying this dinner was a disaster was an understatement. I would eventually buy several more bags of peas and promise myself never again to become attached to any of them.

Sadly, Ms. Taylor, after years of many illnesses, died of congestive heart failure in 2011. Unfortunately, no amounts of frozen peas could have prevented that. Though she is gone, her advice on how to ease pain will forever live on. To this day, every time I open my freezer and see a bag of peas, I'm reminded of Dame Elizabeth Taylor. I think that's the way she certainly would have wanted to have been remembered.

EDDIE VEDDER

Eddie Vedder, lead man from the alternative rock band Pearl Jam, once told me that in his younger days, he used to come to the San Diego Improv comedy club to watch me perform stand-up. He said he would surf most of the day and then hustle over to the club if I was performing that weekend. I was beyond flattered that he was a fan. I later found out he was hustling to get there because his girlfriend at the time worked there as a server. Well, I was still flattered, but also disappointed to learn that particular waitress had a boyfriend. Not just any boyfriend but a stud, surfer-dude boyfriend. I've only attempted to surf twice and nearly drowned both times. After the second near-death outing, I decided to store my bright yellow Stewart longboard in my garage and it has been there ever since.

During my stint on *SNL*, Pearl Jam performed several times. Once when Eddie was the musical guest, he proudly and discreetly informed me that Lorne Michaels was allowing them to perform three songs instead of the usual two. He was thrilled and asked me for suggestions on which three to play. I froze—I wasn't that familiar with their latest album and didn't know many of their songs. Very diplomatically I suggested that all the songs were really, really great and that he couldn't go wrong with whatever he chose. This seemed to relax him, and I stand by my answer to him—all their songs were really, really great.

Eddie is a very passionate and intense performer. I was amused by how much he spat while he sang. Seriously—giant globs of saliva flew from his mouth after every few lyrics. I mean, is that a thing for alternative bands or just some kind of reflexive habit? Maybe it was just from the crappy food they served at *SNL* preshows. Maybe it's because he is a huge Chicago Cubs baseball fan, and he knows that baseball players are always spitting. It's true. Baseball players love to chew tobacco or gum, or gnaw on sunflower seeds, spitting the shells just outside the dugout. I wonder if sunflowers actually grow in the infield in front of the dugout during off-season.

I heard through the grapevine that Eddie saw this portrait and was floored. He said he's had lots of fans send him paintings over the years, but this one really moved him. Maybe it was because I knew he was a Chicago Cubs fan and snuck the baseball cap in on the amplifier? Maybe he was just being nice? Not that I am looking for a thank-you, but I heard he sends thank-you cards written by his own hand in calligraphy. Who would have ever thought that Eddie Vedder does calligraphy!

I look forward to seeing Eddie in concert again soon. Who knows, I might even offer him my barely used surfboard as a gift, and of course, no thank-you card expected.

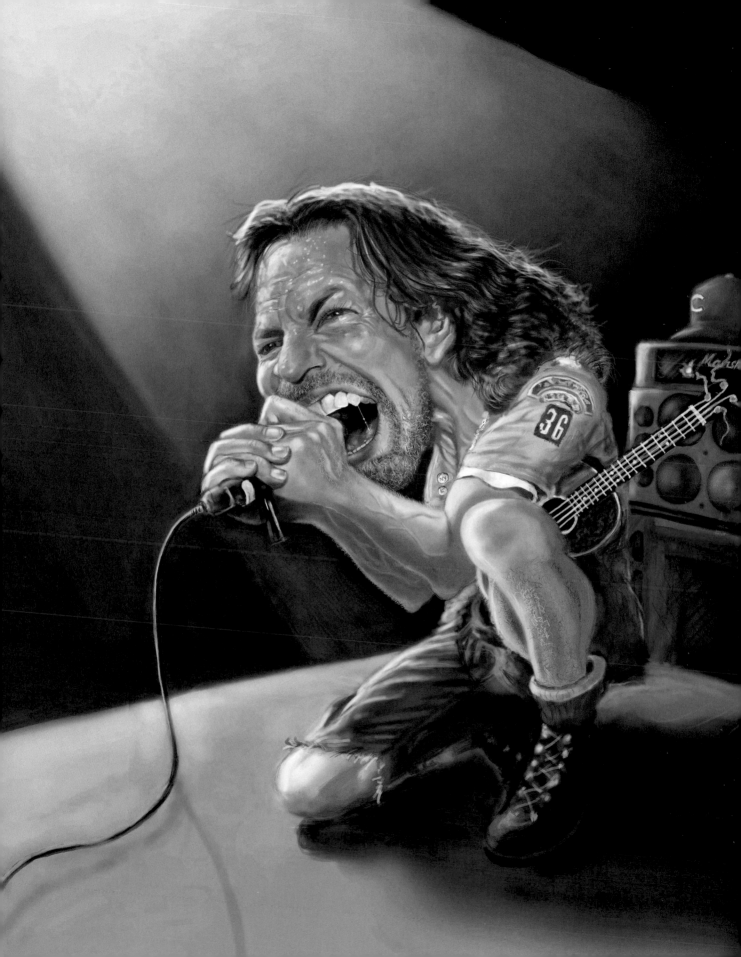

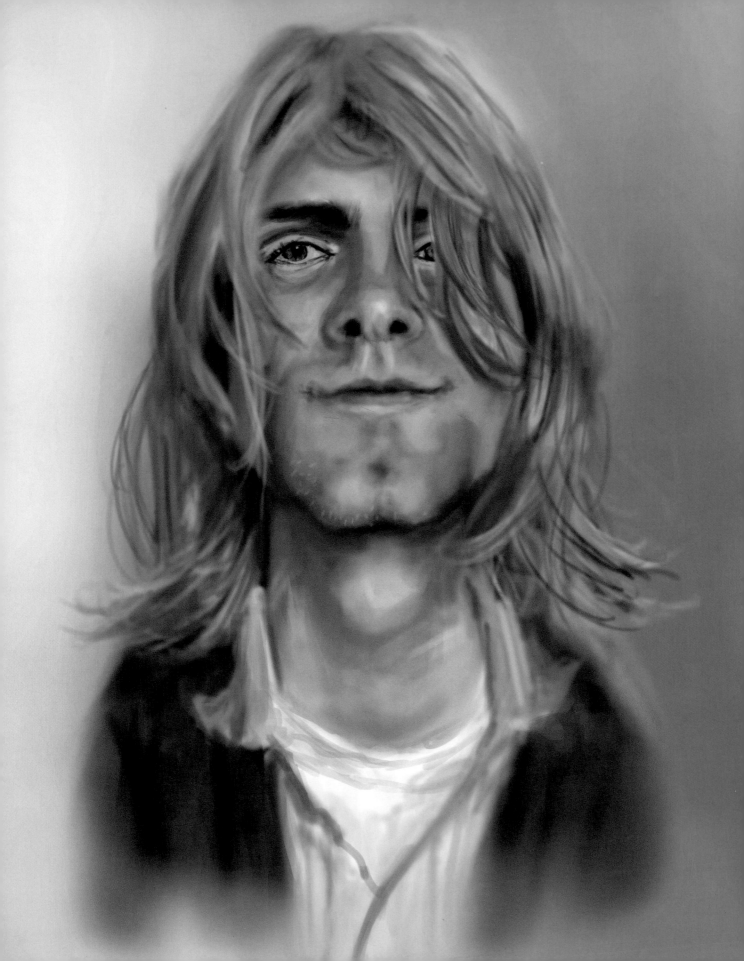

KURT COBAIN
1967-1994

Kurt Cobain, the front man for the Seattle-based grunge band Nirvana, is often cited as a spokesman of Generation X. He is known as one of the most influential musicians in the world of alternative rock. Much of his songwriting and Nirvana's hits are fueled with angst and antiestablishment sentiments. One of their biggest hits, "Smells Like Teen Spirit," was derived from a night of uncivil disobedience in August 1990 involving Cobain and his friend Kathleen Hanna, who was a singer in the band Bikini Kill. After finishing a bottle of Canadian Club whisky, they decided to perform a little public service and graffitied the exterior of a teen pregnancy center that had just opened in town, and was, in fact, a front for a right-wing operation telling teenage girls they'd go to hell if they had abortions.

They ended up back at his motel room, where they continued to drink, and then Hanna, with a large Sharpie, scrawled lots of graffiti on his walls, including the words "Kurt smells like teen spirit." Hanna meant that Cobain smelled like the deodorant Teen Spirit, which she and Tobi Vail, his then-girlfriend, had discovered during a trip to the grocery store. Cobain said he was unaware of the deodorant until months after the single was released and was said to have interpreted it as a revolutionary catchphrase and named a song after it.[2]

Once the band became more mainstream, Cobain grew concerned over the direction his music. In losing control and entering mainstream popularity, he began using heroin to deal with his stress.

Cobain is really known as a musician, but much to his dismay he also became an unlikely fashion icon.[3] His scruffy look helped launch the "grunge" fashion trend. Young people like to emulate their idols—in the nineties they began emulating Cobain, a counterculture icon, by wearing flannel shirts, long-sleeve thermals, ripped jeans, and Converse sneakers. Cobain's mismatched clothing was a result of wearing mostly hand-me-downs, thrift store finds, and clothes from Army-Navy surplus

stores. The fuzzy oversize cardigan he wore in "Come As You Are" and a striped T-shirt over a gray flannel in "Smells Like Teen Spirit" were quickly copied. Interestingly, Cobain regularly opted to wear a dress—often floral—while performing. This was particularly shocking given the clear masculine nature of rock music up until that point. Cobain saw no shame in wearing a dress; femininity was nothing to be ashamed of. But as Cobain grew thinner and thinner from heroin use, wearing baggy sweaters and doubling up on jeans often hid this.

On April 5, 1994, in the guesthouse behind his Seattle home, a twenty-seven-year-old Cobain committed suicide, leaving behind an infamously long note in which he addressed his many fans as well as his wife and young daughter.

Before his death, Cobain appeared as the musical guest on *SNL*, which is when I asked him to sign a copy of his unauthorized biography that I could use as a charity auction item donation. He agreed. I handed him the book; he took my Sharpie and scribbled something on the inside page. I didn't look at it for a few weeks and then finally one day flipped it open. In what appeared to be a seven-year-old's chicken scratch, he wrote: *I am not Liberace! Kurt Cobain.* I decided to keep the book for myself.

JOHN TRAVOLTA

Many of us first got to know John Travolta from his role on the 1970s TV sitcom *Welcome Back, Kotter*. The young Travolta portrayed Vinnie Barbarino, one of the unruly students at a Brooklyn high school that called themselves "Sweathogs." Johnny, of course, went on to become one of the biggest movie stars ever, having starred in such blockbusters as *Saturday Night Fever*, *Staying Alive*, *Grease*, and *Pulp Fiction*, to name a few. The iconic footage of him whirling Lady Diana on the dance floor at a White House state dinner will forever be etched in my memory.

I got to know Johnny through some mutual friends of ours: Anson Downes and Linda Favilla. Anson and Linda were an aspiring comedy and writing team, and were romantically involved at the time. They had been friends with Johnny since the movie *Carrie*, where Anson had a small but important role.

During the summer of 1987, after our first year on *SNL*, Dana Carvey, Dennis Miller, and I performed a thirty-two-city stand-up comedy tour. Linda and Anson showed up with Johnny as a surprise at our last performance in Denver, Colorado. We all had dinner after our show and then we were invited to fly back to Los Angeles with Johnny piloting his Learjet. Johnny had his pilot's license and had been flying for some time. In fact, he had a pretty good reputation as a pilot. I immediately accepted this rare offer, but Dana and Dennis, not being good fliers, graciously declined and opted to keep their morning commercial flight reservations.

We bid adieu to them and headed for a small private airport. Within thirty minutes we all piled into Johnny's Learjet, and I must say it was not as spacious as expected. What did I know about Learjets? Nothing. Should this be a red flag? Not at all. Johnny joined his copilot in the cockpit. He was an older gentleman with silver hair, which is what I think all pilots should look like. Linda, Anson, and I strapped in our seats, which were facing each other. From the cockpit Johnny welcomed us

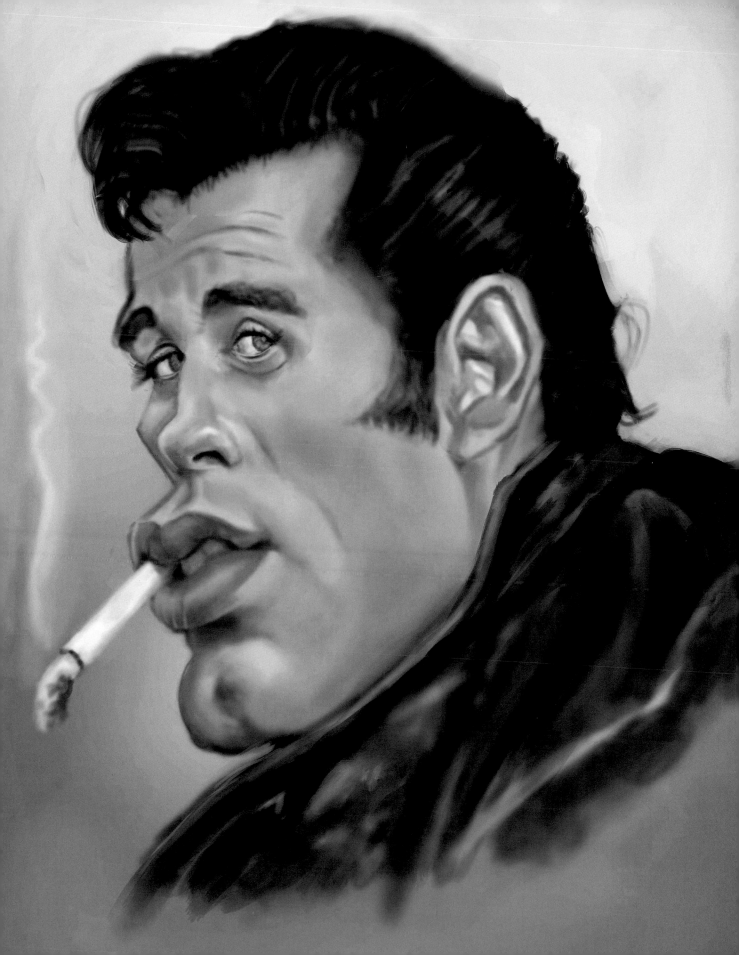

on board and told us to sit back and enjoy the quick two-and-a-half-hour flight home. Soon we were barreling down the runway and within minutes we were over the Rockies as the jet began to bump up and down. Should I have been worried?

It was at this moment I realized that Linda and Anson were also not good fliers. They both became ashen white. After another quick drop followed by a sudden rise, the cockpit door flew open. I could see Johnny "struggling" with the controls. I say struggling but only for the effect. He wasn't struggling at all. He was in fact simply steering the jet through the clouds as any experienced pilot would. But I was now not looking at John Travolta: I was looking at Vinnie Barbarino from *Welcome Back, Kotter*. How did I agree so quickly with abandon to fly in a small jet with Vinnie Barbarino at the controls? OK, *now* I was worried. But soon the flight smoothed out and we were cruising at 35,000 feet toward LAX. Johnny eventually unbuckled and came back to visit us, leaving his copilot at the controls. He apologized, in

his brilliant John Travolta accent, "Sorry for the bumps back there. There's always a little turbulence over the Rockies. Perfectly normal." Travolta always has that charming sparkle in his eyes, even when he plays a villain. We were soon taxiing to our waiting cars at LAX. It may have been bumpy, but I had just saved a bunch of money and thirteen minutes by not flying commercial.

During the next few years, I would occasionally get together with Johnny, Linda, and Anson. Eventually, Johnny agreed to host *SNL*. I was incredibly stoked, as were Anson and Linda. Johnny loves to create characters on the spot, improvise, and do absurd impressions. He insisted on portraying Marlon Brando with me as Larry King, interviewing him. We had a blast, and it made for a great episode.

On one night, after rehearsal, we took a cab to Jan Hooks's apartment. This was when Jan was my girlfriend in addition to fellow castmate. It was Jan's birthday and John surprised her with a beautiful brown, full-length

leather coat. He barely knew her at the time, and Jan was over the moon. She cherished that coat, wearing it often for many years to come. During our visit at Jan's, we each took turns imitating John's character, Danny Zuko, from *Grease*. We practiced the scene where he leans against the wall with one hand, then turns to look over his shoulder with a cigarette hanging out of his mouth. The goal was to re-create him noticing Sandy Olsson, Olivia Newton-John's character. Jan smoked at the time, so we each got our own cigarette. Anson and Linda went first, then Jan, followed by me, and finally by John. Johnny, of course, won the competition. He looked just like him!

We then decided to go out for a late dinner at the Palm restaurant on the East Side. We were all walking up 2nd Avenue, talking and laughing as we happened to pass a homeless man. He was sitting on the sidewalk leaning against a chain-link fence. He casually looked up in a fog and asked us for spare change, but in the middle of his request he recognized Johnny. "You guys have any spare—Hey!

Vinnie Barbarino!" Johnny graciously gave him some money. When we arrived at the Palm we looked inside at all the people eating and knew there might be a wait. Anson asked Johnny to look in the window at everyone so we could enjoy their reactions when they recognized who he was. John, like I said, was playful and he agreed. Positioning his face right by the glass, he peered through the window and the reactions and expressions were priceless. Diners dropped their forks, jaws dropped, and people pointed. I was surprised how recognizable I was.

Though we haven't been in touch lately, I always smile when I see Johnny's face on a new movie poster. Dana, Dennis, and I may consider another thirty-two-city stand-up comedy tour, but this time we will each require our own separate jets—all with silver-haired pilots.

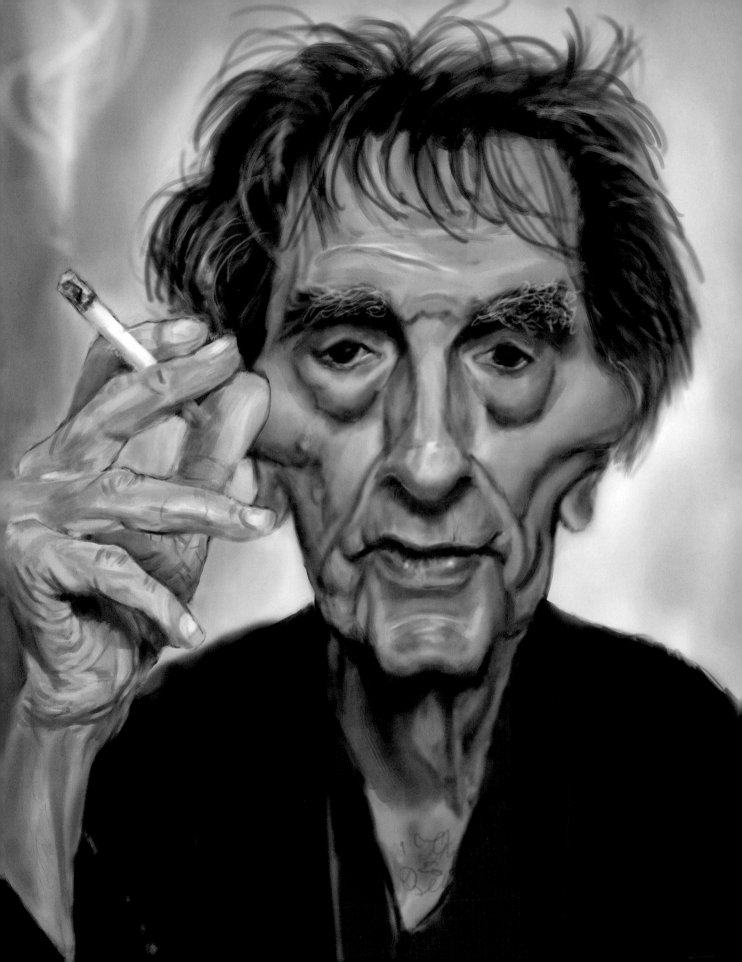

HARRY DEAN STANTON

1926-2017

Harry Dean Stanton was a triple threat—an actor, musician, and singer. In a career that spanned more than six decades, Stanton played supporting roles in films such as *Cool Hand Luke, Kelly's Heroes, Repo Man, The Godfather Part II, Alien, Wild at Heart, Repo Man*, and many more. Stanton was mostly a character actor but was given rare lead roles, like when he played Travis Henderson in Wim Wenders's *Paris, Texas* and *Lucky*, which was the last film Stanton appeared in. Though we'd never met, I found myself wanting to paint Stanton because I love his weathered face. I love all the cracks, bags, and wrinkles. It's been said that his face is his story. If that's true, then I bet it's a lot of partying stories with his Hollywood friends. Director David Lynch once said that Harry had an innocence and naturalness that were very rare in Hollywood. "Harry is a man of few words," he'd said, which made me think, *If only that face could talk. Oh man, the stories it would tell.*

We didn't know each other but I did see him on occasion over the years around Los Angeles. An actor's actor, he was adored by Jack Nicholson, Dennis Hopper, Marlon Brando, and Hunter S. Thompson, to name a few. In fact, I learned that he used to be roommates with Nicholson for several years in Laurel Canyon when Nicholson was shooting *Easy Rider*. He was also the best man at Nicholson's 1962 wedding. (It's unfortunate when your weddings are labeled by years like a wine.) Stanton never married, though he did propose a few times over the years, and apparently had several offspring from various affairs that he never stayed in touch with. He did have a year-and-a-half relationship with the actress Rebecca De Mornay. According to him, he got her into the movie *Risky Business*, where she met Tom Cruise—and then left him for Tom. That's gratitude for ya.

Stanton was known to tell strangers who thought he looked familiar that he was, in fact, a "retired astronaut." I loved that! I, too, am often told that I look familiar, or I look like that actor from *SNL*. I usually respond by saying, "Yes, I get that a lot but I'm much wealthier and better looking than that guy." I

who barely understood English. As an added bonus, each audience member received a noisemaker on their way in. Right before I was introduced, the stage manager informed me to do the exact amount of time as the previous nights and keep everything the same. I should have detected the slight concern in his voice. Three minutes into my act, some "loser" blew into his noisemaker. Soon, the entire audience was blowing into their noisemakers. It literally sounded like a flock of large Canadian geese were flying through the room. I bailed eight minutes in, exiting through the curtains as I did after every performance, but this time the pedestals were empty. The stage manager came running up to me yelling, "What happened? What happened?" I said,

"The noisemakers! It got really out of hand. I had to get off." "Oh man," he griped as he started yanking levers to control the stage lights and whatever else levers are used for backstage. "You have put me in a world of trouble! I told you twelve minutes just like all the other nights!" "I know," I said defensively, "but nobody told me they would be blowing those noisemakers!" Now the three Pointer Sisters came running onto the stage in a panic. I'll never forget the quick short steps they were taking in their super-tall platform shoes. "Kebin! Kebin! What happened?" they asked as they poofed their hair and scurried past me to their platforms. "All good," I said. "You're gonna love this crowd. Have a great time!"

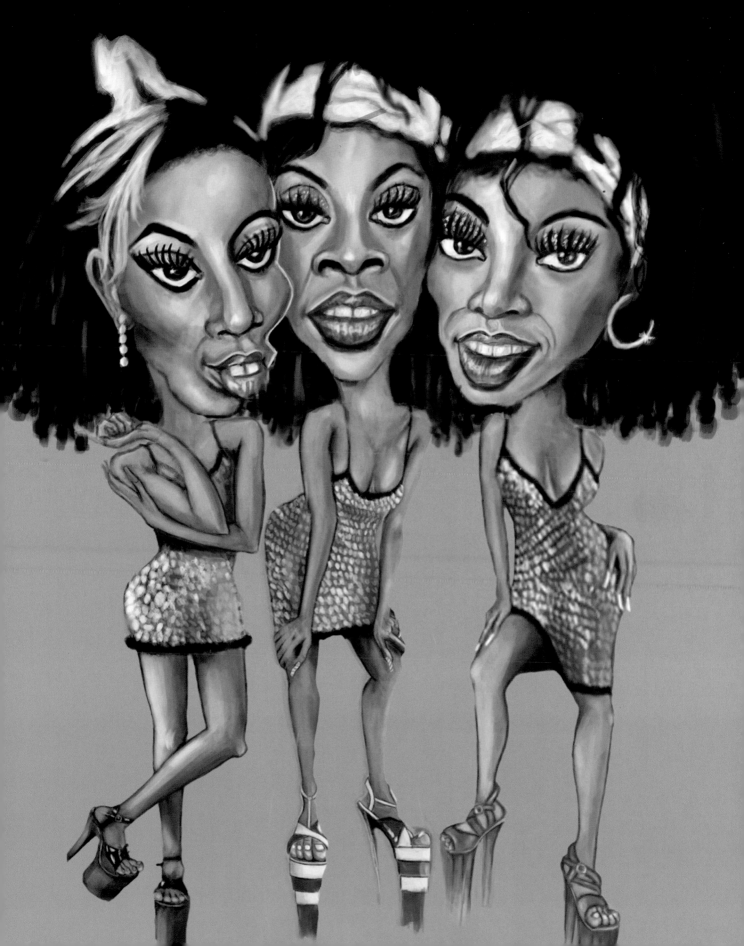

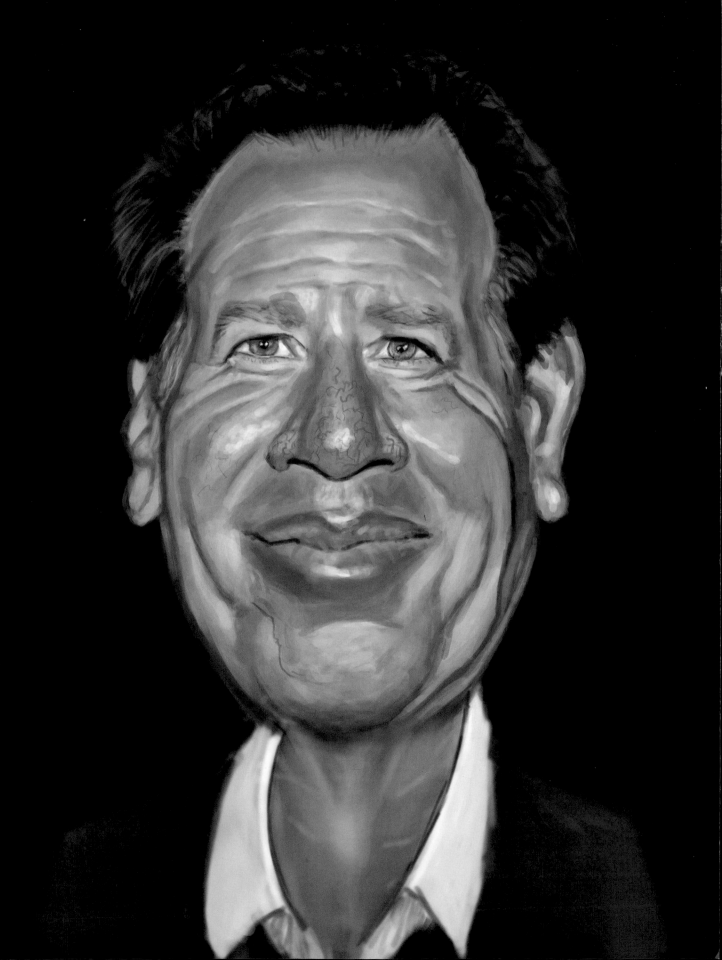

GARRY SHANDLING
1949-2016

Not only was Garry Shandling an incredible stand-up comedian, he was also my very good friend and mentor. This essay is partially derived from the eulogy I delivered at his memorial service in Los Angeles a month after he passed.

Garry and I often wrote jokes and performed together; we'd go shopping for workout clothes together; and we'd laugh hard playing basketball at his house every Sunday with a bunch of other comics, writers, actors, producers, and directors.

I always felt it was very, very challenging to be Garry. To be honest, he was complex, at times neurotic, persnickety, high maintenance, a perfectionist with the highest standards. He could be a handful. I think the fact that he spelled his name with two R's was fair enough warning.

Garry could never fully commit, and it drove a lot of us crazy. If I invited him to an event or party, there would be a lot of hemming and hawing, doubt, and second-guessing, and then stipulations. If he should decide to go, he could only stay five minutes because he *may* have somewhere else he *might* have to be. I learned eventually that was his process, his social dance, and I came to expect and accept it. That was Garry. Of course, he always ended up coming, staying longer than expected, and having a good time. I'm sure when he got to heaven, he probably told God he could only stay a few minutes. After Garry passed, some of us were reminiscing and looking through various photos of events or parties, and he was always somewhere in those pictures. Mostly he was found looking toward the exit, but he was there.

It took some work to be Garry's friend, but it was so worth it. He was quality. He was the gold standard. He was funny, brilliant, self-deprecating, playful, kind, generous, stylish, spiritual—I got those off his Tinder profile—and handsome.

He was more than just one of us neurotic comics. He was the first friend I had that

meditated. He was my only friend that had Buddhist monks for friends who, on occasion, actually stayed at his house. I mean, that's a sitcom right there. He was the first person I ever saw French-kiss a dog. He was the first male friend I had that sent me flowers on my birthday. He despised gossip, and you were confident that anything personal you shared with him was safe. He was also the only friend I ever had that was into the almost-defunct citizens band (CB) radios and ham radios that truck drivers used to communicate with on the road. I had no idea where that passion came from. I might understand it if he lived in the Arctic Circle or something, but, quite honestly, Brentwood, California, was not that isolated and cell phone reception was quite good.

Garry loved architecture and looking at houses. He had such an appreciation for light and the effect it had on spaces. For years he complained about his house not facing the right direction for optimal lighting. Over the years he toiled with architects and contractors, and there were always blueprints and home magazines on his dining-room table. Despite his toiling, he never changed his house for as long as I knew him, except installing some new speakers in the living room. His beautiful, amazing home in that gorgeous parklike setting with a stunning view of the Pacific Ocean continued to be Garry's albatross. That was Garry.

When I was first getting to know him, he would often invite me to go hiking. I quickly discovered his idea of a "hike" was walking from open house to open house in one of the Los Angeles neighborhoods. I should have realized this because Garry would only hike on Sundays and Tuesdays between eleven A.M. and two P.M., when realtors typically held open houses. Also, I was told to bring a pair of those little blue paper booties realtors ask you to wear so you don't track dirt in from your shoes.

Despite our hikes mostly being indoors, he did still have such an appreciation for nature. A few days before he passed, we went for lunch

at one of his favorite places on the Pacific Coast Highway in Malibu. We sat together at a picnic bench, outside, overlooking the ocean, and he would just look out and say, "How great is this? How great is this?" I would hear him say that a lot about other things as well. On the drive home, I asked him if he was seeing anyone. He immediately thought I was talking about a therapist. He was very private about his romantic life. He quickly responded that he was more concerned with getting healthy. Though Garry never married and never had a traditional family, those of us who knew him and loved him felt like a little family.

Though I did play a part in hooking Garry up with his longest and most fulfilling relationship.

My wife and I were staying at a resort in Hana, Maui, that Garry had stayed at about a week or so before. On our first day there, we came across a black-and-white Border Collie that strolled around the hotel grounds. He was very friendly despite having suffered a compound fracture to his back leg, which dangled from his body. The hotel manager told us he had probably been hit by a car, and said he belonged to a local rancher who would probably shoot the dog rather than pay the vet bills to get him fixed. We brought him to the vet on the island and got his leg set with rods and a cast and decided to take him home with us. During our week there, when the dog was still at the vet, I called Garry and casually mentioned our episode with the dog, which we had by now named Hana. Garry got very curious and excited. He asked me to describe the dog. "Wait a minute. You know what?" he said. "I think that's the dog *I* was going to bring home." His leg wasn't broken at that time, but Garry said he had an incredible connection with that dog, if indeed it was the same one. He said on the day he was scheduled to fly home he was playing with him in a field, chasing him around, when he accidentally stepped in a hole, spraining *his* ankle. By the time of his flight, he was hobbling and couldn't find the dog. He had to leave without him.

Garry really wanted to look at our Hana when we returned, just to see if, by a long shot, it was him. Of course, by now my wife and I were attached to this dog. But when we brought him to Garry's house and they saw each other, it was just so obvious they belonged together. I wasn't going to be that person who tore them apart, so . . . I thought $500 was a fair price. He renamed him Shep and they were inseparable for the next twelve years. After Shep died, Garry never got another dog.

Aside from being a good friend and loving dog parent, Garry was so enthusiastic and supportive when it came to nurturing other comics. We went to him for his advice, for his experience, and for his wisdom. He took such a personal interest in our lives and careers, and he made each of us feel so special and so talented. He was always in our corner. He would often tell me, "Kevin, you're at the top of your game!"

I don't even remember the exact day I met Garry forty-one years before his death in 2016. It's almost like we just melded organically over time from our paths crossing and sharing similar passions. It's hard to think back on a time when we weren't friends. In fact, I go back so far with Garry that I actually met his parents, Muriel and Irving. One of my favorite jokes of his was about his mother:

"I told my therapist that my mother wanted to marry me and that's when I saw something I had never seen a therapist do. Like a blackjack dealer leaving the table, he flipped his hands over a few times then clapped them and left."

(Other favorite jokes include: *"Sometimes when I feel lonely, I'll shave one leg so that it feels like I'm sleeping with a woman."* And: *"I can't afford a private jet, but I can afford to pay the other passengers on my commercial flight to get off."*)

Garry must have spent a fortune on therapists to deal with the emotional damage his mother caused him. He had tons of material about the overbearing and smothering Muriel, and how she screwed him up. The saddest irony of all of this is that Garry is probably now reunited with his mother for all of eternity—and that absolutely kills me.

Garry was brilliant in so many ways and unbelievably inspiring. Having his approval meant the world to me, and, of course, his friendship meant more. I loved Garry for everything he was, and I don't know how I will ever stop missing him. I don't want to stop. I read somewhere that grief is not a sign of weakness. Grief is just the price you pay to love someone, and I can tell you that Garry turned out to be very, very, expensive.

TOM PETTY

1950-2017

Over the years at Sunday-morning basketball games at Garry Shandling's house, I had met quite a few interesting people. I would sometimes ask Garry who was playing that day as if they were a guest on his talk show. "Oh, um, let's see," he'd say. "Brad Pitt is playing today and maybe Al Franken." Some were better players than others, but it didn't really matter because aside from an occasional ringer, none of us were really that good. Those Sunday mornings were more of an excuse to get together, kibitz, and get a little exercise. Garry's half-court was in his lower backyard in a parklike setting. Before the game could start, an electric leaf-blower was necessary to clear the court of the fallen eucalyptus leaves.

The lineup on one particular day surprisingly included rocker Tom Petty. We all know Tom, of course, from his popular band, Tom Petty and the Heartbreakers, and also his stint as one of the Traveling Wilburys. Here was an absolute icon just hanging out at our game (he wasn't actually playing that day—he just

wanted to sit and watch). I had a hunch Tom was not a basketball player given that he arrived in his street clothes and was never without a cigarette. Apparently, Garry knew Tom from his guest appearance on *The Larry Sanders Show* and they became unlikely friends—but good enough friends that Tom would post up on the sidelines to watch Garry dribble on a Sunday morning.

As we played several hours, Tom relaxed on a courtside bench with his legs crossed and a cigarette dangling from his mouth. I must say, no one seemed more adept at folding and crossing their legs than Tom. They just seem to drape over each other so easily, almost as if his legs were two lengths of rope. I wouldn't have been surprised if on occasion he braided them. Some people just have that uncanny ability to wrap into themselves, whether by folding their legs up and under and settling into a tiny chair or slipping into some complicated yoga position. My legs are extremely long and don't really have much bend, even in the wind. I'm guessing Tom had very flexible

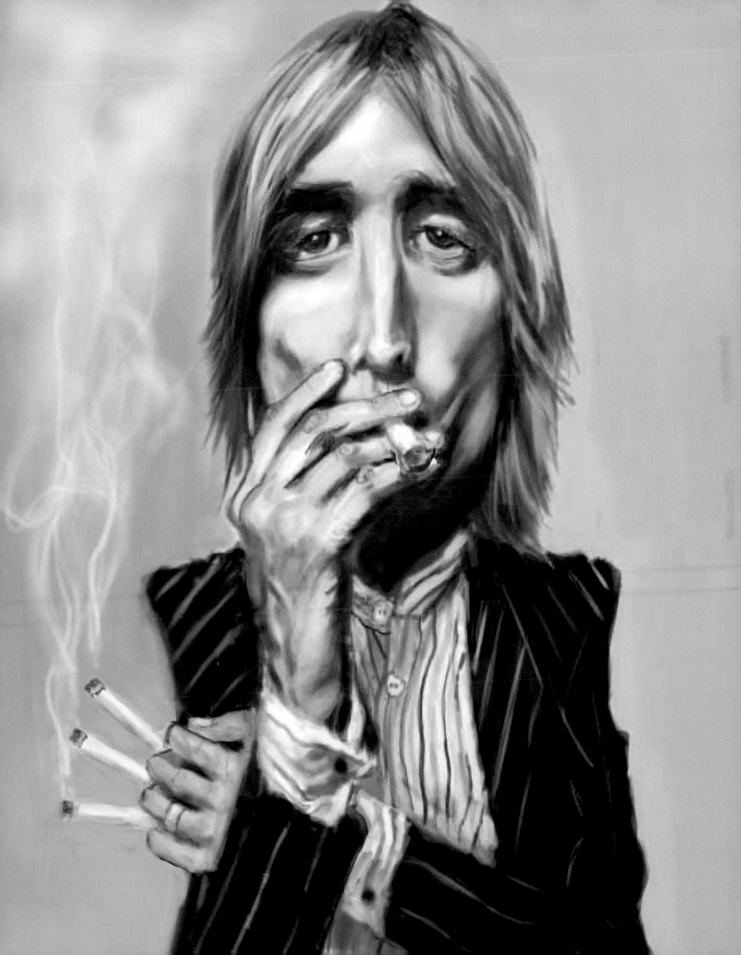

joints because of his lack of muscle tissue and slight build. After he took a puff on his cigarette, I began to observe that he never actually moved it too far away from his mouth, keeping it nearby for easy access for his next drag. I imagine you probably would not want to be around him if he was without a cigarette.

Though Petty may have been known as a singer and songwriter, he was also a style icon. He was known for his Western hippie style and had no shortage of printed shirts. Petty even donned a black top hat during his 1989 Strange Behavior Tour. No one was wearing a top hat onstage back then except for maybe an actor in a Broadway play or, of course, guitar hero Slash, from Guns N' Roses. For that matter, Petty enjoyed wearing a variety of eclectic hats onstage. I must say, though, to pull off wearing a tall top hat was pretty impressive. It really is second to wearing a lampshade on your head.

Sadly, Tom passed away just a few years after that surreal day at Garry's basketball court. I bet there are still cigarette butts on the ground, under that very bench.

TIFFANY HADDISH

Tiffany Haddish often reminds her fans that she was no overnight success. She had been working the clubs as a stand-up comedian for years while playing small roles in TV and films. It really wasn't until she starred in the 2017 film *Girls Trip* that people started to take notice.

I first met Tiffany in Los Angeles when she was around fourteen. Every summer, Jamie Masada, who owns the Laugh Factory comedy clubs, generously held a comedy camp for underprivileged kids mostly from South Central LA. Jamie would invite a few established comedians, like myself (I actually wasn't invited but crashed the camp), to critique and encourage these brave kids as they each took the stage trying their hand at stand-up. One of those kids was Tiffany. Even back then she had unbridled confidence, charm, and an undeniable funny bone. I lost track of her when I went back to New York to continue my stint on *SNL*, but when I returned to Los Angeles eight years later Tiffany was all grown-up and performing regularly at the Laugh Factory.

Even though her stand-up was raw, reckless, and daring, she was extremely likable. I knew she was going places.

Tiffany and I have become good friends over the years from hanging out together at Los Angeles comedy clubs or hiking together. Our chats, like our hikes, take wandering paths, discussing everything from her boyfriend (the rapper Common) and the Black Lives Matter movement, to attending George Floyd's funeral in Minneapolis and her fabulous garden. Tiffany is passionate about her garden and on our last hike alerted me that cucumbers were in season. At the time she was beginning to prepare for her role as the Olympic track star and fastest woman of all time, Flo Joyner. Tiffany was consuming large quantities of water—fortunately, cucumbers are 96 percent water. I asked her if she was trying to lose weight for the role. She said, "No, just cellulite."

Tiffany enjoys celebrations, too. In 2019 she invited me to tag along as her plus-one to

Kevin Hart's fortieth birthday bash at TAO nightclub in Los Angeles. I never would have thought I'd be hobnobbing with the likes of Hart, LeBron James, Usher, and Gabrielle Union. Tiffany, of course, was beloved by everyone there and spent most of the night making all of us laugh.

Unlike a lot of celebrities, I've learned that when Tiffany says she will be somewhere at a certain time, she will be there. On top of her being punctual, I can't think of anyone who is more down-to-earth and authentic; she considers herself an "Administrator of Joy." One of the many reasons I admire her is that she has not let fame go to her head. She had to work hard for it and overcome many obstacles as a child. When she was three years old, her father left and soon thereafter her mother was institutionalized. This left Tiffany, the eldest child, to act as the surrogate mother to her four siblings. She is such a talented and wonderful person, and I'm so excited to watch what else life has in store for her.

Tiffany grew up in South Central LA, where she even spent time in foster care. In her midtwenties she discovered her biological father and found out he was a Jewish refugee from Eritrea. Tiffany couldn't be happier to discover her Jewish heritage and decided to hold another celebration: a bat mitzvah. I've been to bat mitzvahs before, but this was unlike any other, if only because everyone so enthusiastically *loved* celebrating Tiffany.

On a recent hike she confided that a picture of her was painted on a wall somewhere in Hollywood that she lamented looked nothing like her. I decided that day I would try my hand at painting her. She loved it! Who's the Administrator of Joy now?

PEYTON MANNING, ELI MANNING, AND EMMA STONE

In February 2015, I attended *Saturday Night Live*'s 40th Anniversary, a star-studded event that took place in Studio 8H at 30 Rockefeller Center. The attendees included lots of actors, athletes, musicians, politicians, and other notable past hosts, cast members, and friends of the show. Everywhere you looked you saw someone famous. It really was like being at the Hollywood Wax Museum except without the lifelike faces.

The after-party was held a few blocks away at the Plaza Hotel. Everyone arrived in their tuxes and gowns and mingled in the lobby just outside the ballroom. It was there that I spotted the Denver Broncos quarterback Peyton Manning. He was at least as tall as me but not nearly as handsome or funny. I chatted him up with some of my go-to small talk before asking if I could get a picture with him. In all transparency I was not a Broncos fan. I only wanted the picture to impress my seven-year-old son. Peyton, naturally, was more than happy to be in a picture with me. I handed my phone off to a tuxedoed Norm Macdonald. As soon as Norm snapped the picture, Peyton snatched my phone and handed it to his younger brother, Eli, the New York Giants quarterback. "Check it out, Eli, and see if it's good," he said.

Eli looked at it for a few seconds then replied, "Yep, looks good." Peyton handed my phone back to me, patted my butt (as a quarterback does), and told me to have a fun night. *What a nice guy*, I thought. He and Eli wandered off into the ballroom along with the other guests and I headed to the bar. About fifteen minutes later I went to text the picture to a friend and was shocked to see that my entire iPhone was now in Mandarin. The entire phone! There was nothing on it that was English. I couldn't operate it at all in this condition. *How did that happen?* I wondered. It quickly dawned on me—the Manning brothers! They'd pranked me. That's probably a thing they do to a lot of unsuspecting fans. I went over the whole scenario in my head: When Eli was supposedly checking out our picture for approval, he was really switching my phone into Mandarin.

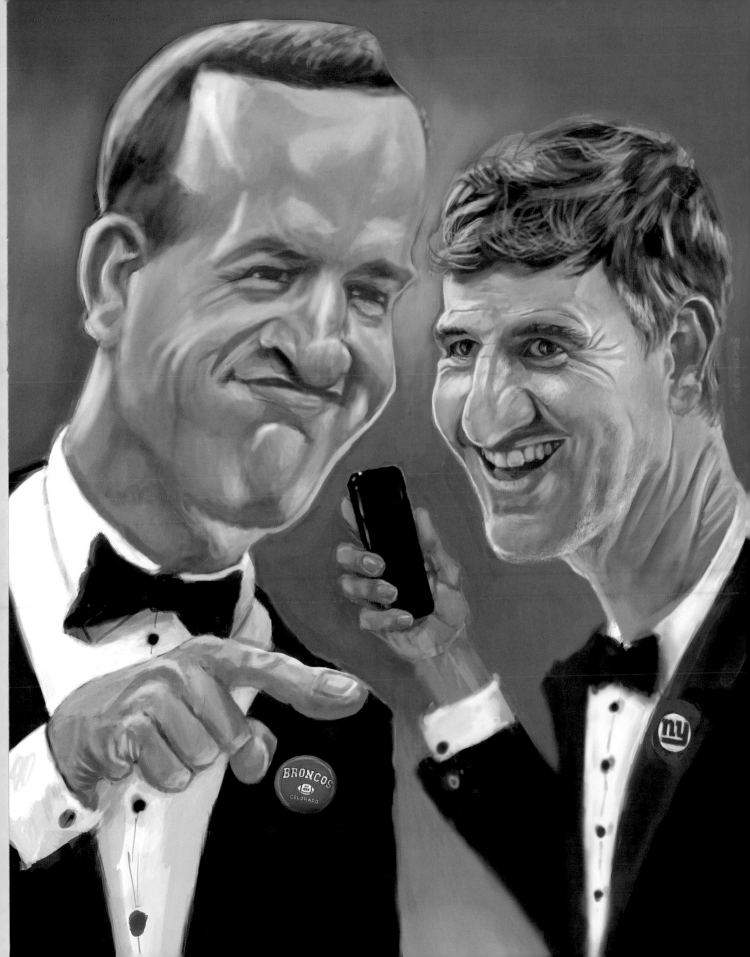

PRINCE ROGERS NELSON

1958-2016

Pictured here is the Prince I came face-to-face with in 2015. Our happenstance meeting occurred at the *Saturday Night Live* 40th Anniversary after-party. We are all used to seeing pictures of the mysterious mastermind musician Prince emoting his brand of androgynous, smoldering, sexy, intense, brooding solemnity. This, though, was an unfamiliar but strangely accessible side of Prince. Standing outside the Plaza Hotel ballroom with a mass of other anniversary guests, I happened to glance over my shoulder and there he was. He approached me surrounded and shielded by three uber-hip women, his then all-female backup band, 3rdEyeGirl. As our eyes locked, we each grinned from ear to ear. When people that usually don't smile in person or in pictures do smile, you see a whole different side of them. It's very disarming. His happy expression reminded me of a small child who just noticed the clown at the circus.

I uncontrollably blurted out his name. We shook hands and exchanged some brief small talk about how crazy the night was as his wall of protégées continued scanning the crowd for privacy threats from inadvertent, would-be troublemakers. I was always a fan of Prince's music and his showmanship, and my wife, Susan, was even more of a superfan. I just knew I had to introduce them. In stunning disbelief at her good fortune, she smiled nervously and extended her hand. As they clasped hands, I could have sworn I witnessed a glowing, electric, purple charge shoot up her arm and ricochet throughout her body. Susan was beyond smitten. As he proceeded to leave, I quickly pulled out my iPhone to snap a selfie when one of his protective protégées put her hand up defiantly and firmly ordered, "No pictures! No pictures!" Oh, wow, that was such a Prince move. They had been well-trained to defend his holiness on- and offstage—and I loved that. And then, just like he'd arrived, off he went, quickly dissolving into the crowd of equally stunned partiers.

Susan soon snapped out of her trance and exclaimed in disbelief, "Prince shook our hands. He never touches anyone, but he shook

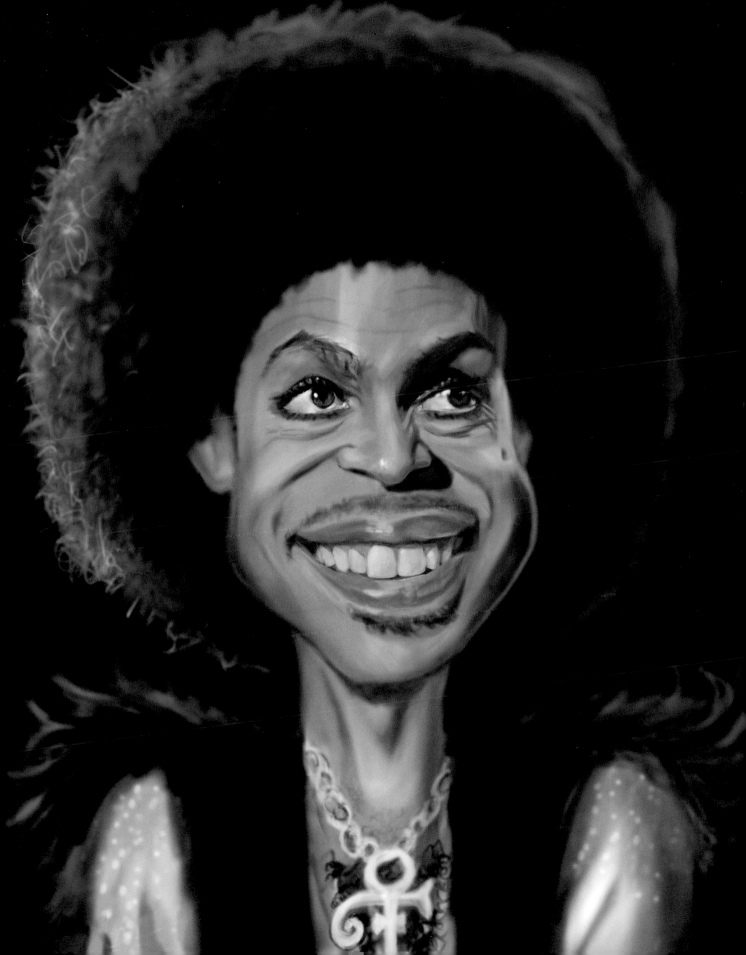

our hands!" This would be a story she would tell repeatedly to her fellow Prince fans. We left the party shortly after that because, of course, after meeting Prince what more was there to do? Unfortunately for us, though, there was more. While we slept soundly in our hotel, Prince apparently took the stage later in the wee hours of the next morning and thrilled the crowd by playing many of his hit songs.

Aside from Prince and I both loving everything about Prince, I learned later he and I had something else in common: We were both huge fans of ping-pong. Growing up he would often go to the YMCA or various table-tennis venues to play. The most notable match he played was on the TV sitcom *New Girl*. As a fan of the show, he agreed to appear in an episode where he destroyed Zooey Deschanel in a ping-pong game.

According to his former sound engineer David Z, Prince once played ping-pong with Michael Jackson in a recording studio and trash-talked the music legend for playing the game "like Helen Keller." "You want me to slam it?" Prince taunted Jacko, according to Z. "Michael dropped his paddle and held his hands up in front of his face so the ball wouldn't hit him," Z recalled. "Michael walked out … and Prince started strutting and said, 'Did you see that? He played like Helen Keller.'" It was no secret, Prince was extremely competitive.[4]

Prince was also an avid roller-skater and used to throw rink parties for his celeb friends. He owned a mesmerizing pair of see-through skates that had light-up wheels attached, so when he moved, he sparked a trail of multi-colored lights in his wake.

In a little over a year from that night we met Prince at the Plaza Hotel, he would be dead at the age of fifty-seven. There was nothing his wall of protégées could have done to save him. The morning after he died, I found myself on a flight into Minneapolis for a previously scheduled stand-up gig. The sunset that evening over the city was a beautiful, surreal tinge of various shades of purple and gold.

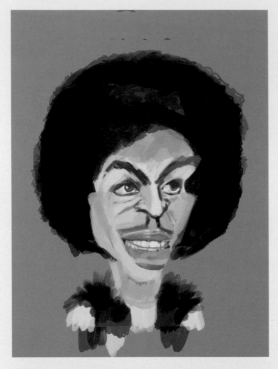
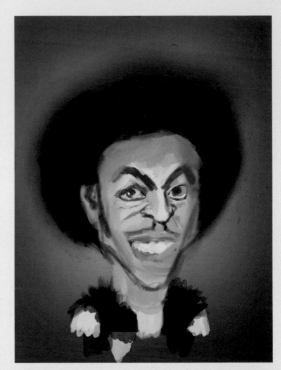
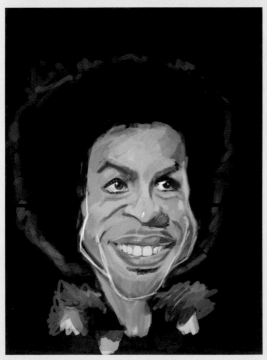
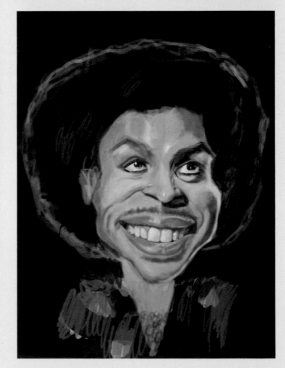

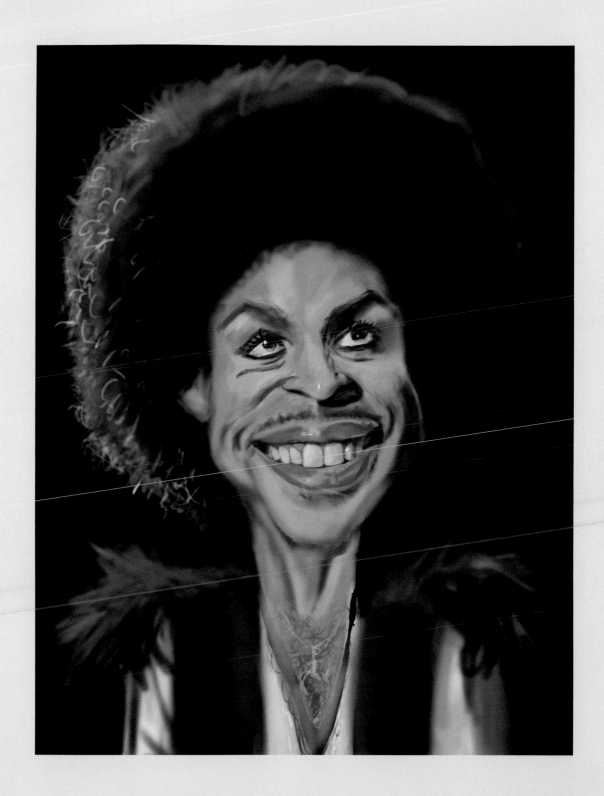

MAGGIE GYLLENHAAL

I first crossed paths with Maggie Gyllenhaal at Pasadena's "Rose Bowl Flea Market," back in the nineties. She was browsing the aisles with her mother. I noticed that Maggie was carefully inspecting a Rocco mid-century table lamp as I was homing in on a poster of Scooby Doo. I did not approach Mrs. Gyllenhaal because, for some reason, she intimidated me. I had met and worked with many talented and famous actors over the years but for some reason she made me nervous. But I'm sure part of it was that she was the opposite sex. I mean that's a given. There are only a handful of actors who intimidate me: Maggie Gyllenhaal, Julia Roberts, and Julie Andrews, all women. What if she didn't recognize me and just dismissed me as another fan? That would not only be a blow to my ego but also an embarrassment in front of an entire parking lot full of scavengers looking for a deal on unwanted, secondhand junk.

It's hard thinking of Maggie without thinking of her actor brother, Jake Gyllenhaal, unless of course you are watching Maggie in the black comedy *Secretary* (2002). *Secretary* is a sexy film about two people who set out on a mutually shared lifestyle of bondage, discipline, dominance, submission, and sadomasochism. Jake is not welcome in any part of this journey. If that's what you wish for then I suggest you watch his breakout role as Jack Twist in *Brokeback Mountain*, where I would absolutely welcome Maggie.

I read once that Maggie was shocked to discover her actual first name, according to her birth certificate, is "Margalit." She did not learn this until 2013, when adopting her husband's surname (Sarsgaard). Obviously someone changed her first name to Maggie because they realized the Swedish name, Margalit, was too unusual and may be difficult for people to spell. Quite honestly, if they were worried about that they should have changed her surname, Gyllenhaal. Actually, she and her husband both have last names that do not please spellcheck.

Maggie has a beautiful and interesting face. I certainly didn't do her any justice in this painting by giving her those Marlon Brando Godfather cheeks. It's unfortunate that so much emphasis is placed on our appearance. Many actresses, though still youthful and talented, face the stigma of being labeled "too old" for certain roles. The *Guardian* reported that Gyllenhaal learned of a previous role she was passed on due to her age. She shared, "I'm thirty-seven and I was told recently I was too old to play the lover of a man who was fifty-five. It was astonishing to me. It made me feel bad, and then it made feel angry, and then it made me laugh."[5]

Sometimes you're not made an offer so you can't refuse.

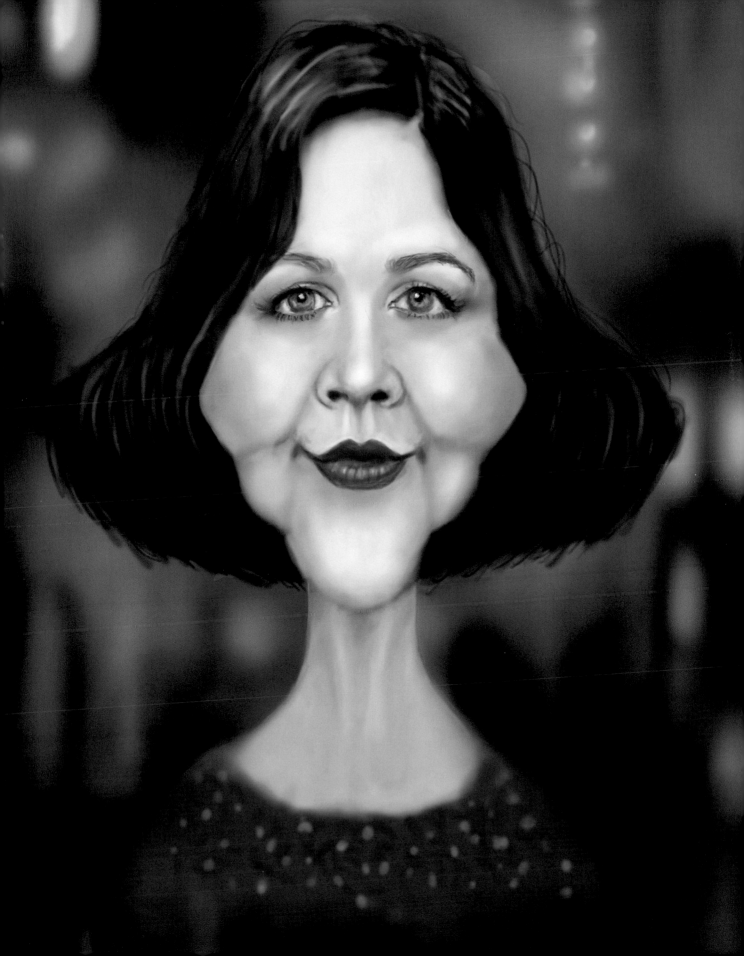

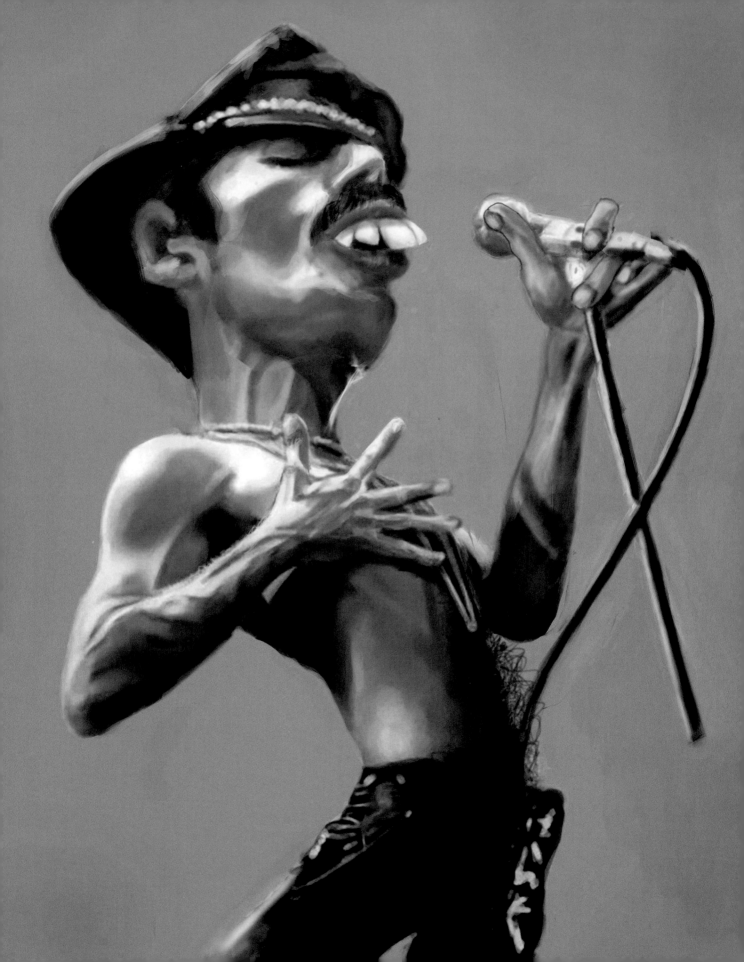

FREDDIE MERCURY
1946-1991

In January 2020 I was doing a weekend of stand-up comedy in Indianapolis. During those few days in my hotel room, I sketched this caricature of Freddie Mercury, the flamboyant lead singer for the rock band Queen. I was under the weather in every sense: It poured that weekend, and I was dealing with a nasty cold coupled with an annoying, relentless cough. Freddie was a nice distraction and got me through an otherwise dismal weekend.

Freddie Mercury, a baggage handler at Heathrow Airport in London–turned–front man, cofounded Queen along with guitarist Brian May and drummer Roger Taylor. Queen became one of the most popular rock bands at the time with the success of their album *Night at the Opera*. They played some of the biggest venues in the world, including Live Aid in 1985. Mercury himself wrote numerous hits for Queen, including "Bohemian Rhapsody," "Killer Queen," "Somebody to Love," "We Are the Champions," "Don't Stop Me Now," and "Crazy Little Thing Called Love." Many consider him one of the greatest singers in the history of rock music. With his flamboyant stage personal, theatrical style, and four octave vocal range, he withstood the conventions of the common rock frontman. Onstage he was incredibly charismatic, taking his performance over the edge and easily engaging with huge stadium crowds. He loved to portray an extravagant persona, a version of himself, onstage, and he held audiences in the palm of his hand. Mercury was known for using a microphone on stage with a broken stand. After accidentally snapping it off the base during an emotionally charged performance, he continued to use it and it became his brand.

While performing, Mercury soaked up the outpouring of love from his fans. Nirvana front man Kurt Cobain's suicide note mentions how he admired and envied the way Mercury "seemed to love, relish in the love and adoration from the crowd."[6] Although apparently Mercury was an extrovert onstage but a private and reserved person offstage. He strayed from discussing his ethnic or religious background with journalists. Whenever he

recordings. The Red Special was originally based on a Spanish guitar shape with double cutaways. They created the original with a variety of woods, including a friend's fireplace, part of an ancient oak table for its massive neck, and acoustic pockets within the body designed to cause feedback. He said he also modeled it on the old acoustic he had as a kid.

Another layer of that distinct sound comes from his picking. Instead of a plastic pick like most guitarists use, Brian uses a sixpence coin. In an interview with *Guitar World* on BBC Radio's "Raised on Radio," he shared how he came to use a coin as a pick: "I wanted more hardness in the peak; the more ridged it is the more you can feel what's happening at the strings in your fingers."[8] Eventually he picked up a coin and never went back. Another great advantage this has over a plastic pick is that it is hard enough to make sound but soft enough not to break your steel strings—the coin's serrated edge, if turned at an angle to the strings, creates a lovely kind of splatter. According to May, "The guitar is like a voice and that splatter is the consonant and that helps the guitar to talk." He said he uses a 1947 sixpence or earlier because after that the material was changed. He added, "They don't wear out and I have a thousand of them." He said a dime or quarter will work equally as well. The point of this is, if you ever need to borrow money, go to Brian. You know he's good for it.

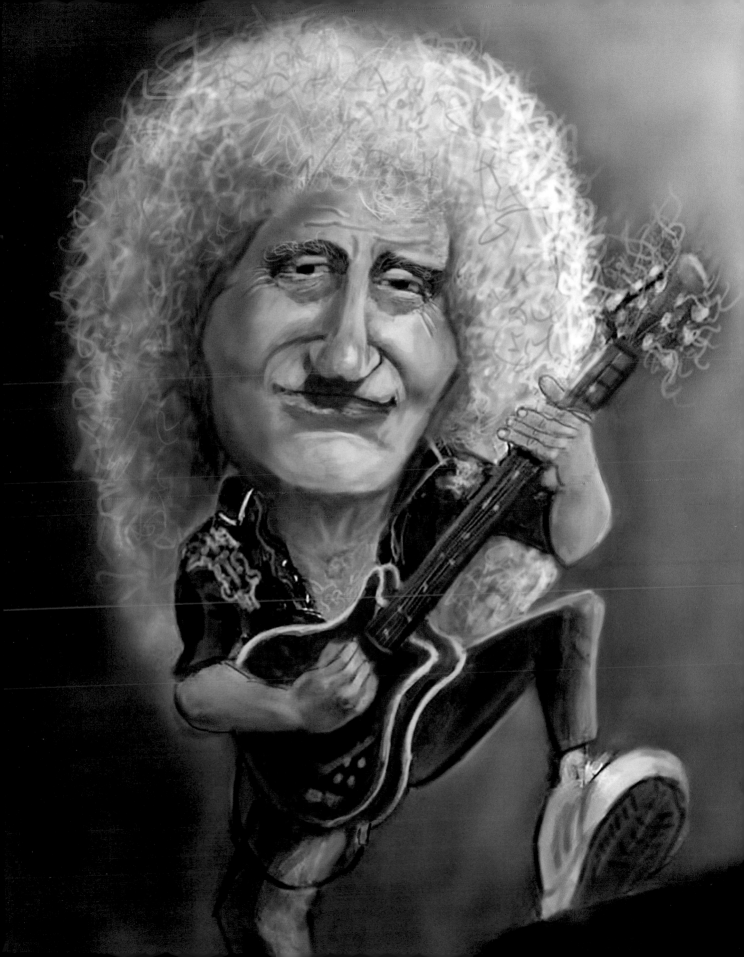

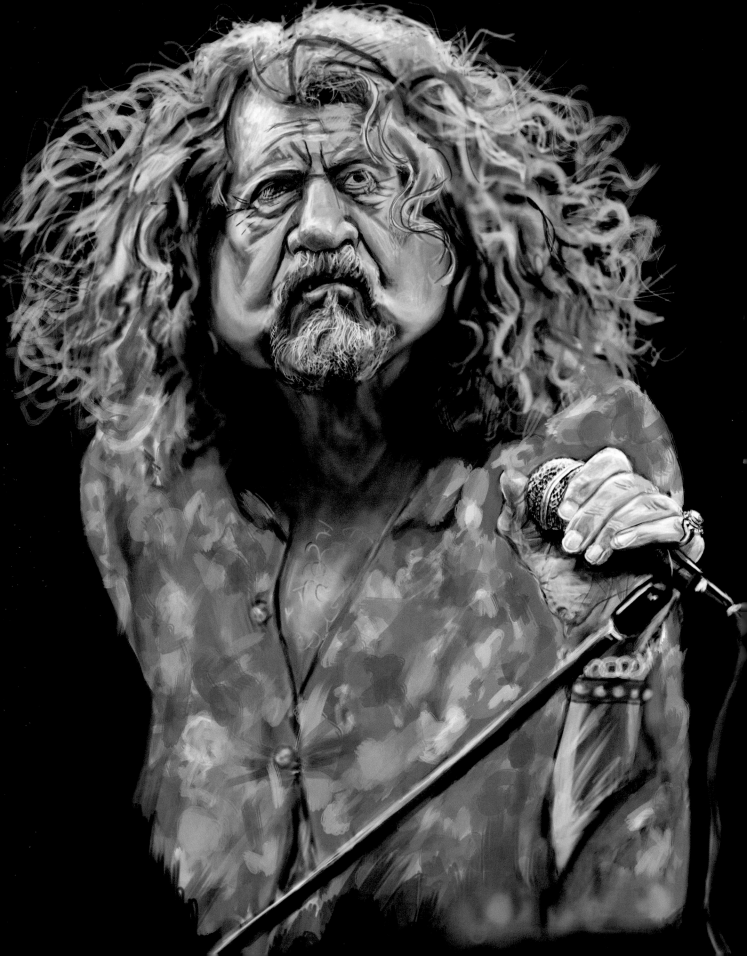

ROBERT PLANT

've painted Robert Plant as his current age of seventy-two, but long before this he was known as the front man for Led Zeppelin from the late 1960s to the end of the 1970s. He helped create the "god of rock and roll" or "rock god" archetype. There are a few bands I regret not seeing in concert and Led Zeppelin was one of those. I suppose they still go out on tour occasionally, but I imagine it's not the same as seeing them in the seventies.

Sometimes, though, I think it's a curse for a "rock god" to live to a very ripe, old age. We are only now experiencing this with the surviving mega–rock icons from the seventies like Mick Jagger, Keith Richards, Paul McCartney, Ringo Starr, and, of course, Robert Plant. They have become senior citizens but still desire to tour and dance around onstage as if they were in their twenties. Essentially, they are still trying to sell sex, youth, and danger as grandparents. Grandparents who spent the first several decades of life partying as much as making music, I might add. Sure, the hips and knees can be replaced (just like the hair), but once the voice goes it might be time to throw in the towel.

I guess if you don't go gray or bald, can still fit into those supertight latex pants, and wear tons of silver rings and necklaces, you can still take the stage. The "big hair" bands from the eighties are now the "Big Receding Hairline" bands of the 2020s. But hey, if they're still up for performing and we're still up for seeing them, ride on! Maybe playing their hit songs brings back memories, too. Most fans don't like it when these dinosaurs introduce a new song, although I don't mind because it serves as a bathroom break. I once golfed with the road manager for the seventies bands Journey and REO Speedwagon. On the sixth hole, as we were about to tee off, I asked if those guys ever write new songs. He grimaced a bit and said, "We don't encourage it."

By the same token, their audiences have aged, too. They may still be rockin' but a good number of them are rollin' . . . as in a wheelchair. With younger bands and youthful audiences, the long lines tend to be at the women's restrooms, but now, with the older—or should I say "more seasoned"—bands and audiences, it's the men's restroom with the long lines. And the band's merch is a little different now, too. Instead of T-shirts, it's the band's logo on a Cialis bottle, or on a pair of Depend adult diapers.

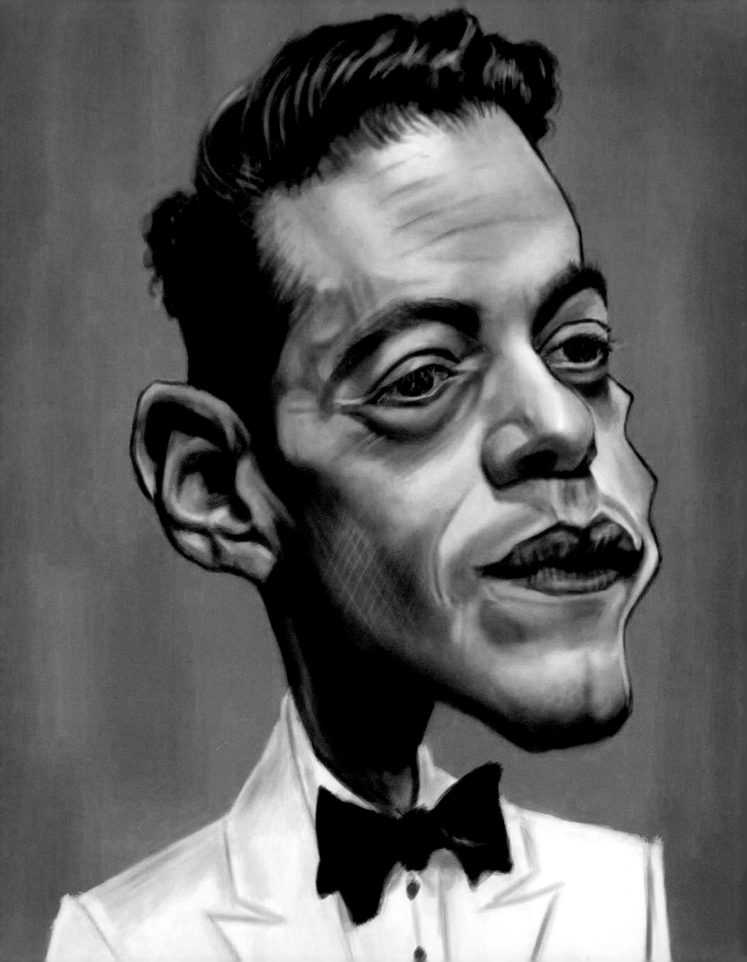

RAMI MALEK

I loved painting Rami Malek because he has such an interesting face. Incidentally, he doesn't just have one interesting face, he has two—Rami has an identical twin brother, Sami. According to Rami, they were bad boys growing up and took advantage of being identical twins. Rami has said he once took a test for his brother at UCLA. Sami was struggling with his Greek studies and was in jeopardy of not graduating. His teacher said that she would give him the points to graduate but he needed to deliver a monologue from a Greek tragedy. "Do you know any monologues from a Greek tragedy?" he asked Rami. Well, it just so happened that Rami was in acting school at the time and had just performed one in class. He agreed to step in and deliver it. It was a success. He fooled Sami's teacher and Sami graduated with flying colors. I would say Sami owes Rami a huge favor.

I don't have a twin, but people are always telling me I have a doppelganger. I'll walk past a restaurant in some city, and someone will recognize me and insist that I must come inside and see their bartender. "We always kid him that he looks just like you!" they'll say. I usually humor them, but I never think the guy looks like me. They might have dark eyebrows and a big forehead, or back scabs, scoliosis, bloodshot eyes, and a gut. But other than that, nothing like me. Definitely not an identical doppelganger, at least.

Rami could have been Freddie Mercury's twin in another life and was amazing at portraying Queen's lead singer in the biopic *Bohemian Rhapsody*. If I were to play Freddie, the first thing I'd buy is prosthetic teeth to match Mercury's protruding teeth. (I don't think we say "bucktoothed" anymore—instead, we say "protruding" or "orally challenged" teeth.) But now that I think of it . . . do we really know it wasn't Rami's brother that played Mr. Fahrenheit?

As I mentioned earlier, not many of my subjects have seen or at least responded to my caricature painting of them—however, Rami has. Shortly after I painted this caricature, I posted it on Instagram. Rami was a guest on Jimmy Kimmel's show a few nights later and Jimmy showed him this very painting. Rami studied it briefly, taking it all in, and then Jimmy asked him what he thought of it. Rami, still processing my work, looked up and said, "Kevin Nealon is no longer my friend."

JENNIFER ANISTON

When I first moved to New York City to work on *Saturday Night Live*, I discovered a great burger joint on the Upper West Side called Jackson Hole. You could sit at the counter and watch as the cook sizzled each burger on the grill right before you. Each patty was placed under a small chrome dome and then served with a topping of delicious grilled onions and a fresh bun. For me, half of the points I give to a burger comes from the bun. The bun has to be fresh and tasty and it certainly was here.

The other reason I ate there several times a week was because of what was going on just inside the entrance. A hostess of, I'd guess, about nineteen years old, and probably the cutest girl I had seen in New York at the time, worked the door. I was extremely shy back then and never engaged in any kind of conversation with her. I came very close once to asking her where the bathroom was but then bailed out at the last minute. Besides, she was always engaged with the young good-looking waiters in their formfitting shirts. In fact, every time I frequented the place they were constantly flirting with that hostess, and she playfully flirted back. That's OK, I was fine just sitting at the counter gazing from afar while stuffing my mouth full of burger and onions.

I always wondered what happened to that hostess, and many years later I found out. I was a guest star on a comedy sketch show called *The Edge* where Jennifer Aniston was part of the ensemble. After we got to talking, she revealed, in fact, that she was that hostess. Of course she had no recollection of me, but she said she did remember the little chrome domes they cooked the burgers under. And from there, we all know what happened to Jennifer next. Hello, *Friends*.

I've since become a vegetarian and got married. Sadly, Jackson Hole really has nothing to offer me now except the grilled onions and fresh buns.

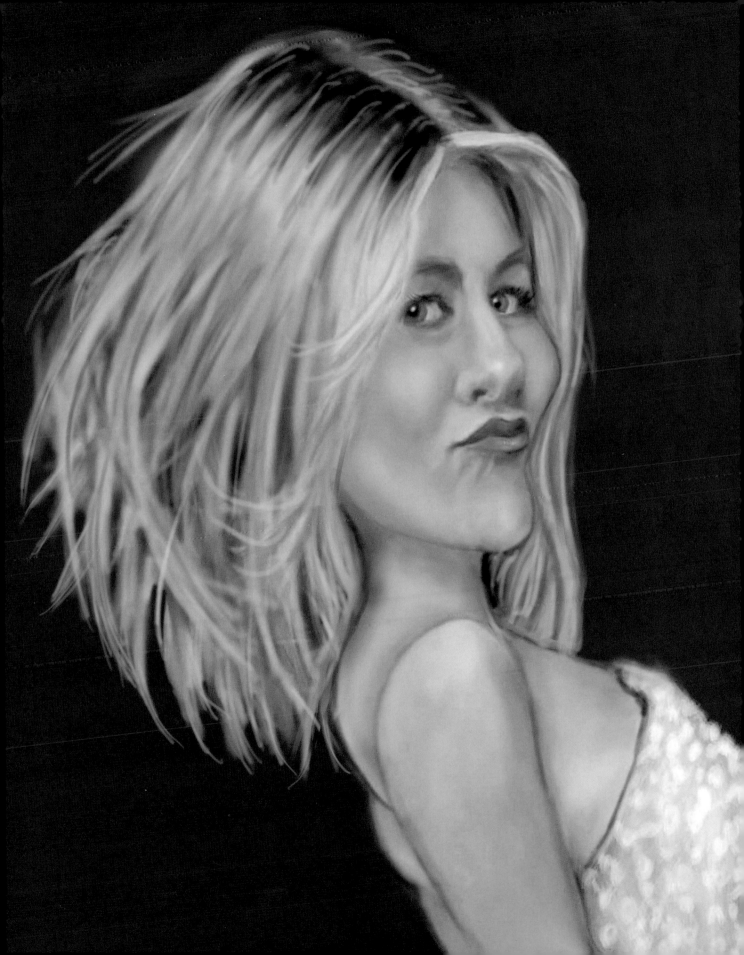

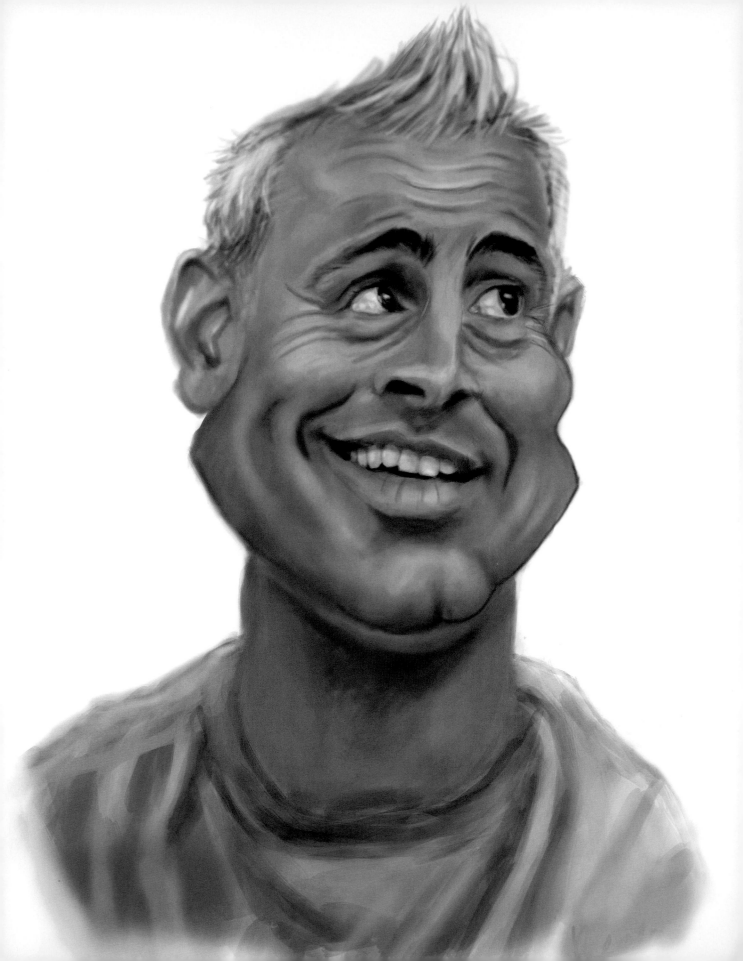

MATT LEBLANC

We all know Matt LeBlanc from his role as Joey on *Friends*. He would forever be known for his catchphrase, "How you doin'?" It's a fun phrase to repeat with that slight East Coast, blue-collar accent. Matt, of course, has gone on to do many other successful TV shows including Showtime's *Episodes*, *Joey*, BBC's *Top Gear*, and the now-defunct CBS series *Man with a Plan*. The latter is where I met Matt for the first time and I played his "not so bright" older brother, Don Burns.

As I got to know Matt, I quickly learned of his love for sporty Italian Ducati motorcycles. He also had an affinity for certain Mercedes and Porches. Clearly the key to Matt's heart is cars—he could talk cars and Ducati motorcycles for hours on end. Unfortunately, I had very little interest in motorcycles or cars. Sometimes when I saw that Matt was a little stressed or overly concerned about something, I'd simply give him one of those red oil rags to clasp. Without fail, it would immediately relax him, like a beloved blankie. He would subconsciously wipe all his fingers with it as if he had just finished overhauling an engine. I guess that oil rag transported him to his happy place—a greasy garage.

I landed the role of Matt's brother on *Man with a Plan* after a "chemistry meeting"—or a respectful way of phrasing "an audition." It was a last minute and I came straight to it from getting a cavity filled (I hate canceling on my dentist). I didn't think it would be a big cavity, but the dentist ended up giving me plenty of Novocain. Within minutes I couldn't feel the left side of my face or talk without slurring my words. Maybe it was the Novocain, but the dentist seemed to take much longer than usual. I remember telling him I had an important "chemistry meeting" in the Valley to get to. In hindsight, he must have thought that was code for meth lab.

I've never told a dentist to hurry up, but time was of the essence. As soon as they pulled the bloodied cotton balls from my cheek, I jumped in my car and scurried over to

Radford Studios. I would make it just in time if I didn't hit any lights or pedestrians. During the drive I reviewed my character's lines from the script and kept slapping the left side of my face, feeling nothing but the occasional drip of drool on my jaw.

When I arrived I strutted into Bungalow 3, where I sat alone in a side room waiting to be called in to meet with the show's creators. Suddenly Matt strolled in, more grown-up and grayer than Joey. He said hi (but not *How you doin'?*) and asked if I'd like to read through the script once before we went in to see the producers. "Thur," I said with dead lips. "Of courth."

After we did a quick pass-through, he headed in to meet the show's creators and producers. He told me to join them all in about five minutes. Apparently, they asked Matt how I was and he jokingly said, "He's got really good comedic timing but I think might have had a stroke." Stroke or not, we had "chemistry."

Over the course of filming, I would comment to Matt that my character seemed awfully dumb. He would turn to me and said, "Hey, I made a lot of money playing dumb." It's true. Joey was absolute perfection, dim-witted but a well-meaning and lovable guy. In working together, I discovered Matt was far from dumb. I was astounded by how much industry knowledge he had absorbed from spending years on highly respected sets. It all seemed very second nature to him—he could have easily directed every episode of *Man with a Plan* and acted in it at the same time. He was astute with story, pacing, and character development, and had a great instinct for comedic timing and blocking scenes. What was truly remarkable about working with Matt was that his character had a boatload of lines, but he still ended up learning everyone else's lines, too. His memory was uncanny. Sometimes it was even a little annoying and distracting because, in a scene, I might notice his lips, ever so slightly, mouthing my lines as I delivered them to him.

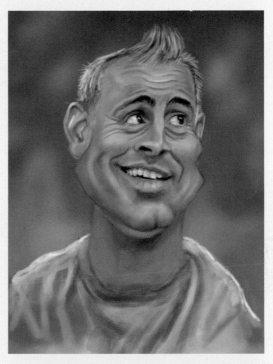

During my first season on the show, there was one particular line my character was supposed to deliver but for some reason I could never get it out. This was frustrating to me—and Matt—as it was an incredibly well-written and funny line. My character was explaining to Matt's character the trials and tribulations of marriage. After about twenty failed takes, they reluctantly cut it and Matt would never let me forget not getting it right. Even long after that shooting day, in fact for the rest of the sitcom's run, Matt would recite the line with me. To this day I know that paragraph better than any prayer I recited growing up.

DON BURNS:

Just remember, even if you reach the straits of forgiveness and dock at make-up-sex island, somewhere there's a torpedo heading your way from the S.S. Menopause.

I think that was the line—Oh God, I hope that's right, because I can just picture Matt reading this and saying, "No, No, No! You still messed it up!" His constant needling was in good fun, but I sure did feel guilty and still do. I should have blamed it on my "stroke."

Despite all of our "chemistry," I never got him to say his famous *Friends* catchphrase. He was adamant about that. No more. Sometimes I would chide him by saying it in his voice, and he would get revenge by spouting out my Hans and Franz catchphrase from *Saturday Night Live*: "We just want to pump (clap) you up." Thus, our battle of the overused catchphrases was born.

Just for the record, the massive doses of Novocain in my jaw finally wore off halfway through Season Two and I finally had feeling back in my tongue and cheeks. How'm I doin'? I'm doin' just fine, thank you.

DAVE CHAPPELLE

I could go through Dave Chappelle's entire bio here but that would be incredibly tedious. It includes a hell of a lot of credits, accomplishments, and awards—a more succinct bio would be if I merely listed the awards and accomplishments he hasn't achieved. *Esquire* called him "comic genius of America,"[9] "the best" according to *Billboard*, and *Rolling Stone* ranked him number nine in its "50 Best Stand-Up Comics of All Time" list.[10] As far as my ranking, it was like trying to find my birthdate—I kept scrolling and scrolling down until my thumbs got blisters. Yes, Dave Chappelle is an incredibly talented comedian with a solid net worth and, yes, I am extremely jealous of his career. Who wouldn't be? That said, I am still happy for him. He deserves every accolade and bit of praise.

I didn't know Chappelle when he first started his stand-up career as a fourteen-year-old in Washington, DC. On several talk show interviews, he claims that his first real big influence was a rabbit, specifically Bugs Bunny. He said, "If you watch a lot of the stuff I do, you can almost see the influence in it, because these animators would animate these performances that were off the hook, and the guy that did the voices was Mel Blanc. This guy was like some kind of savant or genius or something. But they had some kind of real big comedic influence on me, like, I liked those cartoons." Other non-rabbit influences include Richard Pryor, Eddie Murphy, Chris Rock, and many others.

I got to know Chappelle and his stand-up in the nineties around Los Angeles at a lot of the smaller, hip comedy rooms. We would often perform at a one-hundred-seat nightclub called Café Largo.

At the time he was probably in his early twenties, very skinny with rounded shoulders and a head that seemingly cantilevered out from his chest. He always wore an iconic look of a tattered green army jacket and an ivy flat cap, with an unlit cigarette behind his ear. His delivery was incredibly laid-back and gentle. He would often gaze down at the stage and

then sheepishly raise his eyes up to the audience on his story's payoff or punchline.

On occasion, after a Largo show, I would find myself hanging out with Chappelle, Sarah Silverman, and a few others in the nearby bank parking lot. A doobie was always being passed around and the conversation was always fun.

Later, in 2003, Chappelle cocreated and starred in the acclaimed and satirical sketch comedy series *Chappelle's Show*. One of his most popular characters was his portrayal of punk-funk legend Rick James, coining the catchphrase "I'm Rick James, bitch!" (a very good example of Bugs Bunny's influence). In 2005, he walked away from a $50 million deal with Comedy Central and disappeared to South Africa, supposedly to "check his intentions." Chappelle said that he was unhappy with the direction the show had taken and expressed his need for reflection in the face of tremendous stress.

I last spent quality time with Chappelle in 2015 in Georgetown, Maryland, where we were both presenters at the Mark Twain Awards recognizing Eddie Murphy. It was earlier that day that we ran into each other outside our hotel. Here we were, back in another parking lot talking comedy. We spent the rest of the afternoon walking around Georgetown, chatting and exploring various shops. Chappelle is a cigar aficionado and brought me into a store he was familiar with, easily striking up conversation with the owner, discussing cigars and tobacco for what seemed like an eternity. Chappelle was extremely gregarious and uninhibited considering his fame. He was very comfortable around strangers to the extent that you thought maybe he knew them personally. I actually don't care much for cigars. To this day the odor from a cigar reminds me of my family reunions as a kid. I had a lot of loud, heavy-drinking uncles from New York and several of them smoked those big fat cigars. Those reunions, talk about the face of tremendous stress!

As of late, Chappelle performs frequently around Los Angeles, but he's not the same comic I remember from Café Largo. He returned from South Africa with a vengeance and seems to have brought with him a newfound confidence onstage, intentions apparently checked. He is no longer that skinny young kid—literally, he's spent a lot of time at the gym over the last several years. Instead of the green army jacket and cap, he now prefers to perform in a muscle shirt, his clean-shaven head uncovered. He still brings a cigarette onstage with him, although now he lights it . . . and no one complains. He's Dave Chappelle, bitch!

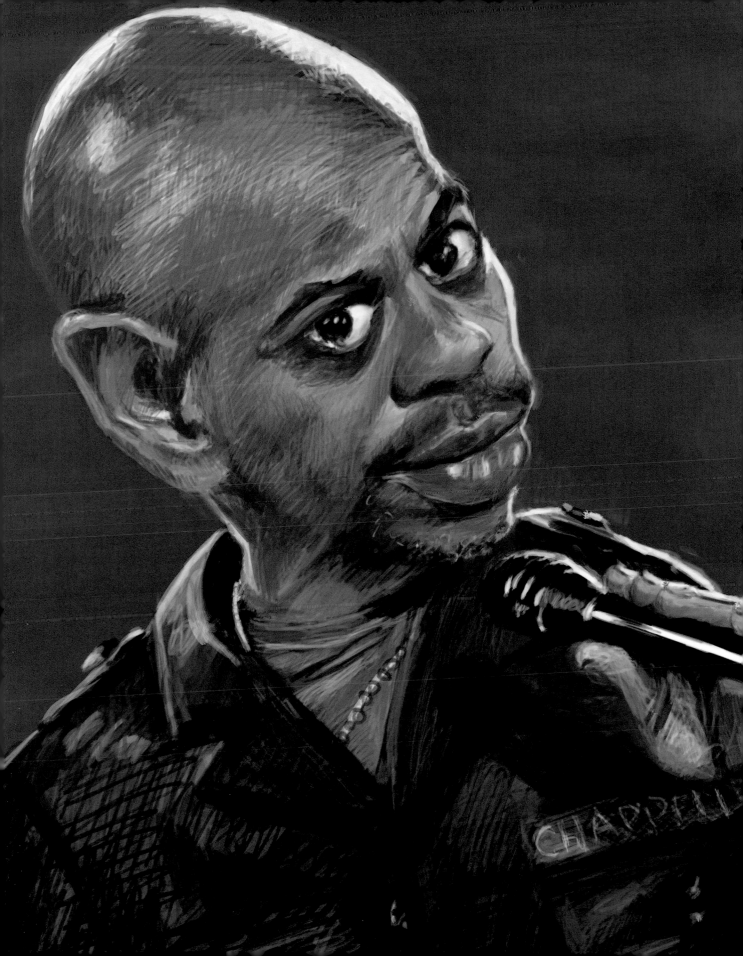

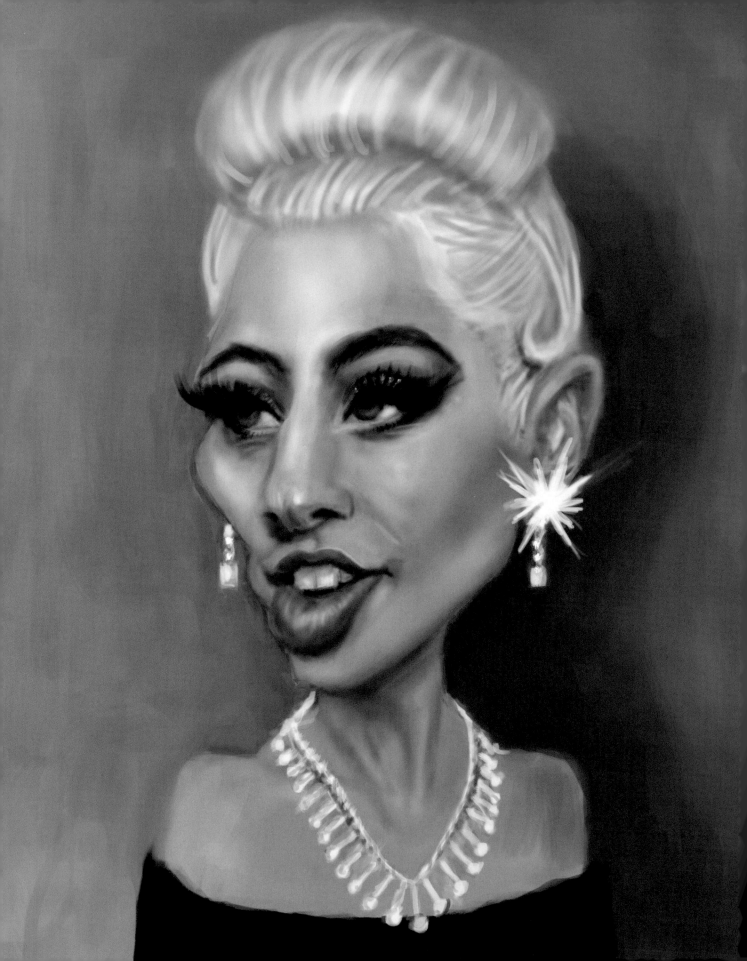

LADY GAGA

You might not recognize the name Stefani Germanotta. Those in the know, know it's Lady Gaga's birth name. I don't know when she changed it to Lady Gaga or how she came up with that particular title, but we have all come to accept and embrace her. In England the prefix "Lady" is usually reserved for British royalty. "Lady Gaga, tea is now being served in the main hall." Maybe she knew that when she'd perform in England, she'd be confused for royalty and get better treatment? Regardless, most of America, and the world, has gone gaga for her.

Would this have happened had she not changed her name? In the music business, you can be blessed with immense talent and determination, but unless you are incredibly unique you can't stand out. There is no question—audiences want shine and sparkle. The public is ostensibly bored. They've seen everything. And unless you create something incredibly unique, you and your talent will most likely go unnoticed. In my opinion, the music now is about half talent, half packaging. Obviously, this is exactly what Stefani Germanotta understood. I'm not only impressed with her talent but by how she constantly reinvents herself and takes risks in her career. Her meat dress

(designed by Omaha Steaks?) that she wore to the MTV Video Music Awards is indelibly etched into my mind. Talk about different! How many other celebs showed up to the event that night with a gown that could feed a small village? Little did that cow standing out in the field know that one day she'd be attending such a prestigious event. Do you ever wonder where that meat dress is now? I was hopeful that she donated it to a charity, and they fried it up for the needy. Someone told me that dress was sent to a taxidermist, preserved, and is now on display in the Rock and Roll Hall of Fame. (The museum paid a taxidermist to preserve the dress—otherwise, it would have had to have been out on display in a meat locker.)

A few years ago, in hopes of catching a glimpse of Stefani, I stopped in for dinner at her family's restaurant, Joanne Trattoria in Manhattan. I had heard that she was occasionally at the bar, but I guess on that particular night she wasn't working. I loved the restaurant, though, for all its ambiance and offerings. If you should ever happen to dine there, I would highly recommend ordering the Meat-Dress Parm with a side of Shallow.

JEFF DANIELS

Jeff Daniels is an incredible actor who you may know from *Dumb and Dumber*, *The Newsroom*, *The Squid and the Whale*, and many others. I met Jeff when he hosted *Saturday Night Live*, and I'm not exaggerating when I say he could have died. Actually, we both could have died. This is *not* a joke. His near-death experience was like one I had a year before.

I was meant to play comedian Jay Leno in a sketch and the makeup artist would have to make a life mask, or a plaster mold of my face, to build a prosthetic chin. The first step involves the makeup artist draping a sheet of plastic over your body to protect your clothes from the mess. Then, they add water to a large bowl and mix with several combinations of powdered plaster until the concoction becomes a white pasty substance. The plaster would be cold and wet when applied to my face, and then as the chemicals interacted the plaster would warm and harden. Before applying this science experiment to my face, the makeup artist asked if I had any history

of issues with claustrophobia. "Nope," I said. "None at all. Do whatever you need to do." At the time, I thought it was silly he'd even asked since the whole process would only take eleven minutes. "Okie-dokie. Let's do this!" I said. He then proceeded to cover my face—in fact, my entire face, ears, mouth, and even over my closed eyes. The only feature left uncovered were my nostrils. I couldn't hear, see, or talk. Four minutes in, the plaster began warming and hardening. This was when I started getting anxious. I wondered what would happen if he couldn't get it off? Or someone plugged my nostrils? I would die. I would definitely die.

The panic settled in, and I pleaded, using only my hands, to have it removed. "Take it off?" he asked. "Ymmmf!!" I mumbled from under the plaster. The last thing I remember before I passed out was his fingers slipping under the plaster on my neck. I came to about a half minute later from a whiff of smelling salts. "Are you OK?" asked the concerned makeup artist. "I think so," I said. "Man, that was weird." Fortunately, he had yanked the

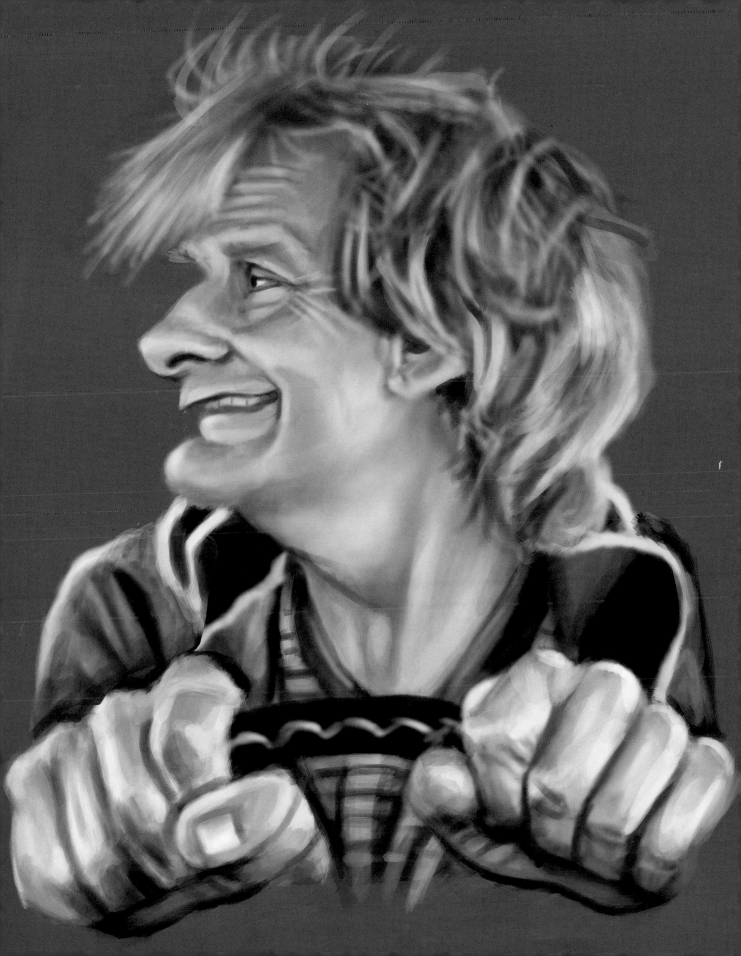

mask from my face and quickly placed it in a sink of cold water to salvage it. It was a very nice mold of my face, but my mouth was wide open as if screaming, resembling something like Edvard Munch's *The Scream*. I reluctantly opted to try again so he could get the perfect mold, and after several anxious minutes, we finally got one.

Two weeks later, I found myself in a subway car stuck in between stations. The entire train went dark for several minutes, and a wave of claustrophobia unexpectedly swept over me. It was like I was plastered up again. For several years after that incident, I developed a severe case of claustrophobia. I dreaded going through the New York City subway tunnels, riding elevators, and even getting stuck in a plane on the tarmac. Getting over this took extensive therapy, learning breathing techniques, and confronting my enclosed-space fears.

Fast-forward a year to Jeff Daniels hosting *SNL*. On Friday evening, the day before the live show, he was nowhere to be found. Jim

Downey, our head writer, sidled up next to me in the studio and asked if I had heard what was going on with Jeff. "No," I replied. "What's going on?" He rolled his eyes. "I'm not supposed to say anything, but Jeff has been in the makeup room for the last two hours stuck in life mask." I almost fell over. According to Jim, apparently after the mask was applied, hardened, and ready to be removed, they couldn't get it off. At this point in his story, I was having trouble breathing.

It was literally stuck to Jeff's face! It clung to his eyebrows, eyelashes, and his five-day-long facial hair. If he panicked, he could have drowned in his own vomit. But the makeup team inserted two straws up his nostrils then slightly pulled the mask away from his forehead. Another makeup artist then slowly poured a pitcher of warm water between his forehead and the mask in hopes that it would loosen the plaster that was stuck to his hair. It didn't work. The straws gave Jeff a bloody nose and now the bright white plaster mask was covered in red. With everyone growing

more concerned and anxious by the minute, they decided to alert Lorne Michaels. Lorne immediately called upon a few of his plastic surgeon friends who were at a nearby cocktail party. They arrived quickly and hovered over Jeff to quickly devise a plan.

They slipped a glistening X-acto knife, ever so gently, between Jeff's forehead and the mask, carefully cutting off every hair of his eyebrows. Once they removed that section of the plaster, they continued farther down and delicately sliced his eyelashes free. Now they could at least pull off the top part of the mask. Since the plaster was now only attached to Jeff's beard, they would have to inject his face with many shots of Novocain and chip the mask, piece by piece. Three hours later, Jeff was finally free.

The next day he approached me with no eyebrows or eyelashes, and red, blotchy cheeks. "Did you hear what happened to me?" he asked. "No," I said, playing dumb. As he relived his experience to me, I almost passed out again. "You didn't hear about it?" he asked again. "No," I said again, playing even dumber. I shared that I had had a similar disaster but not quite as bad. I asked him if it traumatized as well. "Yeah, a little," he said, sort of laughing it off. I couldn't believe how he was actually *laughing* off his ordeal. Had I been a drama queen? I wanted to impress upon him how serious and traumatizing it was and that he shouldn't downplay it. I made sure to tell him that in the future he will most likely experience claustrophobia and years of therapy. In the end, we both survived, and he brilliantly hosted *SNL* that evening sans eyebrows and eyelashes.

It was suspected that the culprit was a disgruntled makeup artist that had been recently fired—allegedly out of spite, before leaving, he sabotaged the plaster mixtures so something like this might happen. Who would have thought we would have to go through that much agony to play Jay Leno?

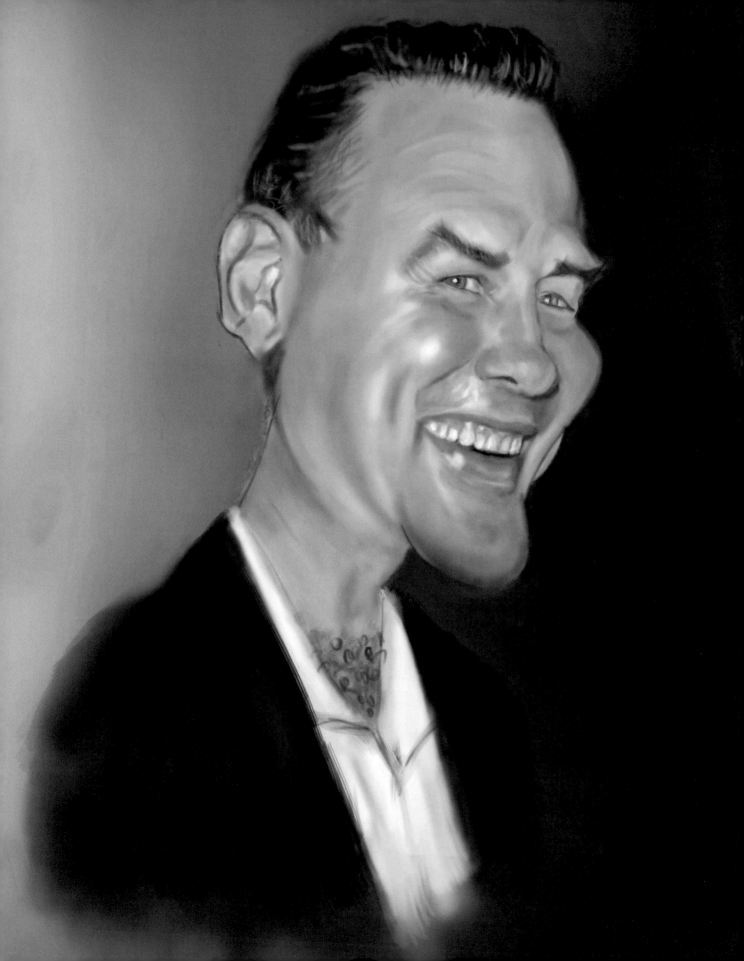

NORM MACDONALD

1959-2021

'm tickled every time someone does their impression of the late comedian Norm Macdonald. Hearing the unmistakable cadence of his voice and laugh is just so fun, if now bittersweet. A proud Canadian, Norm was quite the enigmatic fella. Incidentally, I noticed Norm preferred using the word "fella" quite often. This fella didn't have much in the way of a formal education, but he was well-read, curious, and incredibly fearless—especially when it came to comedy. I would sometimes hear of him clearing a room during a performance because he veered into perhaps sensitive topics with inappropriate points of view or jokes.

Norm was also a brilliant writer. Not only had he been on the writing staff of *Roseanne* and several others, but before his death he penned an incredibly entertaining book titled *Based on a True Story: A Memoir*. I highly recommend it. I first met Norm when he was hired as a writer on *Saturday Night Live*. Initially, it was challenging for the *SNL* writers to craft jokes for me during my "Weekend Update"

years. Most of the writers and cast members were busy trying to get their own sketches on the show, exhausted from a week of writing, or didn't want to be bothered with coming up with a topical joke for the segment. They knew viewers at the watercooler on Monday were more apt to recall a funny sketch or character than some random "Weekend Update" joke. As a strategy to get writers to contribute, Lorne Michaels hired a caterer to make a hot breakfast on the day of the show. It was quite an elaborate buffet: an omelet chef, pastries, bagels, fresh fruit, and hot coffee. Since there was no Google back then, many newspapers were spread across the writer's room table. Also, stacks of Associated Press photos of people in the news that week were available to be used as reference or captioned with jokes. Blank legal pads and pencils were also abundant. Unfortunately, Lorne's strategy didn't work that well. But a few writers showed up, like political pundit Al Franken and Norm Macdonald. Norm, though, never really wrote any jokes. Seemingly, he only showed up to have breakfast and read the paper.

Norm eventually became a cast member and created some fun and lasting characters, like his Burt Reynolds impression. He eventually followed me as the "Weekend Update" anchor and we all loved him. I believe it was Norm who actually coined the phrase "fake news," and I don't think he was ever credited. It is also well-known, only because Norm loved talking about it, that he was fired by NBC's president Don Ohlmeyer for making too many jokes about Don's BFF, OJ Simpson. Norm was relentless with his OJ jokes and everyone loved them except for, of course, Don Ohlmeyer (and probably the Juice). Note to self: Don't upset the guy who pays you or the guy who could kill you.

Unlike a lot of celebrities Norm was a good listener, asked tons of questions, thought about the answers, and formulated opinions. He would always find the ridiculousness or irony in discussions. He sincerely enjoyed his fans—whenever we were together and were stopped for a selfie or just to say hi, he would graciously spend time and engage.

Besides comedy, Norm and I also shared the love of golf even though we were both horrible weekend-hackers, if even that. I was particularly fond of his PGA golf tournament commentating that he did live on Twitter. "And so the stage is set for DJ to make his second putt in as many holes. Can he extend his lead? YES!!! Dustin Johnson is threatening to run away with this early." I mean, his descriptions made you feel as though you were actually there.

Playing a round of golf with him was sometimes annoying due to his extremely competitive nature and knowing the PGA rulebook inside out. He was a stickler for rules and there were no free-drops or mulligans when you golfed with Macdonald. He loved to kibitz, tease, and try to undermine your game. He'd then make a friendly wager like "closest to the pin for $50." I wonder if gambling was allowed in the PGA rulebook. It was not a secret that Norm liked to dabble in the gambling world (to put it lightly). He also had a reputation for not paying back loans to friends. I discovered

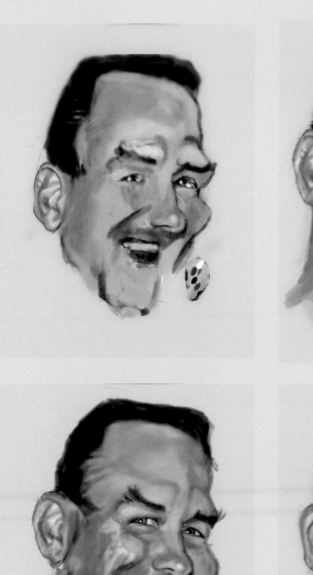
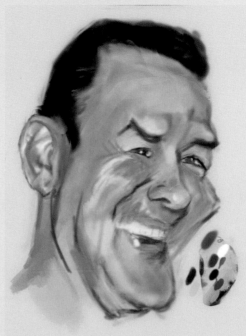
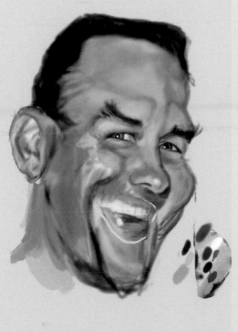
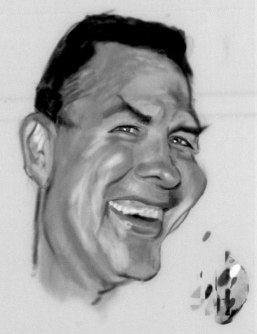

that firsthand. Fellow *SNL* cast member Jon Lovitz did, too. Jon loaned Norm $500 one evening so Norm could play the casino tables. A week later he still hadn't paid Jon back. He continued to pester Norm for his $500 when, finally, Norm spouted incredulously, *"You're* upset about losing five hundred dollars? *I* lost five *thousand* dollars! I'm the one who should be upset!"

Norm was a great guy but also a train wreck. He was the kind of guy that needed a handler and usually had one. The truth was, Norm needed someone to make arrangements, drive him, or just be there to rely on, to figure things out. I was always flummoxed at how far Norm got in his career, or life for that matter, lacking all those life skills. I guess charm goes a long way.

Some time ago, I invited Norm to join me for a weekend of golf-school lessons in Palm Springs. I picked him up on the account that he didn't drive and never had a driver's license. Yes, I knew I would be his handler on this trip,

but it would be worth it. The trek to the desert was about two and a half hours and Norm blasted Johnny Cash tunes on the CD player the entire way, window down with his bare foot dangling out. Luckily, *he* wasn't driving.

The morning of our first lesson I had to knock several times on his guestroom door to wake him. After I'd made several attempts he opened the door, half asleep and unshaven, claiming he was almost ready. There was then a slight delay of fifteen minutes because he couldn't find his golf shoes. We took three days of golf lessons and every morning we arrived late. All our lessons were vidcotaped and reviewed at the end of the course by the pro. I'll never forget Norm's reaction to getting notes on his swing. Our golf teacher analyzed Norm's swing frame by frame and pointed out Norm's weaknesses. To my surprise, Norm disagreed with the teacher. Embarrassed by Norm's petulance or pride, I reminded him that our teacher was a pro and knew what he was talking about. Norm just shook his head, smiled sarcastically, and said to the pro,

"OK, but I'm not doing what you're saying, and I think you're wrong." I learned a lot that weekend, about golf and Norm both. Note to self: Never treat Norm to a weekend of golf school in the desert again.

Not many people knew that Norm was secretly battling cancer the last nine years of his life. He didn't want his presence to remind people about his disease. I had seen him on and off during the last decade of his life, and in hindsight I guess there were clues. I don't know if this was related to his condition, but I did know that he had a sensitive stomach. At every gig, he would ask the bartender for a glass of bitters and soda water.

A few years ago, we were doing a stand-up tour in his native Canada. After finding his misplaced passport, we got to chatting. I shared with him that my mother was recently diagnosed with multiple myeloma cancer. He asked if she was taking a medication called Revlimid. "Yes, she is, as a matter of fact," I said. "How did you know about that drug?"

He shrugged it off and said, "Oh, I just like to read about random things like that." His physical appearance and energy often fluctuated during that time. Sometimes, he was thin and on his game and other times, heavy and somewhat spacey. In hindsight, I have to assume some of his behavior was probably the result or effect of whatever cancer medication he was taking. It really is hard to believe he's gone.

But Norm was, without a doubt, one of a kind. Although, yes, sometimes difficult, he was also so clever, daring, and smart as a whip. His comedy was brilliant, irreverent, and at times biting. Thank you for your unique brilliance and charm. Rest in peace, Norm. God is your handler now.

ARNOLD PALMER
1929-2016

I like golfing but am admittedly horrible. I have so much admiration for good golfers because I just don't have that gene. We all know that Arnold Palmer was the king of golf. During his golf career Arnold won four Masters, two Open Championships, and one US Open. He created a brand and charities, designed golf courses, and formulated a popular drink that is named after him: an "Arnold Palmer" (equal parts iced tea and lemonade). Talk about having a full life.

I had the honor of working with Mr. Palmer on his home course in Latrobe, Pennsylvania, shooting blood-thinner commercials. That's right, at this point in my career I was acting in a blood-thinner commercial. Yes, things were going well for me. The ad also starred Chris Bosh, center and power forward for the Miami Heat, and NASCAR driver Brian Vickers. How did this motley crew get assembled, you might ask? We each had a condition at the time that required us to be on a blood thinner and we all happened to be taking that brand. For the commercial, my being handsome did not hurt

either. But just to be clear, I'm not knocking this job—we were all paid handsomely while raising awareness about "possible blood clots not caused by a heart valve problem." Mr. Palmer was probably paid more handsomely than me, but me more handsomely than the basketball player, and him more handsomely than the racecar driver. But the bottom line is, I was the most handsome of the four.

The setting, Palmer's golf course, had so much history. This was the course where Arnold learned to golf and his father was a groundskeeper. Not only did he now own this golf course, but he also owned most of the homes around the course, a nearby hotel, a car dealership, and who knows what else. Oh yes, the local airport was also named after him.

Around the fourth hole on this course there is a big warehouse where they used to store the lawn mowers, tractors, and golf carts. Now, though, it is more of a museum of Arnold's golf memorabilia. Arnold Palmer had one of the most extensive golf club collections in the

world, numbering more than 10,000 pieces of equipment. The warehouse contains rows and rows of cubicles that hold Arnie's various clubs from over the years including the Wilson set he used to win the 1958 Masters Tournament. However, the only missing club from his collection is the Wilson 1-iron he used in the 1958 Masters that he gave to Augusta National to include in its display of clubs donated by champions. There are many rows of cubicles containing only his golf shoes and other cubicles full of golf paraphernalia. The walls are covered with portraits, photos, caricatures, and paintings of Arnold from throughout the years. It's part museum, part shrine.

During those two weeks, I discovered that Mr. Palmer would spend large parts of the day in his office, where he personally autographed each item that had been sent to him by fans. I would find this overwhelming, but it did not seem to faze Arnie, and this was actually part of his daily routine. I once sat with him as he systematically autographed each item. It wasn't a rushed autograph either. With a fully loaded, new black Sharpie he took his time with each and signed his name very precisely. In fact, each one looked identical. I kept wondering why he didn't just get a stamp of his signature. This, though, was his method. Each one had to look exactly like the last.

I really feel like I developed a bond with Mr. Palmer over those two weeks, quickly becoming buddies. When we were waiting for the cameras to set up, we would sit together in the golf cart and talk about myriad topics: golf, childhood memories, and the like. Sometimes I'd sit in the golf cart and watch him sink fifty putts in a row, and other times he'd sit in the cart and watch me miss fifty putts in a row. I asked him if he could give me one tip that might improve my game. He looked off and said, "Oh, I'd really have to spend the day on the course with you to watch your game." What a lesson that would be. I still wish I'd taken him up on that. When we talked about the AT&T Pebble Beach Tournament, I told him getting invited to that stunningly beautiful course was one of my dreams. "You've never

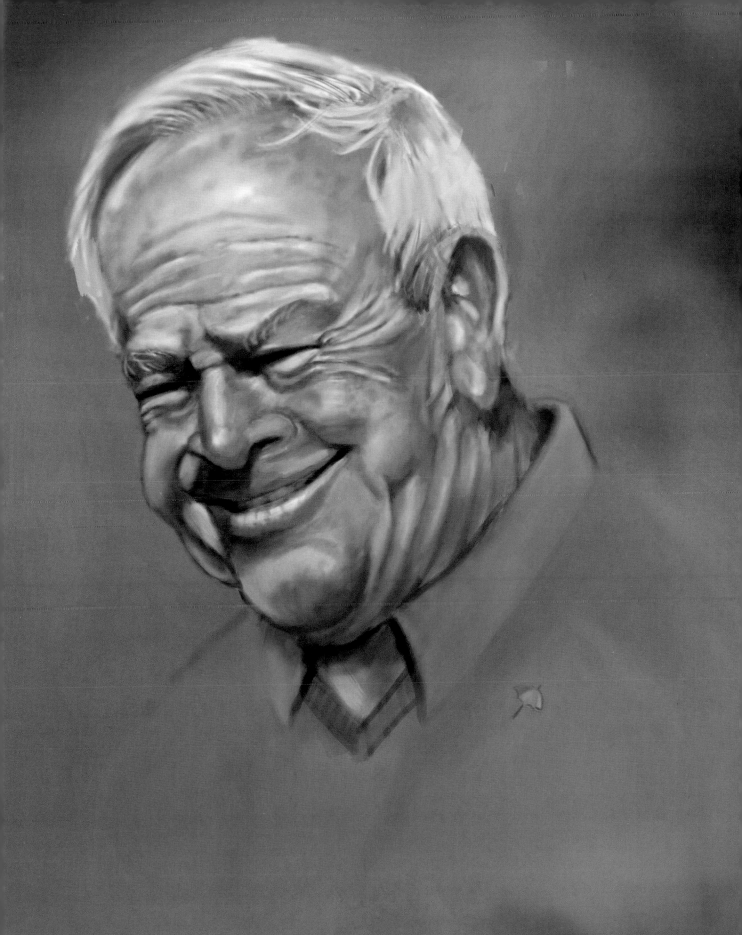

played in that?" he asked. No, Mr. Palmer. I can't seem to get invited. He casually said he would make a call on my behalf, and I couldn't believe my ears.

My only regret during that shoot was how I tried so hard to impress him. This was an impossible task. During a break on the first day of shooting, I suggested he golf at a course I enjoyed in South Carolina called The Ocean Course. He smirked and said, "I designed that course. I won three opens on that course." Oops. I forgot I was talking to the great Arnold Palmer. The next day, I bragged about a course on the Hawaiian island of Lanai. "You should try that course sometime, Mr. Palmer," I suggested. He smirked again and said, "I designed that course as well. Won four opens there." Ack! Nothing I said was new or impressed him. You can't impress a person who's done everything. I tried to stump him the next day. "Mr. Palmer, you ever golf at that miniature golf course on the highway near the airport?"

I thought I had him, but he replied snidely, "I designed the windmill over there."

Even when my mother visited the set, I was so excited to introduce her to the great Arnold Palmer. Arnold glanced at her, squinted his eyes, and said, "Oh, I know your mother. How are you doing, Kathleen?" He then winked at her. I mean, *What hasn't this guy done?* Nothing stumped him. But even that felt like an honor.

I began wondering about his childhood. Did he watch TV, or just play golf all day? "No," Mr. Palmer smiled. "I loved watching westerns growing up." I shot back, "I did, too! I used to watch a western called *The Rifleman* starring Chuck Connors." Mr. Palmer smiled and said, "Chuck Connors gave me his rifle from that show." My head sank to my chest. This man had done everything! Don't forget, he even had his own drink, which I saw him order from the server at his clubhouse.

Arnold Palmer himself was ordering an Arnold Palmer! When the server asked what I would, I looked at the menu for a few seconds and asked for a Kevin Nealon. "What is a Kevin Nealon?" the server asked, both her and Arnold sharing a quizzical look. I quickly responded, "It's exactly like an Arnold Palmer except taller and more handsome." Take that, Arnie! Touché!

A few weeks after the commercial first aired, I received a package. I opened it to find a beautifully laminated wooden box; on its cover was the stunning logo of Pebble Beach Golf Course. My heart pounded but it didn't alarm me because I was still on that blood thinner. I savored every moment as I slowly opened this mini chest. Inside was an incredibly impressive-looking invitation, the grade of paper heavy with quality. Each letter of calligraphy on it was so swirly with loops and twists and swirls I could barely decipher what it said but I knew what it was. I flipped the invitation open and immediately found my name. I was officially invited to play in the upcoming AT&T Pebble Beach Golf Tournament! My dream came true, thanks to Mr. Palmer. He kept his word and that is one of the reasons he is so revered and respected. Thank you so much, Mr. Palmer. I gingerly removed the invitation from the box and sat down with it pressed to my chest. Thank you, thank you, thank you, Mr. Palmer. That's when a separate piece of paper fell out. It stated that all invited golfers are required to pay a $26,000 entry fee to participate that would go to various charities.

Apparently, they must have thought I was paid quite more handsomely than I was. You did make the call, Arnie, and I do appreciate that. But to this day, playing in the AT&T Pebble Beach Tournament remains a dream.

*It must've been a toss-up just what to throw
you today,
A birthday, a funeral—it could have gone
either way.*

I think of Andre the Giant, the guy from Big
Fish, *people with Marfan Syndrome,
don't usually see forty and so you must feel
so alone.*

*I'm not saying you're in denial 'bout your age,
but it wouldn't have been legal for you to
date Susan until you turned thirty-eight.*

*Viagra, Propecia, low-hanging balls, well,
come on all let's raise a toast.
To Kevin, you're not my oldest friend but
you're close.*

*Soon you'll be just some old bastard whose
mind is gone.
Sitting on your porch playing your banjo
shouting, "Kids, get the fuck off my lawn!"*

*As your balls hang lower, you're more and
more nervous 'cause with every fart you
might shit.
Pretty soon when you do stand-up, you'll
have to sit.*

*I'm not saying you're in denial 'bout your age,
but it wouldn't have been legal for you to
date Susan before you were thirty-eight.*

*Prostate the size of a beach ball and you're
all about comfortable clothes.
To Kevin, you're not my oldest friend but
you're close.*

During the pandemic, my wife, son, and I visited family in Nashville for a week. During our stay Brad and Kim invited us into their pod on their nearby farm. We all tested negative for Covid and excitedly moved our bags into their guesthouse. What initially was going to be a week or so turned into a three-month visit. Covid was running rampant in Los Angeles, like most of the world, and there was no sense in rushing back. Each week they encouraged us to stay another. It was the perfect scenario in an otherwise imperfect world. Of course, no one was working. Our tours had been canceled, school was from home, and no one had anywhere to be. None of us had contact with anyone else during this period except one another. Our wives spent most days hanging out, our boys ran around together, and Brad and I played lots of ping-pong. Just a side note, Brad may be amazing on the guitar, but he's got nothing on me with a ping-pong paddle. Just sayin'.

Although it was brief, I loved living in Brad's country music world. His home recording studio was on the second floor of the guesthouse, and I would often hear him upstairs recording or working on new songs. When his latest, "City of Music," was eventually finished and first aired on the radio, I already knew every beat.

Music is such a large part of Brad's life and I have never seen a more impressive collection of guitars than the ones hanging from his walls: Fender Telecasters, Stratocasters,

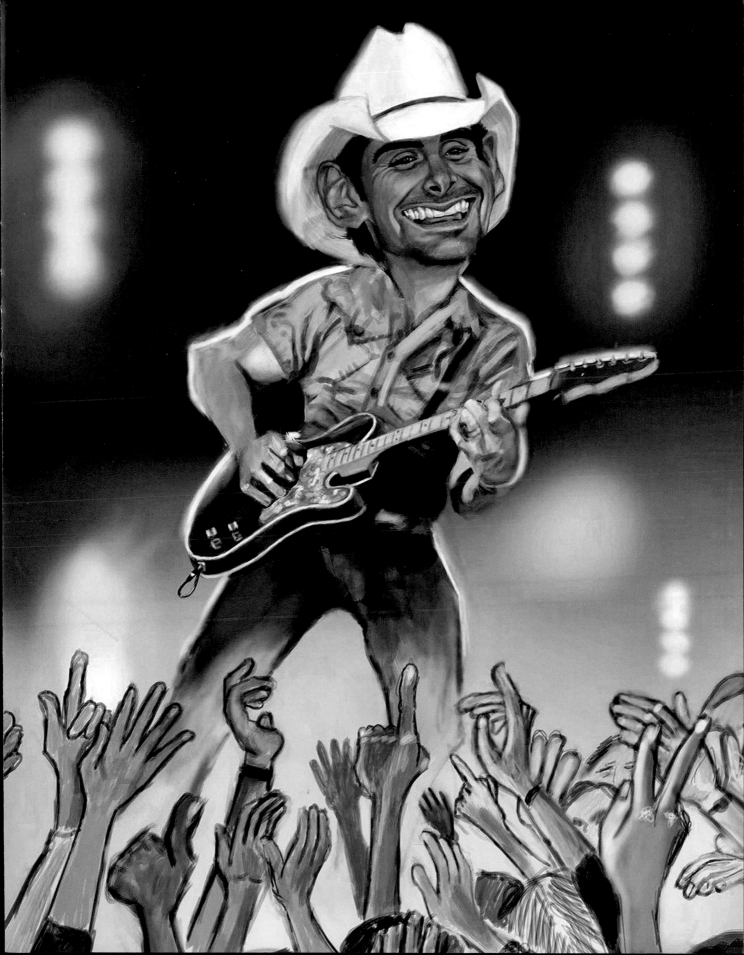

Esquires, and every other guitar Fender makes. His collection of instruments is so extensive he could easily open a museum and charge admission. Aside from collecting, he also likes to refurbish guitars at his workshop in Tennessee. He'll strip the body of the guitar down to its natural wood and paint them a color to match an original Fender. He then rubs on bourbon or whisky and blows cigar smoke all over it. I believe this gives it the feel and the grit of having been in tons of saloons and music halls over the years. (I hope I'm not revealing some secret process here.) He finishes by shellacking it and putting it in the freezer, which allows the finish to develop minute, hairline cracks over the entire body for a real retro look . . . much like me. And on a few he even painted a Marvel character, like Iron Man or Captain America.

Many nights on the Paisley farm were dedicated to watching Marvel movies or binge-watching episodic shows. Most people don't know that Brad (like our boys) is a huge fan of Marvel and Batman—as well as *Game of Thrones*. It's not unusual to stop by his house to find him in a Batman or Captain America T-shirt. After every episode of *Game of Thrones*, we would text about our favorite moments, like the Red Wedding or Arya taking out Walder Frey at the end of Season Six.

As Covid restrictions lifted gradually, Brad performed outside in the parking lot of Nissan Stadium in Nashville to about six-hundred cars and their tailgating occupants. I had already experienced performing stand-up at a few parking lots in Los Angeles during the pandemic, which wasn't ideal, but was better than nothing. At some parking lot venues, car occupants were given those little plastic hands to rattle outside the window if they liked a joke. If they really enjoyed your routine, they would flash their headlights. Brad invited me to do a few minutes of comedy before him at the stadium parking lot. Without putting much thought into it I agreed. But the audience and their cars were so far away I barely heard a laugh—except for Brad's amused yuks from backstage. Then, eventually, I introduced Brad to a sea of flashing headlights and a chorus of plastic hands clacking from car windows. What a night!

Aside from fantastic superheroes, Brad's fandom extends to the Dodgers. He was invited to sing the National Anthem during game two of the 2017 World Series and game three of the 2018 World Series. His ending was timed so that the Air Force Thunderbirds would roar over the stadium as he finished. For me, singing the National Anthem before a game is a recurring nightmare. In my dream I absolutely blank on the words. I'm being compared to Roseanne Barr's butchered rendition. The Thunderbirds fly over and drop bombs on me, and I only narrowly escape on my skateboard thanks to Liz, our birthing instructor.

KEN JEONG

Comedian-actor-physician Ken Jeong has a very recognizable face. You may know him from the TV series *Community* or playing a gangster in the movie *The Hangover*; or you may recognize him as the guy who once squeezed your testicle and asked you to cough.

How can you not like comedian Ken Jeong? Well, I'll tell you how. You might not like Ken Jeong if he had been your doctor before leaving his practice to go into comedy. Had I been one of his patients I think I might be somewhat resentful and suspicious. I would commit to watching every performance to confirm that he wasn't using my medical records or visits as fodder for his act. When he had his fingers up my butt examining my prostate, was he working on a comedy routine in his head? Will he share how miniscule my prostate was with his audience? Would he joke about my PSA numbers? Would my X-rays be used as props? Maybe your upcoming annual physical had been canceled, so you went home and randomly saw him streaking completely nude in *The Hangover*. Talk about reinventing yourself!

Imagine the Jeong family's reaction. Their son *actually* makes it through those grueling years of medical school, internship, residency, vocational training, and finally becomes a doctor—his parents couldn't be prouder. He sets up a successful practice with a bunch of patients and then suddenly quits for a career in comedy! Oh, parents love that! The thing is, you can't gradually quit, you must cut all ties immediately, destroy all records, lose the stethoscope and white coat, and disappear.

How can you not like Ken Jeong? Ask his parents! That's how!

No matter all his success in acting and comedy, the one thing I can tell you is this: He can never go back to practicing medicine. He would never be taken seriously again. Do you think anyone wants Ken Jeong operating on them? No siree!

I ask you again, how can you not like Ken Jeong? Here's another way: You're a comedian or an actor and he's been your doctor for several years. One day your agent calls to inform you of a big audition. It's for the part of a lifetime in a big Warner Bros. picture called *The Hangover*. You couldn't be more excited! You arrive at the studio the next day after working on your lines with a private acting coach for two hours that morning. You join the other anxious actors in the production office, each waiting to go in and read for the part of Mr. Chow, and guess who is called in right before you? It's Dr. Ken Jeong, the guy who had his fingers wrapped around your prostate a short twelve months ago. And guess what? He beats you out for the part. In all fairness, Mr. Chow was written as an Asian character to be portrayed by an Asian actor, but still, it hurts.

I also could understand the reverse: Discouraged performers leave entertainment all the time to find more respectful and lucrative professions. When I was starting out as a comedian at the Improv, each comic's performance was staggered in the lineup with a female singer. Most of these singers, including Bette Midler (before my time), went on to have successful careers in show business, but a handful of others saw the writing on the wall. They're now lawyers or therapists.

All kidding aside, I am happy for Ken. You only live once, and I assume Ken realized that comedy was his passion. We should all be grateful that he got into comedy because, in all honesty, who wants a doctor operating on you who would rather be doing something else, specifically a raunchy buddy picture?

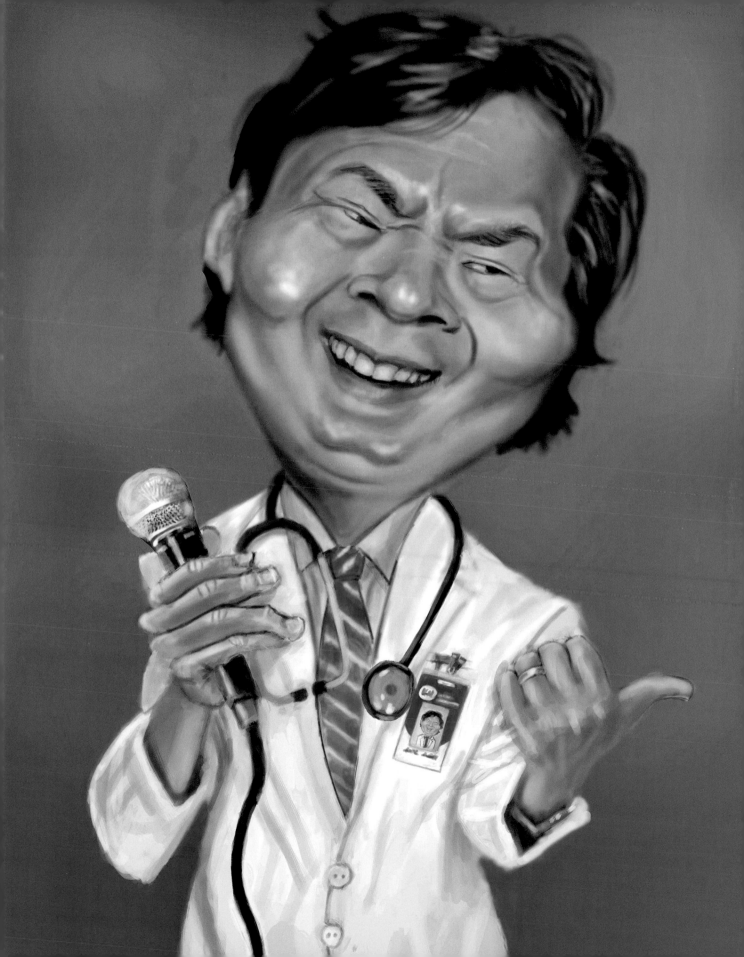

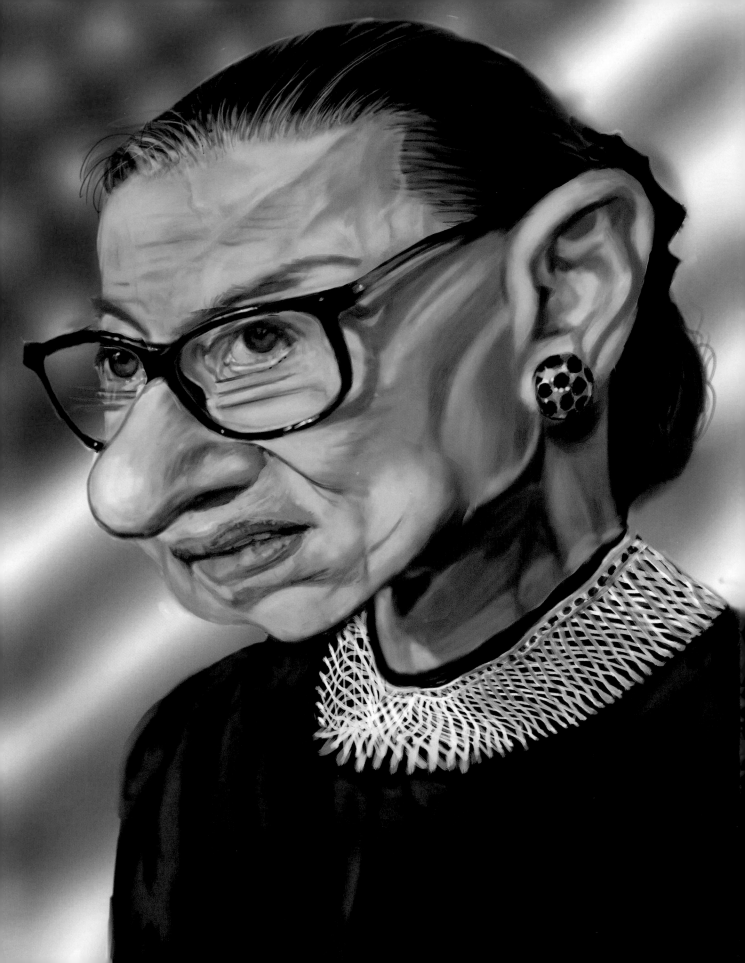

RUTH BADER GINSBURG
1933-2020

Ruth Bader Ginsburg was a US Supreme Court justice and only the second woman to be appointed to the position.

A US Supreme Court justice must make deep and thoughtful decisions based on their knowledge, philosophy, and leanings. They act as the final stop in resolving an issue—the highest court in the land with a decisive gavel. Frankly, I am not a fan of having to make difficult decisions. I may not be the worst ever Supreme Court justice, but I would be right up there. Can you imagine the number of complicated cases that pass before them? Take abortion, for example. Abortion is certainly a controversial subject, and everyone has their own views on it. I think the critical question is, *when does life actually begin?* Now, what worries me is a lot of people believe that life begins at forty. We've all heard that expression. I mean, you have to draw the line somewhere, but I think forty might be stretching it a bit.

As a judge, Ginsburg favored caution, moderation, and restraint. She was considered part of the Supreme Court's moderate-liberal bloc presenting a strong voice in favor of gender equality, workers' rights, and the separation of church and state. Her nickname of Notorious RBG came from a Tumblr post made by NYU law student Shana Knizhnik in 2013. She explained that it was the juxtaposition of Ginsburg's small stature and powerful presence that inspired her to create the nickname influenced by the late gangsta-rapper Notorious B.I.G.[11] This may come as a surprise to many of my readers, but Ruth Bader Ginsburg and Notorious B.I.G. had very little in common aside from both hailing from Brooklyn and, of course, each having an equally long rap sheet of arrests. Other than that, no comparisons whatsoever.

RGB will always be remembered as a tireless and resolute champion of justice, but never as a great rap artist. Maybe in the next life.

JOAQUIN PHOENIX

This painting depicts Joaquin Phoenix as Arthur Fleck in the psychological drama *Joker*. Arthur is a tortured and mentally unstable loner driven by latent rage and narcissism to commit brutal acts of violence in pursuit of an unlikely stand-up comedy career. I didn't realize this path was even an option. Joaquin has a penchant for playing damaged, narcissistic, and anxiety-riddled characters, but there is also a vulnerability in his performances. For my money, he is one of our most interesting and talented actors working today.

In *Joker*, some of Arthur Fleck's most creepy character traits are his ghoulish grin and his cackling laugh. Both send chills up my spine. I've always believed that a person's laugh is a window to their soul. A laugh is the result of an emotional valve that opens impulsively, releasing joyful or even conflicted feelings that can't be contained. As a comedian who is not tortured or mentally unbalanced, I have heard my share of laughs. I realize that everyone has their unique laugh, much like a bird's chirp and call. Some laughs are soothing and reassuring, some are fun and contagious. Others are just downright annoying and distracting. On a few occasions I have had an audience member sitting in the front row of my stand-up show with a very loud and annoying laugh. Every time that person let out that shrill cackle, the audience would recoil and roll their eyes. What is a comic to do? Yes, they are extremely distracting, but how ridiculous would it be to throw someone out of a comedy show because of their laugh? I wonder how Arthur Fleck would handle that.

I had read somewhere that Joaquin lost fifty-two pounds for this role over a span of about two months to play Fleck. Phoenix said the weight loss gave him a sense of control and the confidence to dig deep into Fleck's persona. The task of having to lose weight or gain weight to portray a character in a film is a great incentive or excuse for dropping or putting on some pounds. Whenever I gain weight I justify, "It's for a movie." "Really?" "Yes," I proudly say. "I'm gonna go see the new James Bond film."

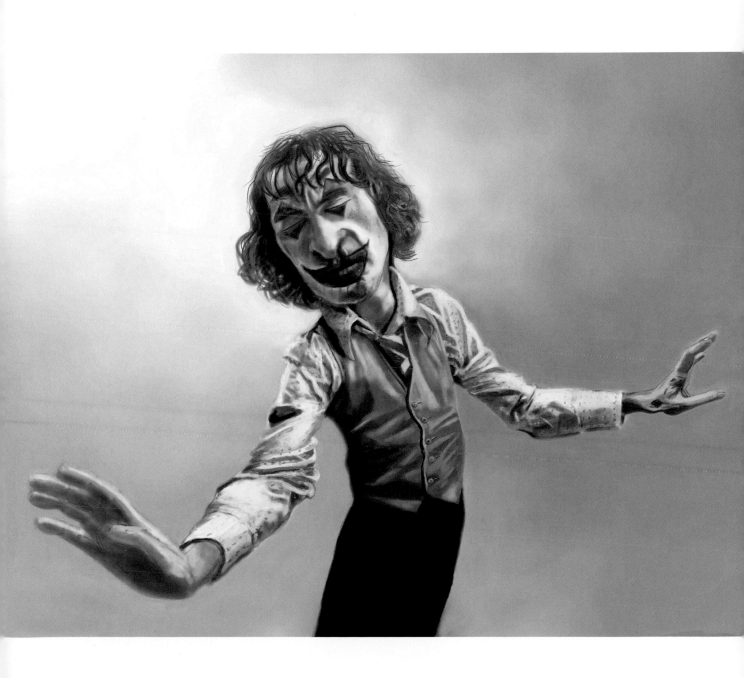

I have two things in common with Joaquin. First, like his character in *Joker*, I also desperately wanted to be on a talk show but, of course, took a different route. Second, Joaquin is an animal rights activist and I am very familiar with the animal rights movement because my former wife was passionate about animals and raising awareness about unnecessary cruelty to animals.

Her biggest beef was fur, and her self-appointed mission was to send furriers and trappers out of business. During the winters in New York City, she would carry a roll of stickers that read "I'M AN ASSHOLE. I WEAR FUR." Anytime she spotted someone wearing a fur coat, she would quickly remove a sticker and discreetly stick it to the back of the ignorant person's coat. She would then turn to me with a devilish grin, much like the Joker: Mission accomplished. Unbeknownst to the fur-wearing pedestrian, they would now be walking around the city wearing my former wife's emotion on their sleeve . . . or at least on their back. I've never had experience with this practice of stickering

before and I will admit, it made me uncomfortable. As a kid I would prank my friends, like many of us did, by taping a KICK ME sign to their back, but that was the extent of it. Even though I believed in the message her stickers sent, I was confrontation adverse and I feared that she might get sloppy with her stickering and possibly get caught by an onlooker. Since I was with her, I would be incriminated as well and, worst yet, I might be recognized. She ultimately acquiesced and agreed not to sticker furs while I was in her company. Apparently, though, over the long run her stickering worked because the production of furs, along with the inhumane anal electrocuting of animals for their fur, has gone down considerably.

Maybe some of these fur wearers weren't as evil and insensitive as we saw them to be. Perhaps a few were just unaware or ignorant and not the villains we perceived them as. Maybe they were just naive. All I can say to them is, count your blessings that it wasn't Joaquin you paraded that fur coat in front of.

ANYA TAYLOR-JOY

I was unfamiliar with Anya Taylor-Joy before her starring role in *The Queen's Gambit*. I was also unfamiliar with the word "gambit." I had to look it up and by now I have already forgotten what it means.

Anya's character, Beth Harmon, was raised in an orphanage and was taught how to play chess by the janitor in the basement. You would have thought he'd teach her more practical things like how to sweep a floor or change a lightbulb. Also, it was pretty naive for a young girl to befriend an older man alone in the basement of an orphanage, assuming that he's just going to teach her to play chess. But that was, in fact, what happened.

I found Beth Harmon to be incredibly compelling. She was determined, curious, and incredibly patient with her adoptive mother. I also loved her character's features—her red hair cut in a fashionable bob, and Taylor-Joy's generously spaced, almond-shaped eyes. I'm sure her peripheral vision far exceeds most . . . much like her beauty. Although I didn't know her, I was drawn to painting her face for its features.

Her character developed a drug habit that was tangled with her chess habit. Obviously, in the game of chess, one needs to focus on their strategy; I can't see how one would benefit from drug use in a match. At night, as she lay in bed, she would envision large, imaginary chess pieces on the ceiling, quickly and expertly moving each from square to square to avoid capture and to trap her opponent's king. As I've lain in bed at night, I've noticed my ceiling looks more like cottage cheese. Not ideal for chess.

But I've always been amused by those large chess sets you occasionally find in parks. The pieces are literally five feet high. Who would enjoy playing with pieces that big? How could that possibly be relaxing? I would need a ladder to look down on the board to determine my next move. By the way, whose job is it to put those pieces back in the box at the end of the day? And why only large chess sets? Why

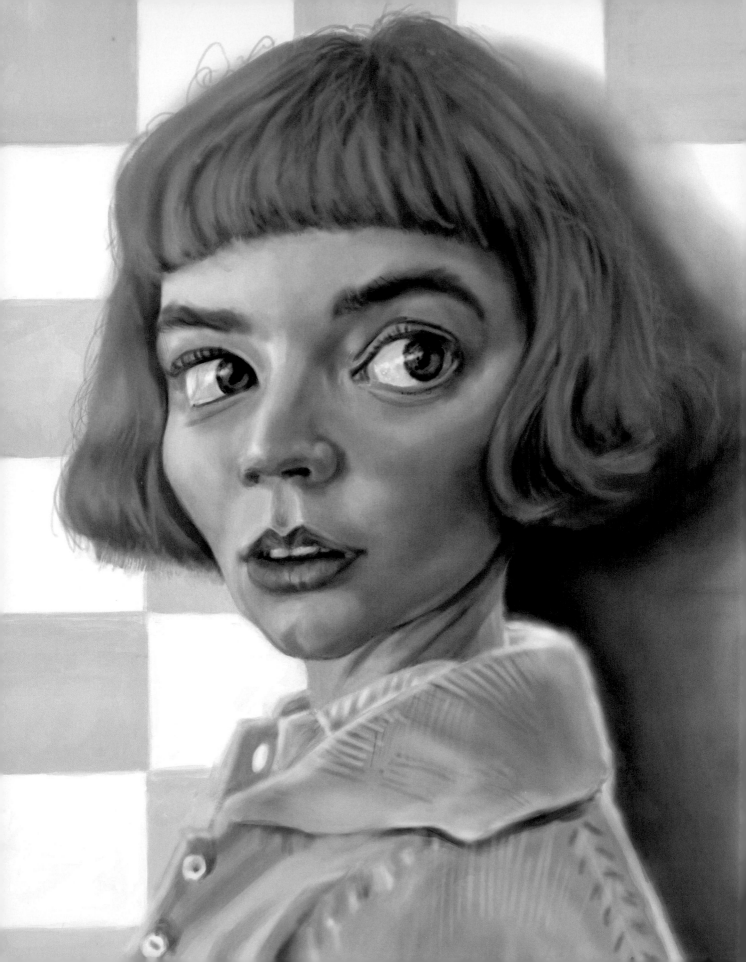

not large backgammon games, Connect 4, or even playing cards?

Anya's excellent work in *The Queen's Gambit* made me want to become an expert in chess. Not just an expert but a master. I was reminded of being a kid, watching Jimmy Stewart portray Benny Goodman as the clarinet-playing big band leader, which made me want to take up the clarinet (in hindsight this would have been a disaster because I am tone-deaf). But maybe I don't want to become a master chess player after all—maybe I'd be content with a short red bob? That's the magic of great acting.

I sometimes think of the Beth Harmon character and what happened to her after she retired. Like an athlete, would she turn to announcing? Do chess matches even have announcers? Now, that's a job where you could be strung out on drugs.

LIN-MANUEL MIRANDA

in-Manuel Miranda may be one of the greatest playwrights of our generation. Like many people, I was completely enthralled by *Hamilton*. I have seen it several times and will never forget the first time I saw it with the original cast with Lin playing Hamilton.

We were told to arrive early because there was going to be a very important dignitary in the audience and attendees had to be searched and subjected to scanning. When we arrived, there were several black officious-looking SUVs parked in front of the theater, several NYPD patrol cars, and plainclothes secret service agents. *Who could it be?* I wondered. I knew the vice president at the time, Mike Pence, had attended a month or so earlier and gotten a dressing-down from the cast. But who now? I mean, was it for me? Finally, after getting through security I took my seat, which was very close to the main exit. As showtime approached, I noticed that the only five empty seats in the house were directly to my left and in front of me. *Very curious*, I thought. Within

seconds of the curtains opening, in came the president of Israel and his wife, surrounded by Israel's elite Mossad secret service. They all plopped down in those empty seats and the curtain opened to a thunderous applaud. I could see the Israeli president directly in front of me, looking excitedly to the stage. Sitting to my left was an agent with his 9mm sidearm strapped to his waist and easily accessible . . . to either one of us, actually.

During the evening performance I split my time evenly between watching the play and watching the president's overjoyed reactions. I also couldn't help noticing the agents' total disregard for the play, constantly vigilant, scanning the audience and the balcony for any possible threats. I'm sure they checked all the actors' phony guns beforehand. I couldn't help but wonder whether a would-be assassin's errant bullet might connect with me. When the curtains closed at the end of the performance, the president jumped to his feet and began cheering. For a minute I thought maybe the Mossad agents would also jump

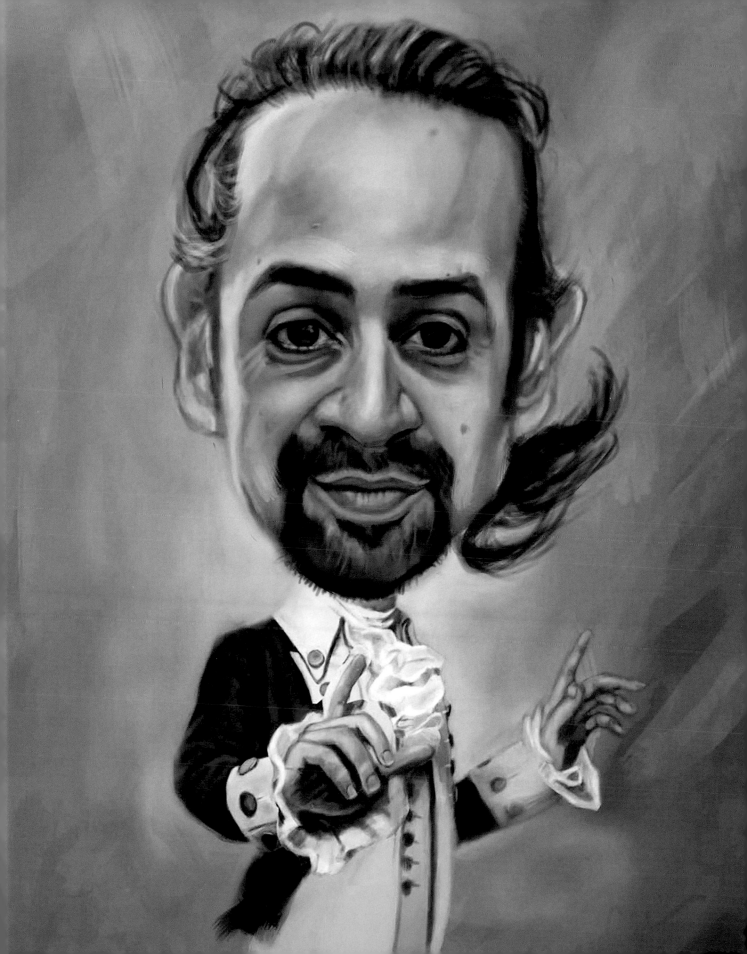

to their feet, draw their guns, and start firing into the air in celebration. But within seconds, the president was hustled out of the theater to his awaiting armored caravan. And there I was—alone and a sitting target.

A year or so later I would find myself on a hike with Lin-Manuel Miranda. He had agreed to be a guest on my YouTube show, *Hiking with Kevin*, where each week I hike with a different celebrity or notable person and interview them with my camera at the end of a selfie stick. Having Lin on the show was thrilling—I was somewhat starstruck. With the popularity and success of *Hamilton*, he was a real "get." We met at the entrance to Inwood Hill Park, overlooking New York's Hudson River, where I thanked him ad nauseam for being my guest. We immediately began our hike and our interview got better as I got over being starstruck. He said, "This is the park and woods that I played in as a child and also the exact trail where I wrote much of *Hamilton*." At one point I dared to ask him if he could throw together a little impromptu rap about our hike. He said he would, but his policy was that any time his Caucasian brothers asked for a rap they would be required to beatbox. I'm no beatboxer, but I desperately wanted him to rap so I tried my best—well, my best came out like "poorly timed wet farts" according to Lin. I agreed and revealed that one of them actually might have been.

When the hike was over, we went our separate ways. But after ten minutes of reveling in my "get," I realized that I forgot to remove my mic pack and microphone from his lapel. He was gone now and anything he said would be recorded. I called his manager, apologized, and asked if he could track him down so that I could retrieve the pack. I found Lin sitting on a stone wall waiting patiently. Thankfully he was very understanding. To this day I have not listened to those twenty minutes of post-hike recording. In fact, I erased the entire tape. I don't want to know any of the possible negative comments he might have made about me while not knowing he was still being recorded. But, Lin, if you are reading this, I've been practicing my beatboxing and they are all beatboxes now with absolutely no wet farts! Come rap with me!

WHITNEY HOUSTON
1963-2012

'll always remember what a force Whitney Houston was, with so much talent and charisma onstage. I never really got a chance to talk to her the week she hosted *Saturday Night Live* in 1991 because she was more or less kept in a bubble. Also, I was completely intimidated. The last time I saw her in person was several years later in an elevator we shared in a New York City hotel. I only noticed her, her daughter, and her husband, Bobby Brown, after I pushed the button for my floor. Again, I was totally intimidated and said nothing but a polite hello and asked what floor they were heading to.

Whitney was not only a powerhouse singer but an amazing actress as well. I really loved her in the romantic thriller *The Bodyguard*, costarring alongside Kevin Costner. Costner's character had his hands full convincing Whitney that her life was in jeopardy from a stalker. To this day, I actually blame Costner for not protecting Whitney from her accidental drowning, which led to her death in February 2012. Truth be told, if he had saved her that day, there would be a lot of speculation as to what he was doing in her suite in the first place.

I have always been morbidly curious about hotel diplomacy when it comes to those rooms or suites where a celebrity succumbed—because there have been many. Are those rooms still available for guests to stay in? Does the hotel manager have to alert a potential guest that someone once died in the room, like you do when selling a house? I would imagine that some rabid fans would purposely want to stay in the hotel room where their idol passed. I'm also pretty sure those rooms are consistently booked if the hotel still operates that room. I mean, do they renovate the room, or do they leave it as is and just change the room number? I know that it is permissible to stay in the suite at the Samarkand Hotel in London where Jimi Hendrix passed, and also I'm told the Landmark Hotel in Hollywood allows fans to stay in the room where Mama Cass Elliot of the Mamas & the Papas died. In fact, there is graffiti dedicated to Mama Cass all over the wall in that room. For that matter, I wonder if you can sit in the balcony at Ford's Theater in DC where Lincoln was shot? I'm asking for a friend.

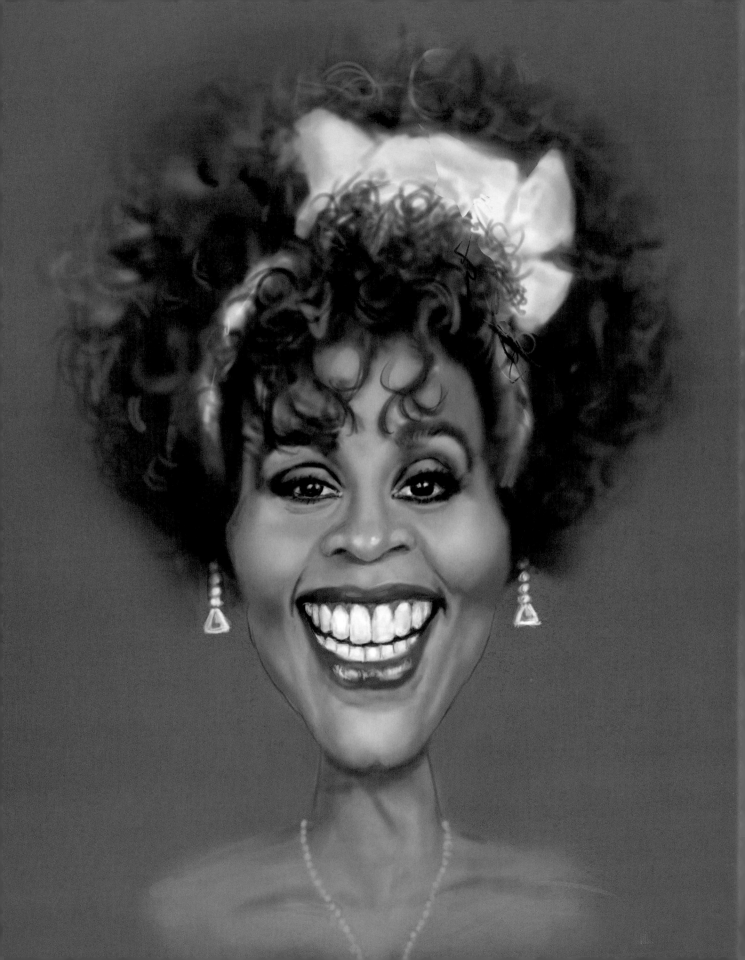

Jim Morrison of Doors fame died under similar conditions as Whitney. Shortly after Morrison moved to Paris, he was found dead in a bathtub at the age of twenty-seven. A doctor was summoned within the next seventy-two hours and pronounced Morrison dead of heart failure. His corpse was removed from the apartment and, under the pretense of Morrison being considered a poet (and not a rock star with a somewhat scandalous past), permission was given to bury him in the city's Père Lachaise cemetery. I recently visited his grave to discover fans had covered it with graffiti, flowers, cigarette butts, and empty bottles of Jack Daniels. He is buried amid other renowned artists such as Oscar Wilde and Édith Piaf, and, unfortunately, their graves have considerable residual Morrison graffiti as well. That said, it is likely that Oscar and Edith, since they both lived in France, were also smokers and probably didn't mind the cigarette butts. Yes, there are so many celebrities that have died in hotel rooms. You might almost say it is a trend. And what about all the non-celebrity deaths that took place in hotel rooms? That must be even more common. I would assume that the hotel must at least change the mattress, right?

Rest in peace, Whitney. I will always love you.

ANTHONY BOURDAIN

1956-2018

I never watched *Anthony Bourdain: Parts Unknown* during its seven seasons airing from 2013 to 2016. To be honest, I had zero interest in following some tattooed, seemingly self-involved, snarky, New York TV chef as he traveled, ate odd food, and mingled pompously with denizens from "parts unknown." I unfairly adopted a sour attitude toward Mr. Bourdain without even knowing anything about him. I absolutely blame this on CNN's publicity department. They were constantly bombarding us with *Parts Unknown* commercials, reminding us about Mr. Bourdain and each of his new, upcoming adventures. I eventually started calling it "Farts Unknown." From these ubiquitous ads, Mr. Bourdain appeared to me as being cocky, arrogant, and self-important. I just was not on the Bourdain Train.

But when I watched the documentary on Mr. Bourdain, *Roadrunner*, I learned so much about him. In truth, he was a charismatic and passionate thrill-seeker that kept searching for adventure and excitement. *Parts Unknown* wasn't about food, according to his friend, it was about Tony—not *Anthony*—becoming a better person. I realized that he had this flawed, damaged side to him, some humanity, that likely contributed to being a powerful writer. He wrote *Kitchen Confidential* (which *he* called an obnoxious memoir) years ago, and it quickly became a *New York Times* bestseller. Like me, he could be dark with gallows humor and a morose attitude about life. He often joked about how his life would end. In this documentary he said when he dies, he doesn't want to be talked about or celebrated unless it's done in a perverse way—like sending his body through a woodchipper and spraying his remains into some fancy store.

Suddenly I found him to be such an interesting person laden with complicated layers. Chef Bourdain was adventurous, daring, and risky. He enjoyed overindulgence, whether it was travel, love, or partaking in and becoming addicted to heroin and cocaine, which he stopped using cold turkey in 1988.

I'm not sure when the singular term "Chef" became a title like "Lord." And somewhere along the way the preceding "the" was dropped.

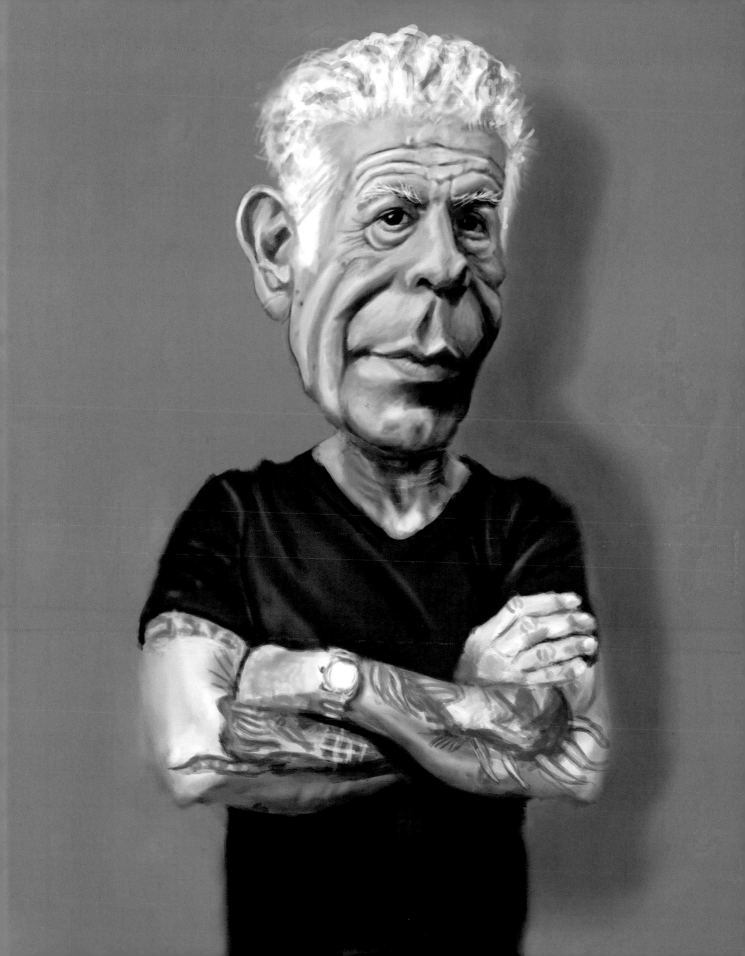

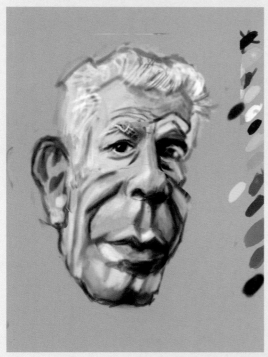
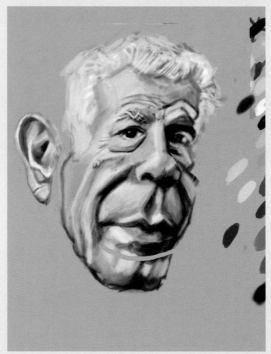

212

"The Chef" didn't prepare your meal—"*Chef*" did. In many upscale restaurants it's very common to hear "Chef" thrown around: "Chef created a sauce for your lamb." Or "Chef has sent you a complimentary appetizer." "Chef will be coming out soon," a server might announce. I always like to ask, "Who's Jeff?"

So when, exactly, did chefs attain hero status? Suddenly they're more revered than doctors.

I actually blame this newly acquired God-like status of chefs on the world's foodies. Foodies are so snobby about their meals, and chefs are akin to being their dealers. Foodies just love to have that personal connection with "Chef." They melt whenever Chef may happen to stop by their table. How do you have that much respect for someone who wears a hat that looks like a tall muffin? As a child, the very first "Chef" I knew was "Chef" Boyardee. I am assuming it took decades for chefs to overcome the association with this popular, inexpensive, and mass-produced can of noodles and watery tomato sauce. I wonder why Chef Boyardee never stopped by my kitchen table while I was slurping down my ravioli.

Little did any of us know that Bourdain came to despise being in the spotlight and wanted out. Chef Bourdain dropped his title and just became Tony. He was working on the road 250 days a year, often struggling with loneliness and depression. His life had changed so dramatically and so quickly. In the documentary, he reflected, "One minute, I was standing over a deep-fryer and the next, I was watching the sun set in the Sahara." He lost important relationships and any sense of familiar routines, and yet, during all this, it is astonishing to realize all the positive influence and inspiration he and that show had on millions of people.

I honestly do believe Mr. Bourdain and I could have been good friends and hung out . . . if CNN had just eased up on all those ads.

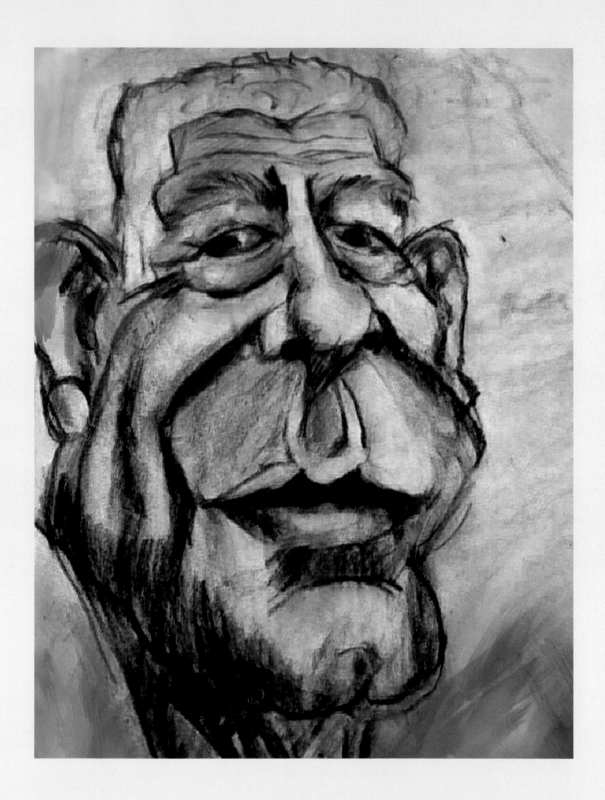

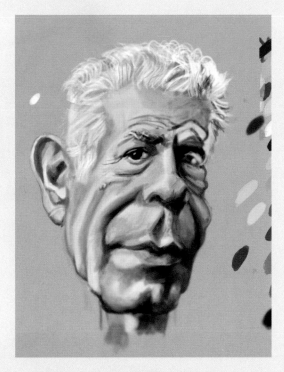
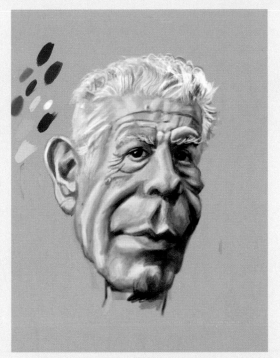
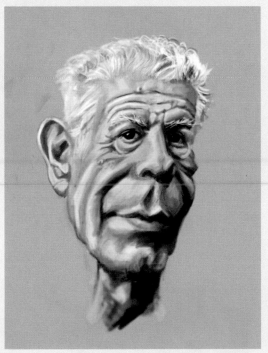

GILLIAN JACOBS

CONAN

AA# 172
seat 9A
LA-NY
11.27.1

ACKNOWLEDGMENTS

I have many people to thank for this book coming together. In no particular order, I am grateful to my family, Susan and Gable, for being so patient and understanding during the process of creating this book. Second of all, this project would not have happened without the generous networking and motivational skills of my buddy Jake Steinfeld and his relentless DON'T QUIT attitude. I'd also like to thank all the folks at ISCA for embracing and encouraging me. Big thanks to the brilliant illustrator Paul Moyse (@Moysepaul) for patiently mentoring me and opening me up to the world of digital art. The incredibly talented Chicago illustrator and caricature artist, Jason Seiler (@seilerpaints), for walking me through so many questions I had during the past few years about color choices, blending, brush selections, and Wacom tablet tech stuff. The collection of our texts is without doubt a book in and of itself. Sending out props to many artists in the caricature community for your support and for showing me what great caricature looks like. And finally, I'm beyond flattered and grateful to all the creative folks at Abrams Books: Samantha Weiner, Zack Knoll, and Diane Shaw. Thank you, Sam, for generously way-outbidding the hundreds of other publishers that were only slightly interested. Oh, and I can't forget, uhhh . . . what are their names? Oh yeah, my supercool book agents: Jan Miller and Ali Kominsky at Dupree/Miller Agency—such clever and knowledgeable strategists and overall decent humans.

(*This is where the wrap-it-up music would begin if this were an Oscar speech.*) Finally, I'd like to start off by thanking my hundreds of Instagram and Twitter followers who always had such complimentary comments for the paintings I posted. I will definitely read those comments when the dust settles. And first and foremost, there would be no progress or improvement in my art had it not been for all my friends and family that gifted me with pens, markers, and sketch pads over the years. (Too many to list but you know who you are.) For that matter, the rest of you know who you are, too. Heck, I'm even grateful to those of you who *don't* know who you are. Muchas gracias!

ABOUT THE AUTHOR

Comedian/author/artist/writer/actor/musician/producer/director/ping-pong aficionado/lover, (again in no particular order) Kevin Nealon will assure you he is not a Renaissance man. He seemingly is well-rounded and multi-talented but claims he is only adequate, at best, in each.

Kevin was a cast member for nine seasons on *Saturday Night Live*, where he was either just adequate or very underrated; he played the role of Doug Wilson on the critically acclaimed Showtime series *Weeds*; and he starred opposite Matt LeBlanc as his older brother, Don Burns, in the CBS sitcom *Man with a Plan*. Kevin has also played roles in more than a dozen Adam Sandler films.

Kevin has written and performed two stand-up comedy specials and is currently touring the country with his new stand-up act. He has written one other book, *Yes, You're Pregnant but What About Me?*, which was not on the *New York Times* bestseller list.

Mr. Nealon is currently a renter in a fire zone in California with his much younger wife and even younger son.

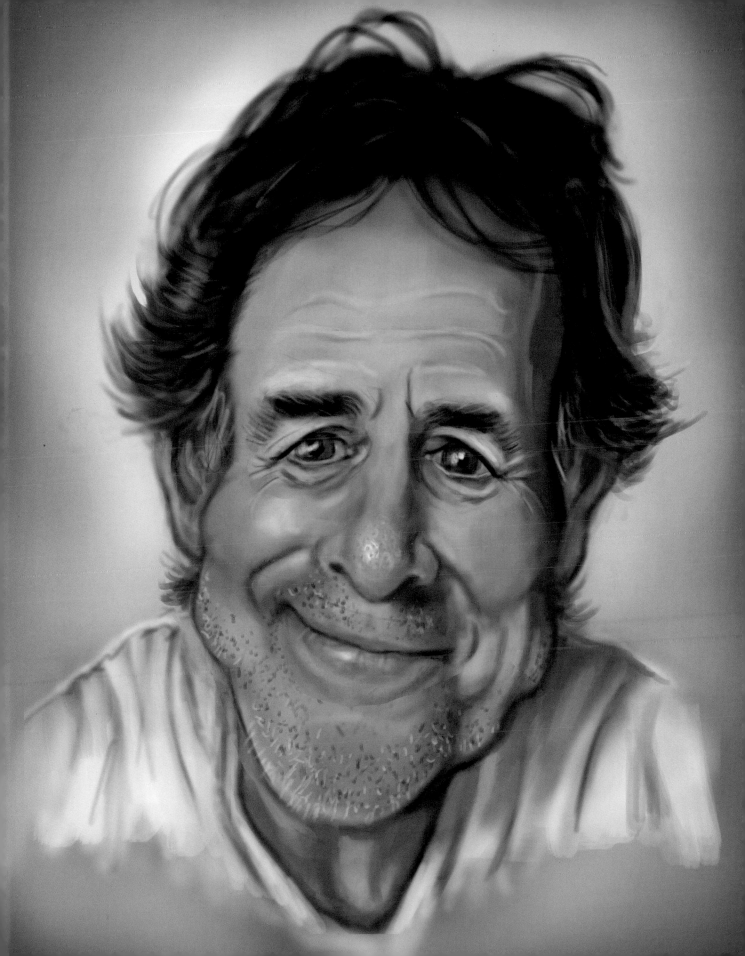

PHOTOGRAPHY CREDITS

Andy Kaufman, p. 33
ABC Photo Archives/Getty

Garry Shandling, p. 124
Lawrence Lucier/Getty

Matt LeBlanc, p. 162
NBC/Getty

Anthony Bourdain, p. 211
Erik Tanner/Getty

Harry Dean Stanton, p. 118
Michael Buckner/Getty

Norm Macdonald, p. 176
Bobby Bank/Getty

Arnold Schwarzenegger, p. 83
Jill Greenberg

Howard Stern, p. 95
Erika Goldring/Getty

Rami Malik, p. 156
Steve Granitz/Getty

Brian May, p. 153
Gary Miller/Getty

Humphrey Bogart, p. 90
John Springer Collection/Getty

Robert Plant, p. 154
Ian Gavan/Getty

Budd Friedman, p. 16
Michael S. Schwartz/Getty

James Taylor, p. 80
Michael Ochs Archives/Getty

Robin Williams, p. 13
Images Press/Getty

Carrie Fisher, p. 99
Alberto E. Rodriguez/Getty

Jennifer Aniston, p. 161
Peggy Sirota

Ruth Bader Ginsberg, p. 196
Shannon Finney/Getty

Christopher Walken, p. 86
Laurent Viteur/Getty

Jim Carrey, p. 38
Ben A. Pruchnie/Getty

Steve Martin, p. 59
Craig Sjodin/Getty

Dana Carvey, p. 49
Deborah Feingold/Getty

Ken Jeong, p. 195
Nicole Wilder/Getty
Charley Gallay/Getty

Tiffany Haddish, p. 134
Jason LaVeris/Getty

David Letterman, p. 28
Brent N. Clarke/Getty

Kurt Cobain, p. 108
Koh Hasebe/Shinko Music/Getty

Timothée Chalamet, p. 76
John Shearer/Getty

Elizabeth Taylor, p. 102
Jennifer Roberts / Philippe
Halsman Archive

Lauren Bacall, p. 89
Archive Photos/Getty

Tom Petty, p. 131
Aaron Rapoport/Getty

Freddie Mercury, p. 148
Phil Dent/Getty

Lin Manuel Miranda, p. 205
Mark Seliger

Tilda Swinton, p. 46
Alessandra Benedetti - Corbis/
Getty